PAINTING WITH PAPER

PAPER ON THE EDGE

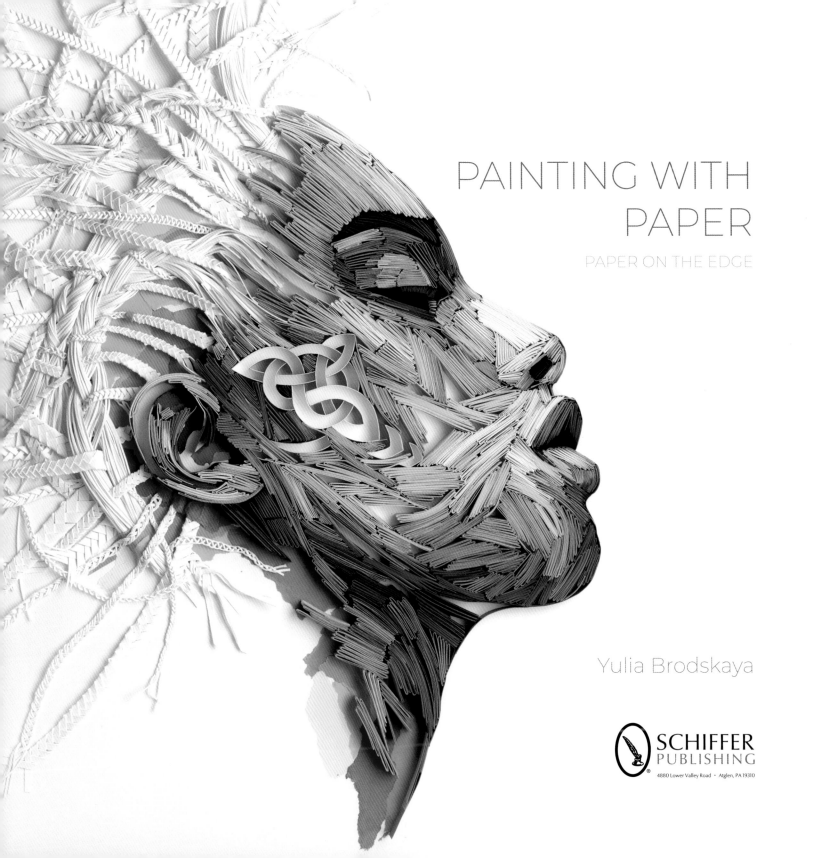

PAINTING WITH
PAPER

PAPER ON THE EDGE

Yulia Brodskaya

SCHIFFER
PUBLISHING

4880 Lower Valley Road · Atglen, PA 19310

Other Schiffer Books on Related Subjects:

Papercutting: Geometric Designs Inspired by Nature,
Patricia Moffett, ISBN 978-0-7643-5808-1

*Threads Around the World: From Arabian Weaving to
Batik in Zimbabwe*, Deb Brandon, ISBN 978-0-7643-5650-6

The Painted Word: Mixed Media Lettering Techniques,
Caitlin Dundon, ISBN 978-0-7643-5647-6

Library of Congress Control Number: 2019934828

"Schiffer," "Schiffer Publishing, Ltd.," and the pen and inkwell
logo are registered trademarks of Schiffer Publishing, Ltd.

Produced by BlueRed Press Ltd. 2019
Designed by Insight Design Concepts Ltd.
Type set in Gotham Light

ISBN: 978-0-7643-5854-8
Printed in China

Published by Schiffer Publishing, Ltd.
4880 Lower Valley Road
Atglen, PA 19310
Phone: (610) 593-1777; Fax: (610) 593-2002
E-mail: Info@schifferbooks.com
Web: www.schifferbooks.com

For our complete selection of fine books on this and related
subjects, please visit our website at www.schifferbooks.com.
You may also write for a free catalog.

Schiffer Publishing's titles are available at special discounts
for bulk purchases for sales promotions or premiums.
Special editions, including personalized covers, corporate
imprints, and excerpts, can be created in large quantities for
special needs. For more information, contact the publisher.

We are always looking for people to write books on new
and related subjects. If you have an idea for a book, please
contact us at proposals@schifferbooks.com.

CONTENTS

Introduction ...7

Paper Lettering ..10

Inspiration from Nature ...28

 Flowers and Plants ...35

 Hybrids ..46

 Animals, Insects, and Birds60

 Composition ...72

Portraits ..88

 "Old People" Portraits90

 Portrait Experiments130

 Case Study—Three Portraits148

Larger Pieces ...160

Final Words ..176

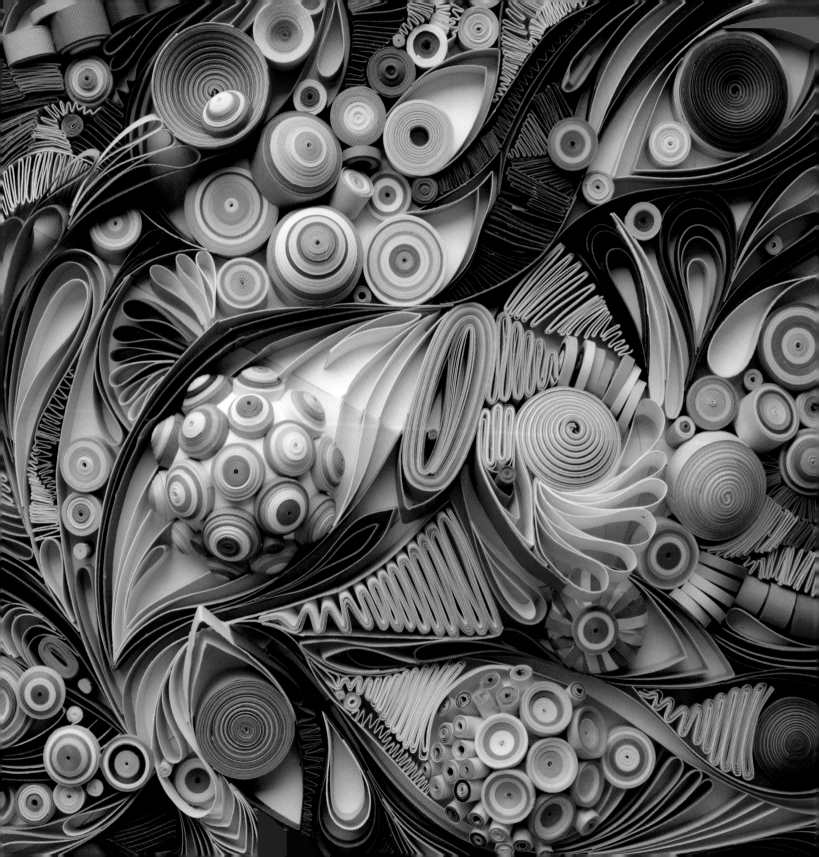

INTRODUCTION

My Paper Journey . . .

For as long as I can remember, paper has held a special fascination for me, but if someone had told me all those years ago that I would become a paper artist rather than any other kind of artist, I wouldn't have believed them. Over the years I've tried out many different paper methods and techniques, but only as a side hobby. First I studied art, then focused more specifically on graphic design. Up until the end of my second degree I was convinced that all things digital was the only way to make a reliable living. The realization that I was destined to become a paper artist came only after I found a way of working with paper—quilling—that has turned out to be the one for me. Now I can say that I draw and paint *with* paper, instead of on it.

Paper art in general, and quilling in particular, is a wonderful way to get the pleasure and joy of creating something special with your own hands. With its simplicity and availability of materials and advice, it's not surprising that so many people are now enjoying paper quilling. It makes me happy to know that I played a small part in the currently popular revival of paper quilling.

The fact that I got into paper art after many years in art and design education—studying, practicing drawing, and painting, all while developing observational and compositional skills—allowed me to approach paper craft from a different perspective.

I'll never forget a little anecdote I was told during my art school years (variations of it conveying the same idea are attributed to several famous artists). It goes like this: a well-known artist was asked, "How long did it take you to create this artwork?" He answered, "Two hours *and my entire life.*" He meant that all the previous experiences and practice had to take place in order for that particular masterpiece to exist. Every time I think about it, I get overwhelmed with the feeling of how true this actually is.

The commonest question I'm asked is "Why paper?" It should be easy to answer, but in reality, this is the very thing that I can't explain to myself, no matter how much effort I put into digging deep in a search for the reasons. I just love it. I recently read a statement that said, "materials wordlessly succeed in revealing much of one's soul." The choice of materials is never coincidental but seems to be governed by unconscious processes rather than logic or knowledge.

Paper has wonderful qualities—such as its amazing versatility, which provides endless possibilities. Paper is fragile, yet strong and resilient at the same time. I also wonder whether my fascination with paper can be related to its origins—paper comes from plants and trees—trees come from the earth = nature. Perhaps this energy can still be felt regardless of the number of manufacturing processes

QUILLING

Initially, I made my name using the technique called "quilling," which involves coiling and shaping strips of paper and then gluing them into a design. The practice dates back hundreds of years to the Renaissance, and probably even earlier. Another term I use to describe my technique is "edge-glued paper." In this book I jump between the terms "quilling" and "edge-glued paper," and occasionally just "paper art," depending on how distant each method or element that I'm describing is from traditional quilling. As will become apparent, the techniques that I use do not fit into just one established category, so the terms change— just as my style does from one paper artwork to another!

that took place in order to transform the raw natural material into the sheets of paper that we buy in a store.

I often find myself faced with the misconception that my work is all about the technique. Don't get me wrong; material and technique play a huge role: they are an integral part of my paper artworks. However, they are just a part, a kind of "instrument" mastered by years of practicing art in one form or another. Sometimes I do question myself, thinking that perhaps I take my paper art too seriously, but I just can't help it. The work is important and meaningful to me; in fact, more important than any other medium and techniques already established and celebrated in the fine-art universe.

At the same time, I honestly believe that any novice artist or arts-and-crafts enthusiast who has gotten some experience with the basics and familiarity with the material is capable of reaching the next level. This is when a technique becomes more of a tool, a way to convey a unique vision of the creator.

I also believe that step-by-step projects can get you only so far. They are very useful for making first steps to get familiar with the material and basic techniques (such as learning musical notes before playing an instrument), but there comes a time to embrace creative freedom, be inspired by the things that move you as a person, and search for individual ways to express your unique vision. This will make your work distinctive and ensure it stands out among all the other works that use the same medium.

In this book I offer practical tips about how to work with paper strips, and the inspirations and techniques that I have learned and found useful over the years. I will expand on these and explain how basic principles of art and design can be applied to paper art specifically. In no way is this an in-depth, comprehensive study of the fundamentals of art. I just want to introduce selective concepts and specific reasons behind the creative decisions that I make on a daily basis, in the hope that my experience will become a useful starting point for anyone interested in working with paper. This paper journey will culminate with the method of manipulating the paper that I like to call "painting with paper," which comes as close as possible to conventional painting.

I wouldn't expect anyone to adopt and follow all of my advice and suggestions: every artist is unique and needs to find the methods that work for them. However, many of the principles and skills I'm writing about are interdisciplinary and can be applied to many other visual art forms, including drawing, painting, and various other crafts and design concepts. Thus, getting a better understanding of the ins and outs of a creative process and, perhaps, adopting one or two tips and working methods might be helpful for anyone who wants to advance their creative skills and join me on a journey to ensure that this form of paper art takes its deserved place in the art world.

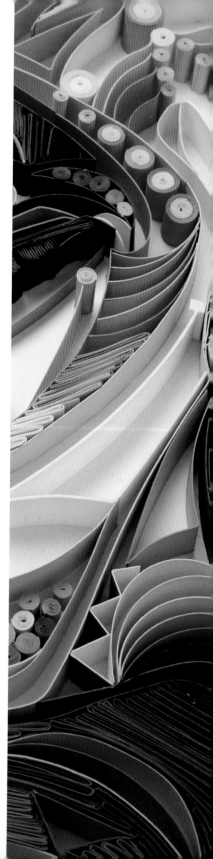

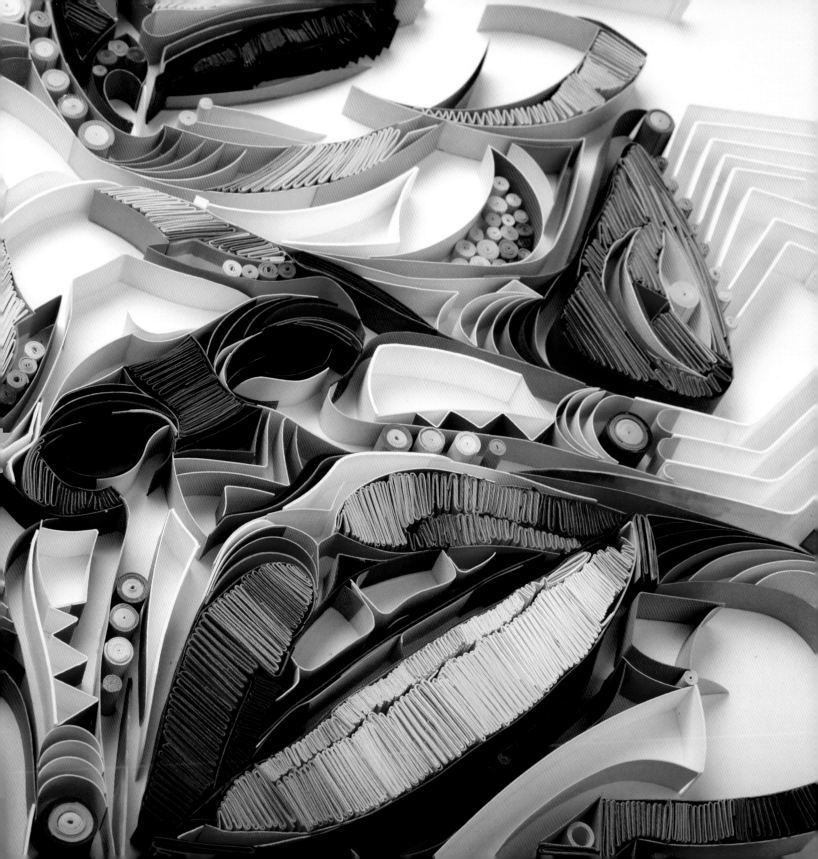

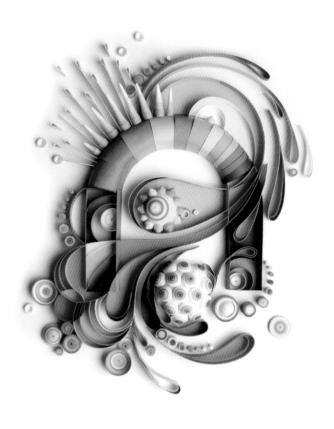

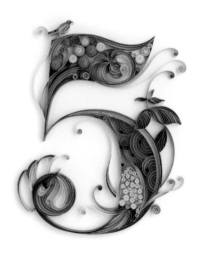

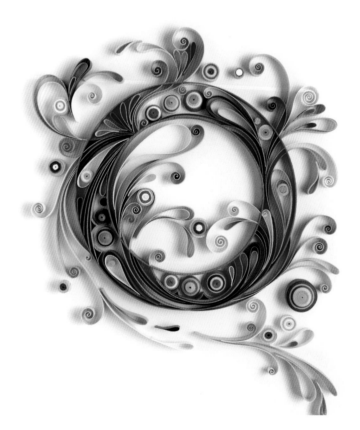

Paper
Lettering

Paper Lettering

Typography was instrumental in getting my work noticed professionally in the first place. I had been interested in using graphic design, letters, and words long before I realized that paper was going to be my medium. I already used graphic pens and colored markers to design and decorate hand-drawn letterforms, and after working at them for a year or so I had put together a number of typographic designs good enough, in my opinion, to get me editorial commissions from magazines and newspapers.

My idea was to make a little self-promotional booklet featuring some of these designs and send it out to potential clients. The crucial thing that was missing was an eye-catching cover image that would make certain my booklet would be noticed. After a little consideration, I decided that it had to be my name masterfully illustrated and featured on the cover. I created several hand-drawn versions of my name—Yulia—but none of them seemed to be good enough or worked as planned, so I discarded them.

What happened next turned my career upside down.

I can't remember how the thought of using strips of paper entered my head or where I was at that moment—maybe I was holding a sheet of paper in my hands? But the fact is that I took a pair of scissors, cut two A4 sheets into thin strips, and began gluing them edges down, repeating the letter outlines that I penciled onto a piece of mount board. I used red strips for the outline and an off-white color for inside details, deciding on the go that it would be nice to break some of the red outlines and have the white strips burst out from the letters. The work took me a couple of hours, and once it was done I realized that I was definitely on to something more interesting than all my previous illustrations. I immediately dropped the booklet idea and instead immersed myself into this new territory of making words with strips of paper.

Most of my early experiments combined paper with hand-drawn elements. I think I was just cautious and wasn't ready to let go of drawing straight away. My switch to working only

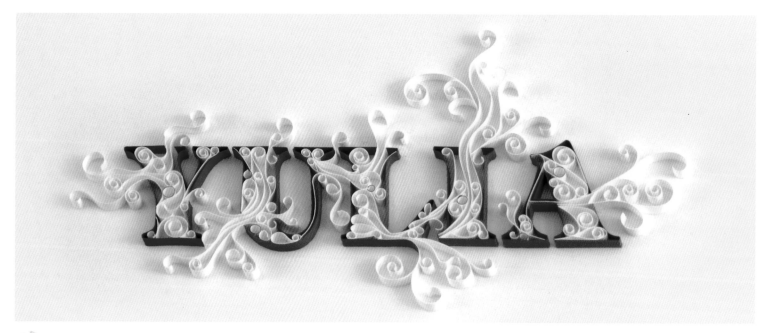

with paper didn't happen overnight, but artwork by artwork I was getting more confident, and after about five months of practicing and experimenting, all the hand-drawn elements were finally coaxed out of my paper artworks.

All this happened in summer/fall 2008, and in December that year I finally managed to get my first commission to create a number of typography-based paper artworks for the Christmas issue of *The Guardian* newspaper supplement. And that was it! It's not that I woke up famous, but I woke up with an amazing feeling of confidence, confirming to myself that everything that I'd been doing to get to this point was worth it and that I was ready to embark on a paper journey and see where it took me.

Following my breakthrough, I was lucky enough to collaborate with international brands and companies and work on exciting projects learning and perfecting my technique along the way. Most of my commercial work featured typography and lettering because that's what the advertising industry looks for—how to communicate a message in a new

and exciting way. Luckily my paper style happened to achieve just that, fueled by a newly found interest in, and revival of, all kinds of paper craft techniques.

Using edge-glued strips of paper to make letters ultimately made my paper designs look cool, modern, and different. Also, the design industry as a whole played a crucial role in reviving the craft of quilling paper. At this point I need to admit that back then, in 2008, I didn't know that the technique I was using had a name—when my first commercial projects started to appear on the internet, people told me about quilling. I had, unknowingly, invented quilling for myself from scratch! But by not knowing any of the established quilling techniques, I came up with something completely new—it turns out that my method is not exactly the same as traditional quilling: the key difference is that I use heavy paper or card, which I shape and manipulate any way I want to, exactly as if I'm drawing with paper strips.

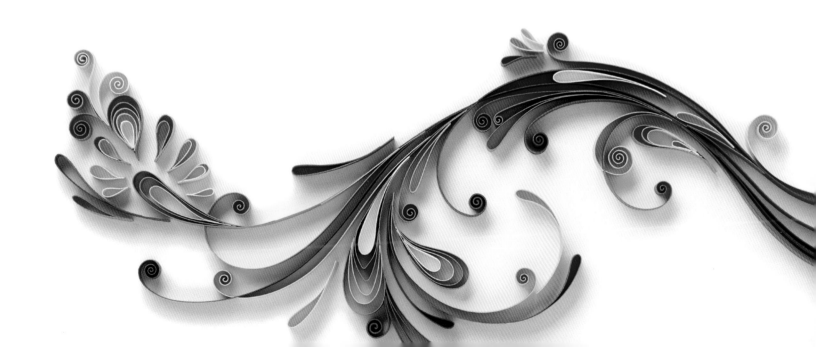

"Yulia"

Traditional quilling uses thin strips of paper that are curled, rolled into coils, pinched, and otherwise manipulated to create basic shapes, which when glued together or onto a background surface make up decorative 3-D designs. The need for basic shapes is explained by the light weight of traditional quilling paper: a strip is too thin and flimsy to stand on its own, unless it is rolled into a shape that will ensure stability and a larger gripping area between the strip edge and a surface. My way is different: by using heavy paper and card, I am able to work with single segments of a paper strip without the need to roll it into a basic shape. Heavy paper allows me to shape a strip into a single line, which holds its shape and is stable on the surface when glued down.

This quality of heavy paper makes possible the conscious and precise work with colors that, to my mind, is pretty much "the main trick" and the most crucial difference between my technique and traditional quilling. When a single strip of paper is rolled into a shape, you get multiple coils of the same color next to each other—it doesn't matter which shape you choose; it will still be just one shape and one color. Recently, however, graduated quilling papers have become available. These allow a certain degree of variation in color tone and intensity when rolled into a basic shape.

By working with heavy paper and adding strips one by one, I can introduce a new color and adjust the color balance with every new strip of paper.

What makes this possible is diffuse reflection: for example, a red paper strip reflects diffuse red light, yellow reflects diffuse yellow light, and so on. Moreover, the introduction of a new color with every added paper strip takes the process one stage further and produces diffuse interreflections. So when different color strips are placed next to each other, the light will bounce off every colored surface, creating new multihued blends—even the slightest variation in color tone and hue will make a visible difference.

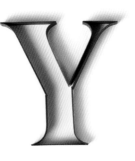

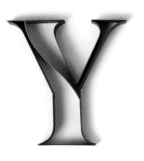

I find these color interactions absolutely fascinating—it's like a shared authorship: the artist does his/her initial part in outlining the design, but the real beauty is created by the empty space in between the edge-glued strips, where the colorful play of light and shadows takes place; without it the artwork is flat and lifeless.

To see my point, study the photo above. It's taken with front lighting that removes reflections and exposes the real background color between the paper strips—all the magic is gone!

TIP: Darkness/color intensity inside the letters can also be controlled by varying how densely the papers are placed. The more space between the strips, the more light can get in—thus the overall appearance is lighter.

TIP: Based on my observation of reflections, I tend to use many similar colors (for instance, groups of shades that are next to each other on the color wheel), which is a guarantee of harmoniously blended interreflections— whereas contrasting color strips placed next to each other require much more careful attention and consideration.

Learning to notice the subtle differences in reflections produced by different color strips will help you make educated choices when it comes to selecting an overall color palette for future paper artwork. Every small decision does matter.

I discovered and formulated these principles for myself quite a few years after my first "Yulia" artwork and thought it would be nice to revisit where I started and create "Yulia" version 2.0 to show how my style and technique has progressed over the years.

For this new version I wanted to make smooth color transitions, introducing new color with almost every new strip but keeping the variation relatively subtle by selecting most of the colors from a limited red-pink-orange range.

This new "Yulia" version 2.0 looks quite different from the very first "Yulia." About four years have passed since this second version, and I already know that if I were to make my name for the third time, it would look totally different from the previous two. I will go into more details about my paper art evolution later, but since my paper journey started with letters, I believe now is a good opportunity to touch on some paper craft basics and explore the numerous creative possibilities contained within such a simple form as a letter.

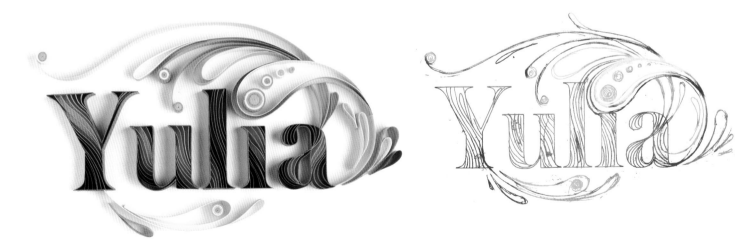

Whenever I want to create a design rich in color and showcase the smoothness of color blends and transitions, I go for a pure white background. This is because reflections are best highlighted against pure white: any coloration of the background surface builds up the reflections produced by the paper strips. The darker or brighter the background surface, the less colorful the reflections from edge-glued paper. For example, on a dark surface all you will see is the presence of shadows, which will stay exactly the same regardless of which color paper strip you use.

"Imagine"

This paper design showcases the gradual blending of colors and proves that outlines are not always needed. By roughly following letter shapes with a variety of tiny paper elements, each letter is still distinctive but with a slightly fluffy "out of the box" look for the shape.

TIP: For the background I chose to use mount board, which is a paper-covered board (though the core material can vary) usually around 1.4 mm thick. Mount boards are commonly used in picture framing, and they can vary enormously in hardness and quality.

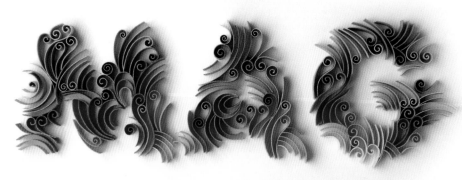
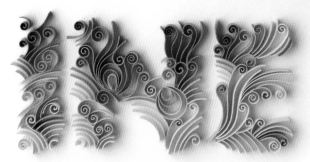

"Flourish" and "Shift"

These are very similar simple artworks, demonstrating some tips that can be helpful for working with paper lettering. There are two ways of incorporating type into an artwork: letters can either be filled with papers or they can be "inverted," meaning that letterforms will be blank/hollow inside and made visible by densely placed elements surrounding them, throwing the letter into visual relief. Additionally, both designs are good examples of how to achieve smooth color transition using a limited number of colors.

TIP: If you use double-sided paper with the white side facing inward and colored side facing out, this can help the words stand out better.

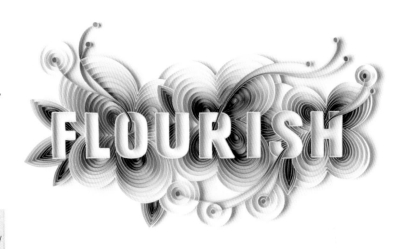

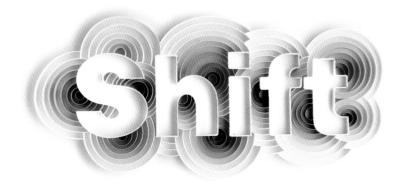

When making a color gradient from dark to light, use the same color strip at least twice in a row. The first strip will have a darker neighbor on one side and the same color on the other, whereas the second strip will have the same color on the first side, but a lighter color on the other—and so on until you finish it up with a couple of pure white strips. This might sound complicated, but by looking closely at the concentric elements it should be apparent how this optical effect works in practice. Many of the paper strips are actually the same color, but because they have different neighbors the combined color reflections will blend differently, thus visually enriching the paper artwork even with a limited color palette.

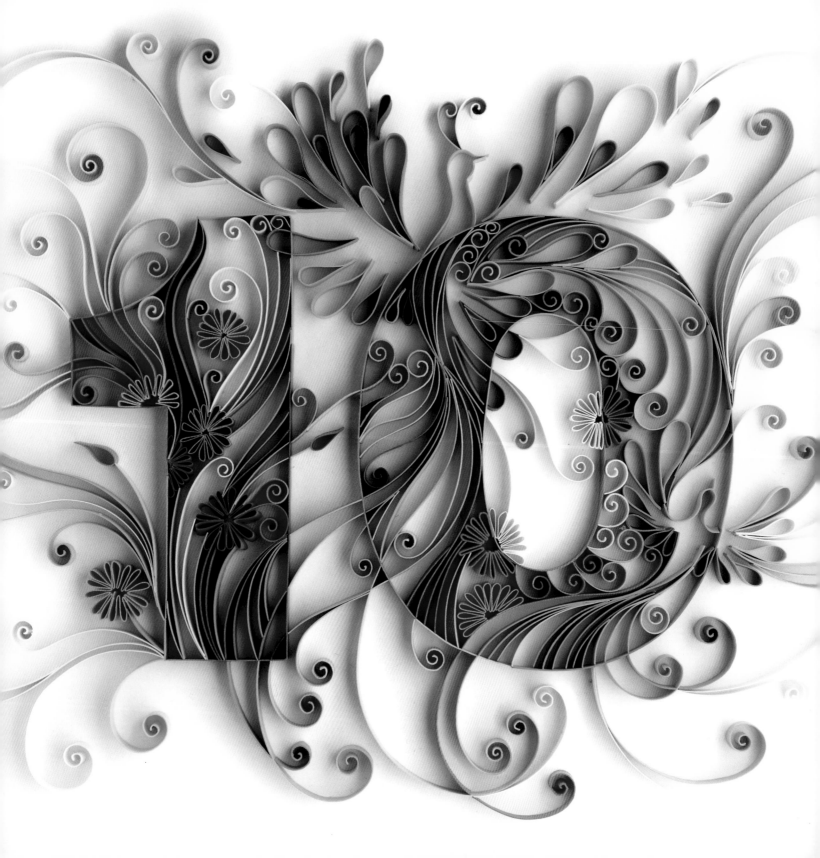

"10"

Illustrating numbers can be even more fun than letters because usually you get a limited number of digits to work with (numbers chosen for paper art projects usually represent age or a date), which provides a good opportunity to go big and bold with the font and incorporate lots of intricate detail.

This number "10" is a busy colorful concoction of flowers, abstract birds, decorative coils, and swirls spreading out in every direction from the digits.

With the exception of the straight geometric outline for the numeral 1, there are just organic flowing lines and forms present. These flowing lines are perfect for edge-glued paper and quilling for several reasons:

- Curled paper strips are more stable and so easier to work with.
- Organically placed strips of paper offer more opportunities for color reflection to enhance the design. Some areas of the paper will end up closer to each other and produce deeper, brighter reflections than those spread farther away from a neighbor. All this produces a soft, natural look for the design.

Pretty much any pencillike item with a smooth texture can be used for shaping and curling strips of heavy paper; the "special tool" that I used for this purpose is a cocktail straw made of firm plastic.

There is no specific reason why I use it, except for the fact that it happened to be the first suitable item that I found when I made my first "Yulia" artwork. I've used straws ever since (they are durable but still snap in half after a few years of constant use—I'm currently on my fifth).

For making spiral coils on the end of paper strips, I use cocktail sticks (wooden toothpicks), exactly for the same reason as the straw—because I found it at home. They don't last very long and snap quite often. There are specially designed

quilling tools available to buy—but my point is that it's really not about the tools: this craft can be practiced using the most-basic things found around the home.

Glue

Another basic—but essential—requirement is glue. It keeps every single element in place. I use PVA glue for all my projects, but not every PVA is the same. Some can be too shiny when dried; others have a yellowish tint. The best PVA for paper craft should not be too runny, although this can be fixed by leaving the bottle open for a long time. I buy new bottles and store them with the lids open for several months before starting to use them. The ideal is a PVA that dries clear and leaves a matte finish.

Another way of making glue easier to work with is to pour a little puddle and wait for 15–30 minutes before starting to use it. This way it becomes stickier and takes less time for a paper strip to attach to the background surface. This is especially helpful when the working surface is not completely horizontal—as in the "&" design project on page 20—an experiment aimed at introducing more 3-D aspects into the technique.

"&"

This early work was created out of firm cardboard with a raised structure and several inclined surfaces positioned next to each other. The intention was to simultaneously showcase different sides of paper strips in a straight overhead view. Working with inclined surfaces is very challenging because it requires lots of paper strip adjustments in order to get the right length, direction within the design, and, most importantly, connecting points—all for the purpose of finding the best way for the lines to go "over the edge" from one inclined plane to another. Having a PVA tacky glue puddle for dipping is a big help because the paper will slide down the inclined surface, so a slightly predried glue will ensure that there is no need to hold a paper element in place for too long until it catches and can be left on its own.

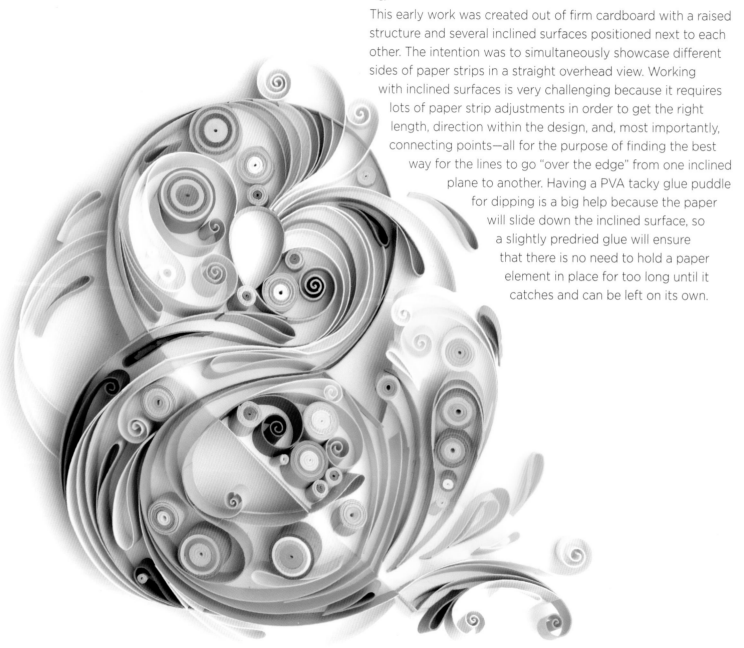

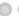

"O"

When incorporating lettering into paper art, you must choose the right font. For large ornamental letters—particularly single letters or initials—it is better to find a bold/heavy font that gives plenty of space to incorporate intricate details. However, at the same time, it should have an elegant quality to it. I usually choose a font that combines thickness with contrasting finer lines.

"O" is a good example of such a font. There's lots going on inside the thicker areas of the letter, and with many elements added to the areas surrounding the main letter, it may seem that it is almost too much. However, somehow the composition still works—this is thanks to the fact that all the outside elements are lighter, more spread out, and placed in a way that gives a feeling they move in unison rather than just randomly.

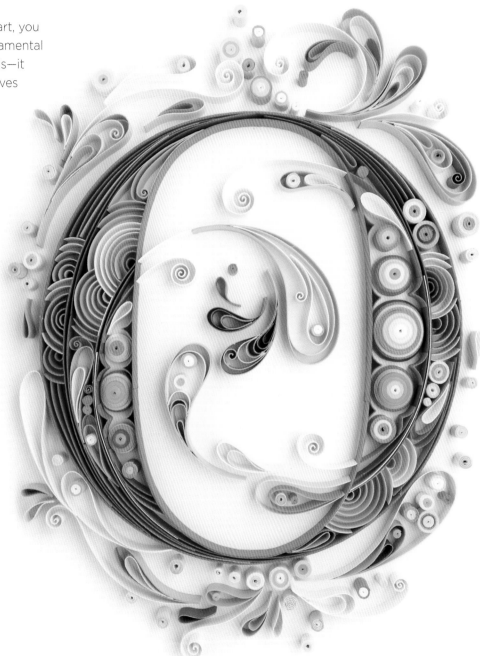

TIP: Sketching is crucial for making any busy design work look effortless.

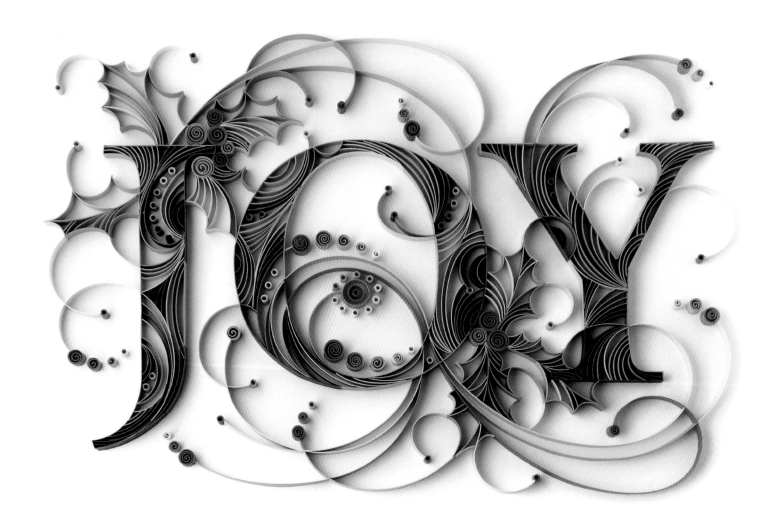

"JOY"

You might suppose that the more experience you have, the less time you need to spend sketching, but actually it's the opposite! Even after ten years, I dedicate more time to sketching than I did at the very beginning of my career. Experience makes you appreciate how much time you save by planning the work ahead. Of course, the specifics of each new project vary, but for typography-based designs a carefully thought-through sketch is a great help.

The fact that the glue is permanent and paper elements can't be removed without damaging the artwork is another reason to make sure the concept and composition work before going ahead with the creation process.

Sketching is even more important for typographic designs incorporating flowing lines and decorative elements outside the letters. Badly done, the artwork will look messy and unbalanced. Poorly placed lines also affect the legibility of

22

the message. The decorative lines should flow with the letters, enhance them, and add more movement.

There's no need to know how to draw in order to produce basic sketches; sketching is about finding the best concepts and refining the component elements that go into the design. This can be achieved by adding details to an existing image reference (for instance, an image from the internet, a photo that's easy to transfer into a drawing, or a ready-made template).

For paper lettering I always start with my chosen font template, then try to establish the most organic movement for the pencil lines that will become edge-glued strips of paper.

TIP: As a general rule, following the shape of a letter is the easiest way to make the design look harmonious.

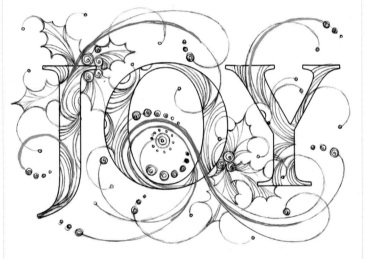

By adding and erasing lines, I finally end up with a basic directional scheme that I can build on to by adding minor lines, details, and simply fine-tuning the overall design.

Learning to see which composition looks best is a skill that comes with practice, but it can be developed by frequent sketching and conscious observation of existing typography designs. Pay attention to how exactly letters are connected, where lines begin, and what direction they follow—all of which

can differ from letter to letter, and from one font style to another.

"JOY" features two dominant movement directions (highlighted in red) and two supporting (shown in blue) to balance out the overall composition.

The final design can be as simple or as intricate as you want, but by making sure the key directions are obvious you can ensure there's no randomness .

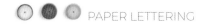

"25"

I used to work only with edge-glued paper strips against a white background, in order to focus on, and make the most of, the color-blending effect of the reflections. However, as my designs became more complicated, I discovered that I wanted more novelty in my technique. I started to add flat-cut colored paper into the background. Such areas of solid color produce a bolder, more striking look and provide a "rest" for the eye compared to the busy areas covered with the edge-glued strips.

For typography-based paper artwork, I usually cut out color paper segments and glue them down onto a background surface, then contour those flat segments with edge-glued paper strips to create an outline or border. The "25" is a good example of this method: it benefits from the bold, eye-catching areas of solid color but also has enough edge-glued strips to add finesse and three-dimensionality.

"Shine"

Because words always mean something, I try to base my color, font, and composition choices around the word's meaning. For this artwork I decided to go minimal and limit my color palette to white and yellow in order to convey the lightness, as well as the shine (gold and yellow are often associated with shining). Another little trick utilized in this artwork is the use of double-sided paper strips. Some drop-shaped elements have the yellow side facing inward; others have the yellow color directed outward, with the white color contained inside a shape. It is so interesting how the look of a closed shape can be affected by which side you decide to go with.

In "Shine," the double-sided paper is introduced in small amounts, but ultimately it makes the whole image more diverse and visually interesting and helps subtly convey the concept of shining.

Paper cutting

Usually I cut paper into strips myself. This way I am not limited by the type of paper that I might need for a specific project. Also, I use the cutting time to think about the project that I'm getting the strips ready for. I use a cutting mat, ruler, and snap-off cutting knife. When I first started working with paper, my strips were 7 mm wide, but gradually, with time, they became wider, and right now my go-to width is around 13 mm.

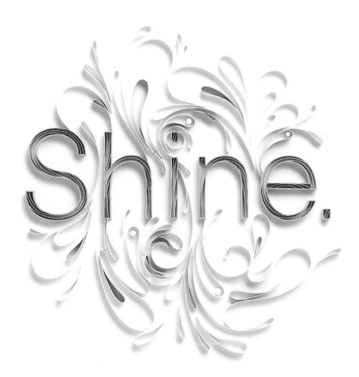

TIP: If you want to cut your own paper and would prefer to keep your fingers intact, find a ruler with a holding part higher than the cutting level. I learned this the painful way by almost slicing off a piece of my thumb!

"Love"

"Love" features solid-color 3-D lettering made in several stages. First, I created a pattern by gluing strips of paper laid flat onto a large sheet of card. Next, I cut the stripey card into strips and made the letter outlines with them. For the last step I added the top layer to cover the blank insides of each letter, working with one color strip at a time. Plenty of measuring, trimming, and fine-tuning was required to ensure the top flat layer fitted precisely on each letter outline—that's why I don't use this technique very often, even though I like the contrast it brings to quilling and edge-glued paper.

Typography

Lettering can be really fun to work with, and when it comes to font styles and typographic compositions, the sky is the limit! After many years of working with type, I started to move toward pictorial art, but once in a while, I happily go back to typography. Lettering helps me keep in touch with my old passion for illustrating words.

It doesn't matter which language you use for typographical designs, because essentially you are illustrating a shape of a letter, number, or character. Such illustration might be based on the word's meaning, thus emphasizing and enhancing the message, or it might be purely decorative.

TIP: Any white surface can work as a reflector. For instance, I often use large sheets of white foam board.

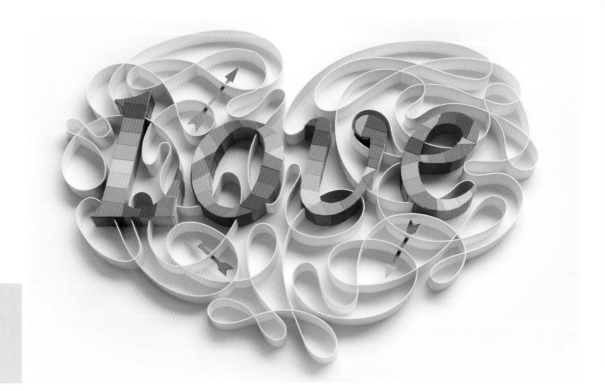

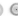

Photography

Considering the popularity and impact of social media and the benefits of sharing work online, it becomes crucial to photograph and present your art in the best light, literally. Photography is capable of making or breaking a piece of 3-D art.

There's nothing particularly complex about the process, and even the most-basic cameras can do the work, provided that the right decisions about light direction and intensity are made. For my photo setting, I usually use one main light source positioned to one side of the art, with a reflector placed on the opposite side to bounce off some of the light in order to soften the shadows.

When there is lettering incorporated into paper artwork, it is important to consider the legibility factor of the words and make sure that the message is easy to read. This can mean that paper design should not be photographed from a side-on angle, even when there is a need to show the sides of the paper strips, because perspective visually distorts letterforms. This rule usually applies to the projects intended for editorial or commercial use; in general, there is nothing wrong with taking a side-look photo for other purposes when legibility of the message is not the priority.

Another consideration is that it often makes sense to direct shadows toward the left side of the letters, since in English and the majority of other languages, we read from left to right. We leave the shadows behind when moving our eyes from the first letter to the last. This works on a deep subconscious level, and following this tip will help with natural perception of the 3-D typography.

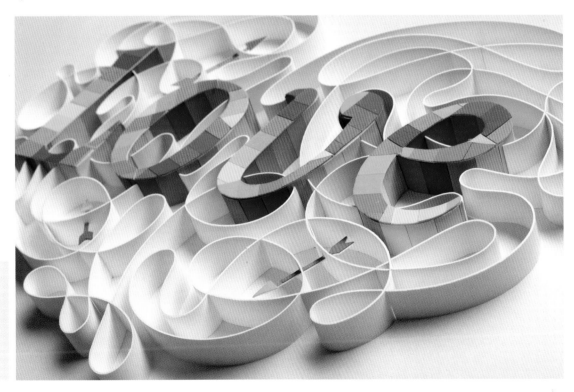

TIP: Sometimes it is helpful to use a slightly cooler white for the background surface because it looks "whiter" on photographs.

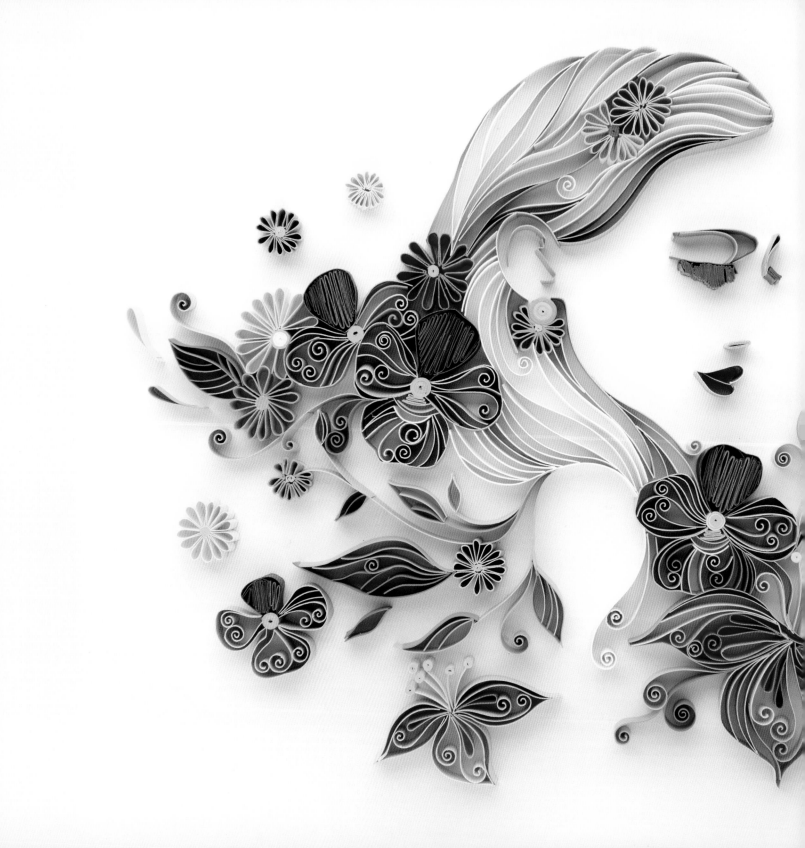

Inspiration from Nature

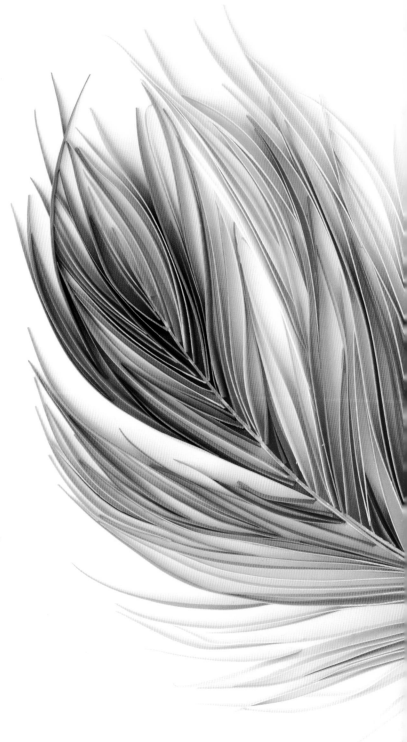

Inspiration from Nature

Creating art is a deep response to things that move us, and nature is probably the most powerful driving force for creative inspiration. It has inspired artists since prehistoric cave drawings because it speaks to us in ways that nothing else has the power to do.

The vast inconceivable variety of the natural world can be an endless source of inspiration—either for a complete idea or any particular detail that I might use, such as a color palette, patterns, shapes, and textures. The way to make inspirational use of the natural world around us is to practice the skill of active observation. This is much more than merely looking at something; it also involves a state of mind when you deliberately look for specific things. For instance, try to notice beautiful color combinations in flowers and trees while out and about. The thing that catches your eye becomes significant only if you pay attention to it and then stop to think about it. I call this "active observation," and that's why a real spark of inspiration happens only occasionally, since we usually observe things passively while on the go, absorbed in other thoughts.

Active observation was first introduced to me at art school, then, quite recently, I realized that there is another way to explain the same thing. If you're searching for inspiration you have to stay in the present as you look around: I know that when I pay undivided attention to a leaf, a bird, or a flower—at least for a few moments—I soon begin to draw a mental picture of how I could represent what I've just observed. If there are long lines, or veins (for instance, in a leaf or a petal), I try to visualize those lines made of paper strips. Or I imagine the round forms depicted with tightly rolled circles and so on.

Artwork previous page: **"Spring"**

Observing and paying full attention to something in real life always has more of an impact; however, I also do the same with photographs that I might find on the internet—this way I can be inspired by a colorful reef fish without the need to dive underwater!

Of course, trying to take notice of all the surrounding color combinations, textures, and shapes would be overwhelming; that's why art students are often asked to concentrate on just a single object. For instance, take a single leaf, a stick, or a flower and examine it, carefully observing the overall shape—how different is it from every other leaf or petal—in its structure, all the intricate color shades inside it—and how do the colors change in different lights? This idea is commonly used for observational drawing, which is an integral component of many art courses.

However, being inspired by nature is not something I grasped in a classroom, but at the art camps and on summer student trips. Then it hit me what it really means to look and see. As students we were encouraged to notice the beauty in every crooked tree trunk, in every leaf half-eaten by insects, in derelict agricultural buildings, and so on—the more battered, older, less perfect the object is, the better and more inspirational it can be for an artist. This is because an imperfection is the quality that makes something truly unique and distinguishes it from an array of similar more or less perfect things. Learning to be inspired by imperfection is a liberating experience and can become so much more than merely an artistic trick.

"Feather"

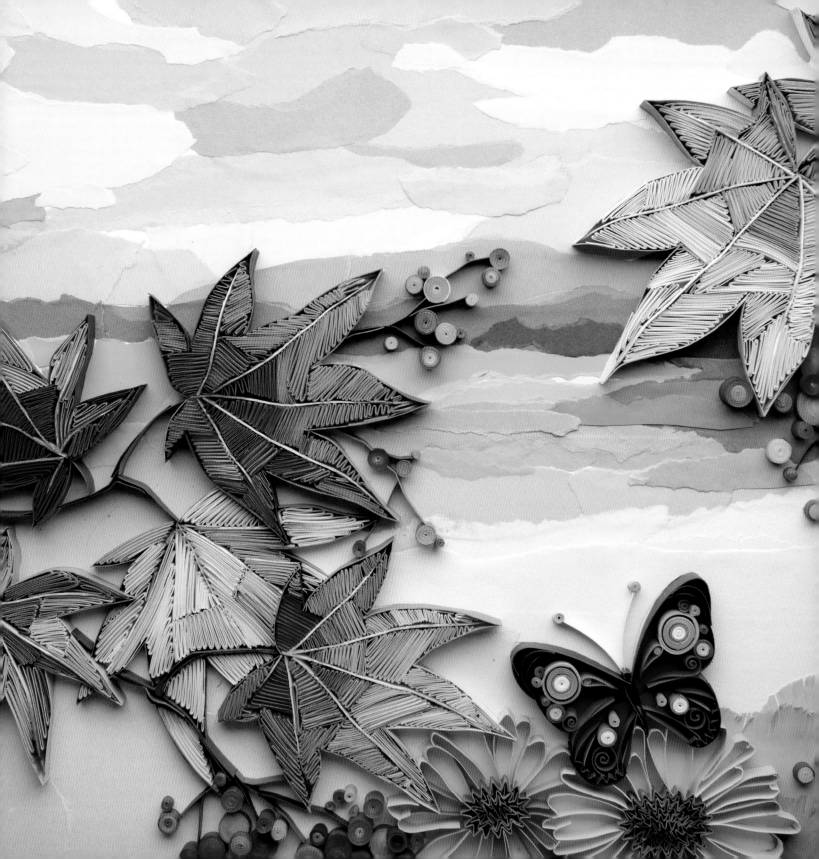

It's worth mentioning here that learning to observe doesn't mean that the creative outcome must necessarily be a realistic piece of art. It can just be a method of collecting inspiration for later works. Observational drawing is a helpful skill to have for making note of an idea or inspiration in a sketchbook, but a quick photo accompanied by a short note about the object does the same thing and is even more useful when it comes to recording the colors.

Keeping an inspiration library and constantly adding to it will ensure that you won't forget the things that moved you. If it was important at one moment of time, most likely it will stay important later when you go back to a sketchbook or a folder containing the collected photos; before you know

it, a new idea, combining fresh inspiration with something previously observed and recorded a while ago, will be born.

I use both sketches and photos. I always try to carry with me a little notebook, and I have a well-organized collection of photographs with notes and comments on my computer that I go back to whenever I'm in need of inspiration.

Natural motifs such as flowers, plants, animals, and birds are the major part of my inspiration library; because of it I can honestly say that I'm never out of ideas: there is always "that special flower" or "that spectacular butterfly" that I can't wait to create in paper when I get a break from other projects. Especially after doing a commercial job, I find that depicting the wonders of the natural world works like a spiritual retreat for me.

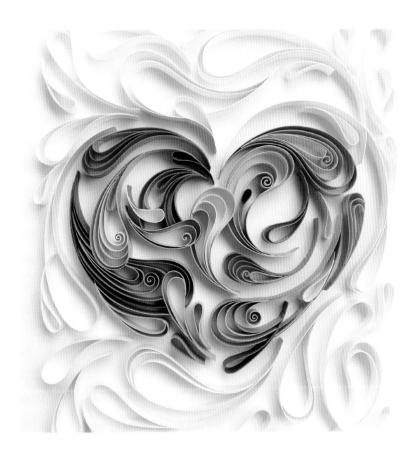

Left:
"Autumnal"

Left:
"Quilled Paper Heart"

33

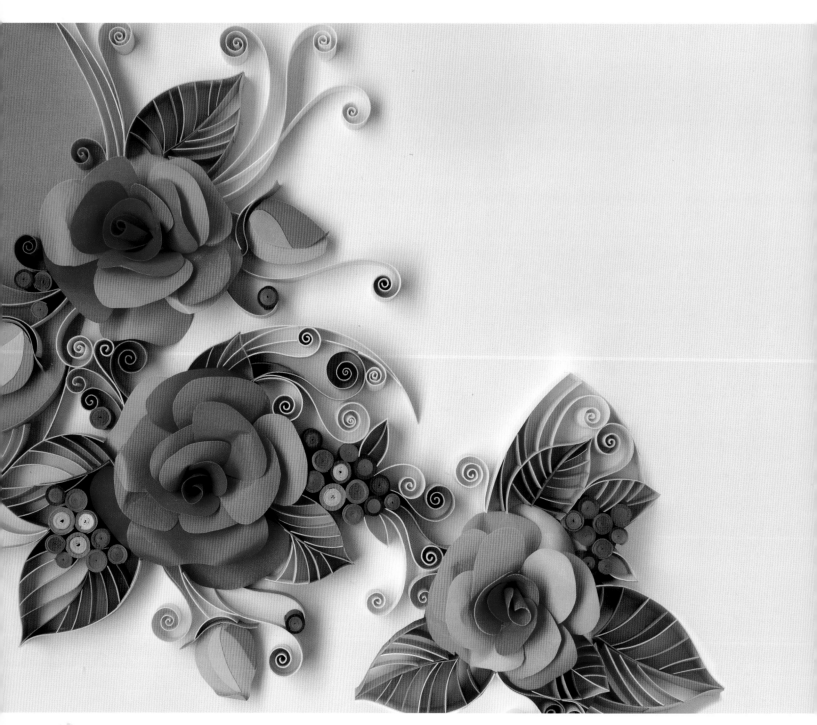

Flowers and Plants

If I had to choose only one thing that distinguishes a beginner's paper artwork from that by a more advanced or experienced practitioner, it would definitely be color use. After all, it is not a big deal if the quilled or edge-glued papers are crooked or roughly placed, but a rich and harmonious color palette does wonders and can be a powerful redeeming quality for even the most-basic designs.

The very first thing I taught my two young children as soon as they could hold a pencil in their tiny hands was to use as many colors as possible. Their first set had 24 colors in it (instead of the usual five or seven basic colors): I wanted them to realize that there is more than one yellow, more than one red—in fact there are so many colors, no one knows how many or how to name them all! I also wanted to show them that if you want to color something green—then use all the green pens from lime green to dark green to turquoise. I use exactly this same approach to colored paper: I don't think of green as a single color, but rather a hue guide, a basic direction, which means using a number of colors in the green range that vary in tone, shade, and saturation.

Color theory is a comprehensive practical guide focusing on explaining terms, color mixing, and the visual effects of specific color combinations. It is essential reading for anyone wanting to study colors in depth. Using as many similar tones and shades of the same color as possible is the quickest way to enhance your paper designs.

"Sunflower"

A good example of the importance of color nuance, the sunflower is actually quite tricky to depict because its yellowness can be overwhelming, and, if created with just one or two yellows around a dark-brown circle, it looks too primitive and flat. So, to really make it shine, many different shades of yellow and light brown are needed.

If your selection of colored papers is limited, introduce a different texture, such as crimped strips. This gives a richer look—the same color strip can appear different depending on whether it is smooth and coiled or crimped and glued tightly next to other crimped strips. Alternating the distance between the strips also helps achieve more variation, thanks to the colorful reflections that get lighter where the strips are more spread out. Having said that, nothing compares to having a huge variety of actual colored paper to pick from.

This is the reason why searching for paper has became my personal obsession—I confess that I'm a paper shopaholic with no plans to recover.

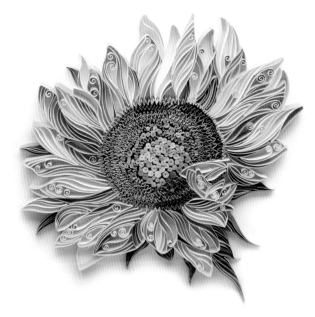

Left:
"Roses"

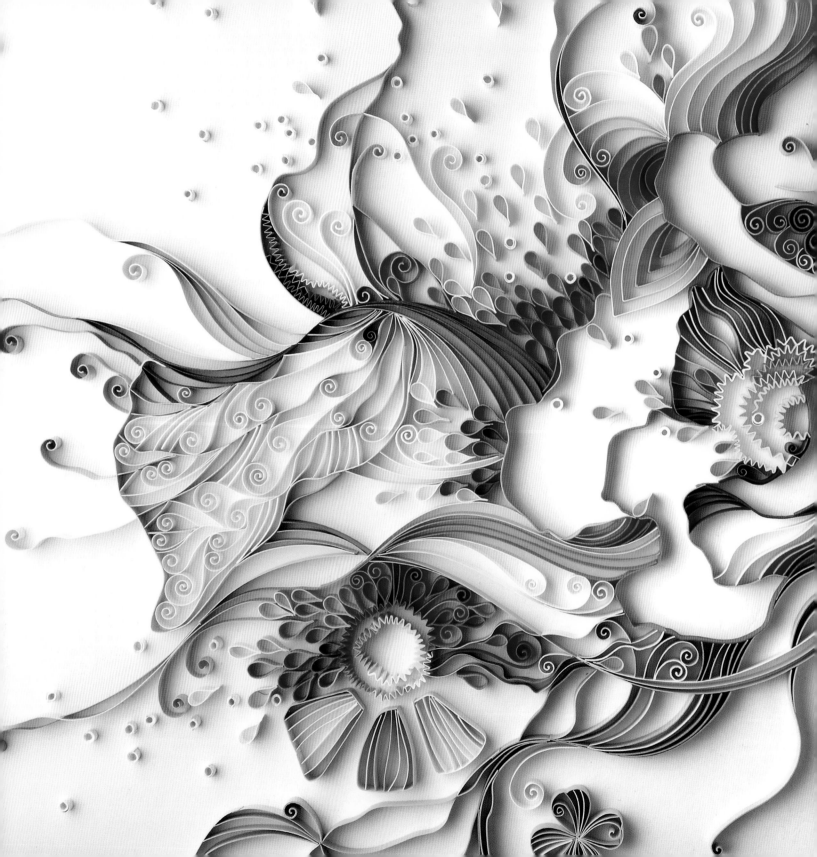

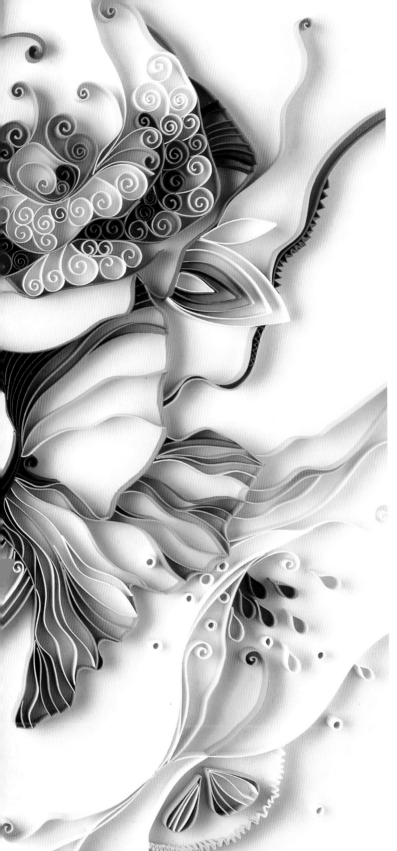

"Scent"

Around ten years ago, when I had just started my paper journey, it was not easy to find much color variation in paper supply. I believe this is noticeable in my earliest pieces. There just wasn't much paper around, with big brands dominating the market and the same paper sold in pretty much every art store. I bought every single color available, but there wasn't enough variety. However, I noticed that some stores stocked papers from local paper mills or small-scale manufacturers, which meant their colors were different: a new shade of red, lighter tint of turquoise, deeper blues—I was excited with every new color I unearthed!

Since then, I have made a habit of visiting every local art store around: whenever I traveled for work or on vacation I was always on the lookout for paper as well. Gradually I have expanded my collection, especially in the last few years as paper crafting has increased in popularity and paper became available online—and can even be delivered from overseas.

I made "Scent" a couple of years into my paper art practice, and I clearly remember struggling to source as many colored papers as I envisioned for this artwork. I think I've done a pretty good job considering the limitations. As a result, it is not apparent that my paper palette was quite limited—around 13-15 colors compared to many dozens that I might use nowadays for a design of average complexity.

Flower Details

I'm pretty happy with my paper collection; however, there are still certain colors that I struggle to find. On the basis of my paper-shopping experience, I have noticed that the most-challenging papers to find are as follows:

Light tints and light pastels: One way of getting around this is to search for paper produced for the print design industry, even though in many cases you would need a corporate account or to purchase the paper in bulk. However, many manufacturers run a sample service where you can order single A4 sheets. Sometimes it is worth going to this trouble if a color is important enough. This is also a good way of finding most unusual papers in terms of weight and interesting texture.

Tones of cobalt blue: These sit in the blue-purple area on the color wheel. It is especially difficult to find the light tints, because for unknown reasons the vast majority of light blues produced are closer to the blue-green segment on the wheel.

Bright lavender and magenta: These hues are closer to purple than to a most basic pink.

It's difficult to describe my excitement when I actually find a paper of the color that I have been dreaming about. I once found a single A4 sheet of an amazing brightly colored paper—a striking blend somewhere between dark lavender and cobalt blue—in a mixed "leftover" pack from a US-based manufacturer. It was like finding treasure, exciting but frustrating at the same time. What would I do with a single A4 sheet? It is too precious to cut! There was no color name specified; nevertheless, I started to research it in an attempt to find more of this gorgeous paper. Fast forward a few months: it turned out this particular paper had been taken out of production and was no longer available directly from the manufacturer's website. I spent weeks searching small online craft retailers and buying whatever was left in stock—this meant three sheets from one place, five from another, and so on. It's funny how much time I spent searching for that elusive color, but in my mind it was worth every minute—I still have a little treasured pile left, and I use it for really special occasions.

An amazing paper color can be an inspiration in its own right. I deliberately sought out the flowers that could incorporate my prized new paper and showcase its vivid blue color in various ways—particularly for these flowers.

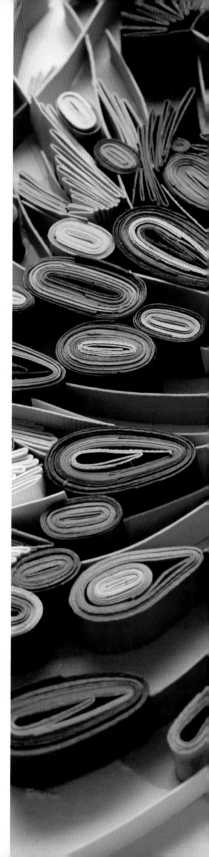

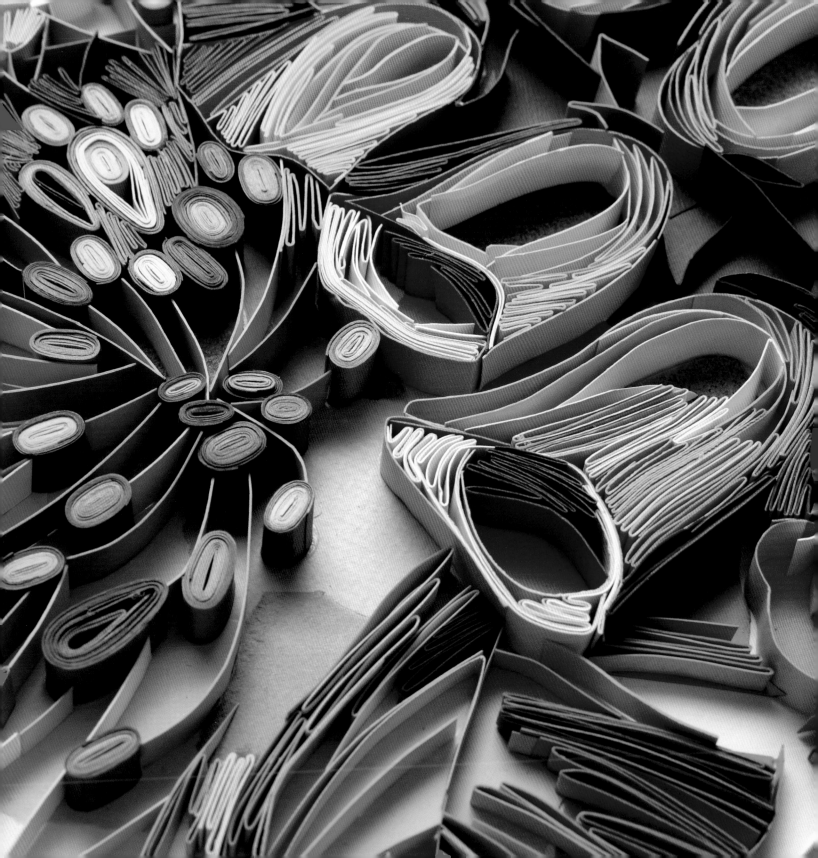

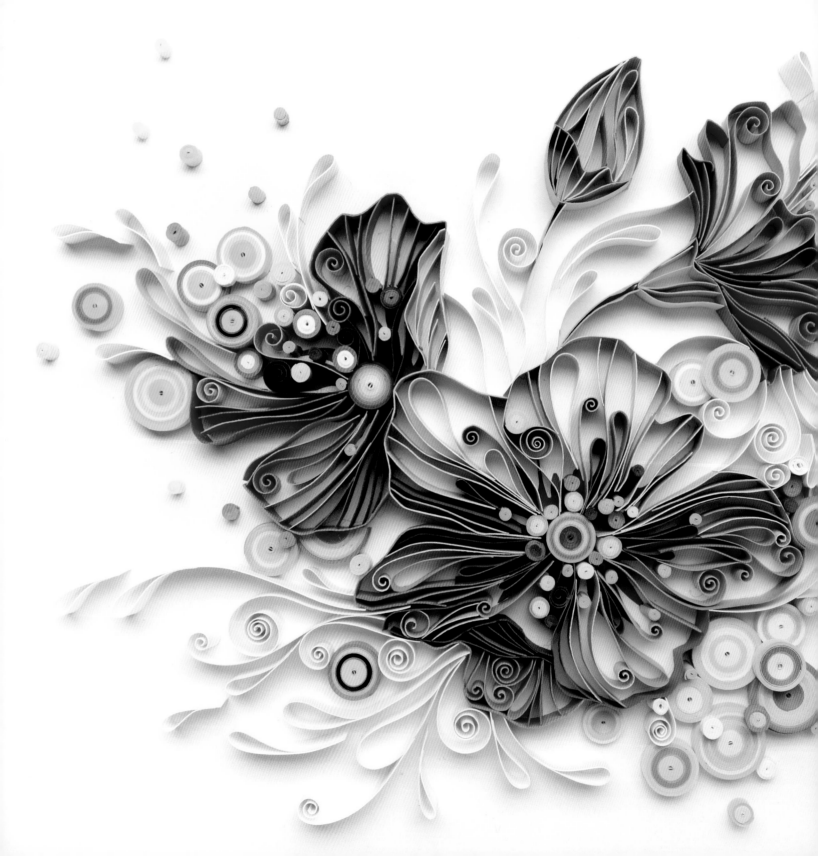

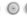

"Hummingbird"

One element I share with traditional quilling is a tightly rolled circle. I love this element: when small, it adds that magical sparkle that makes a paper artwork come alive, while larger circles introduce areas of solid color that can be used as focal points. Rolled circles are an easy way to make a design visually richer and more diverse.

A tightly rolled circle is about the only element that I can get help with, since it takes a minute to learn how to do one even for a novice. Almost every member of my family has contributed circles at one point or another. I roll circles when I wait for my kids while they are at after-school clubs, in front of a TV movie with all the family chatting, on vacations, everywhere! I store the ready circles in little containers sorted by color and size until they are needed for a particular project.

"Hummingbird" uses tight circles galore! I used them inside and outside the flowers. They all are different but work together because I used a single dominant color scheme, in this case yellow hues with pink accents.

I also use color to draw attention to the hummingbird, which otherwise could be lost in the top right corner, but here it stands out because of the bright blue in its wings. There are also little blue circles scattered around the artwork to support the blue in the hummingbird and visually tell a story. Subconsciously, we realize that blue in this situation is a very special color. It makes the hummingbird special, regardless of where it is placed in the composition, and the little blue circles just add a bit of magic.

"Grapes and Fruit"

This is another example demonstrating the tight-circle element. For the grape circles I chose colors that grade from a light center to a darker outside, which means I started with a light-paper strip, then rolled a slightly darker one as a next layer, and finished up with a bright color. I used mostly just three colors—enough to create a smooth shading effect. However, it is important not to use the same color combination for every circle. Neighboring circles should differ slightly from one another. This trick makes a huge difference in how we perceive that area. Subtle variations in color bring the artwork closer to the way an object looks in real life—always changing, always affected by light.

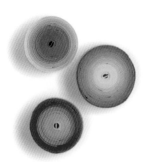

TIP: Any weight of paper strip can be used for tight circles. I use both heavy and thin quilling papers, depending on the size and smoothness of the circle required. Heavy paper is more difficult to roll, but it is faster to make large circles with. Thin paper circles require more layers and thus take more time, but it is easier to achieve a smoother color gradient with thin paper, and such circles have a more refined look. Also, there are special tools available for rolling tight circles out of thin paper, such as a slotted quilling tool and a quilling coach.

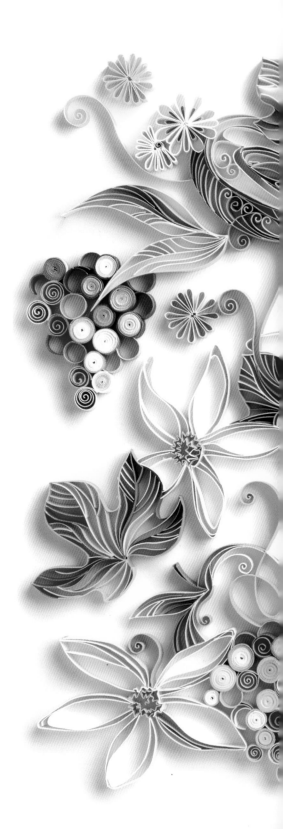

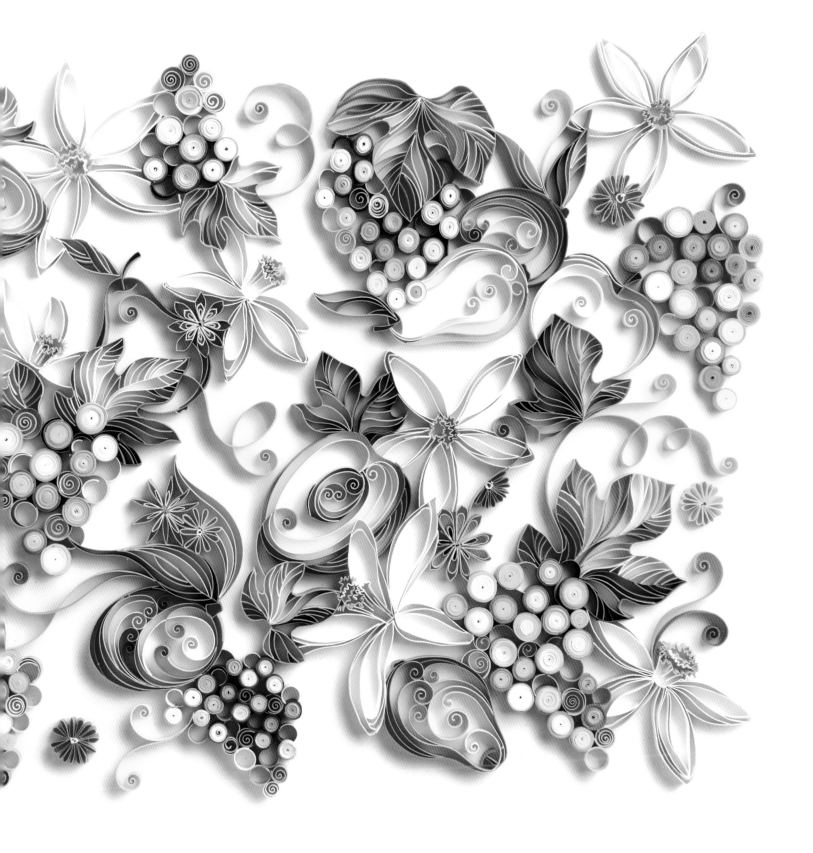

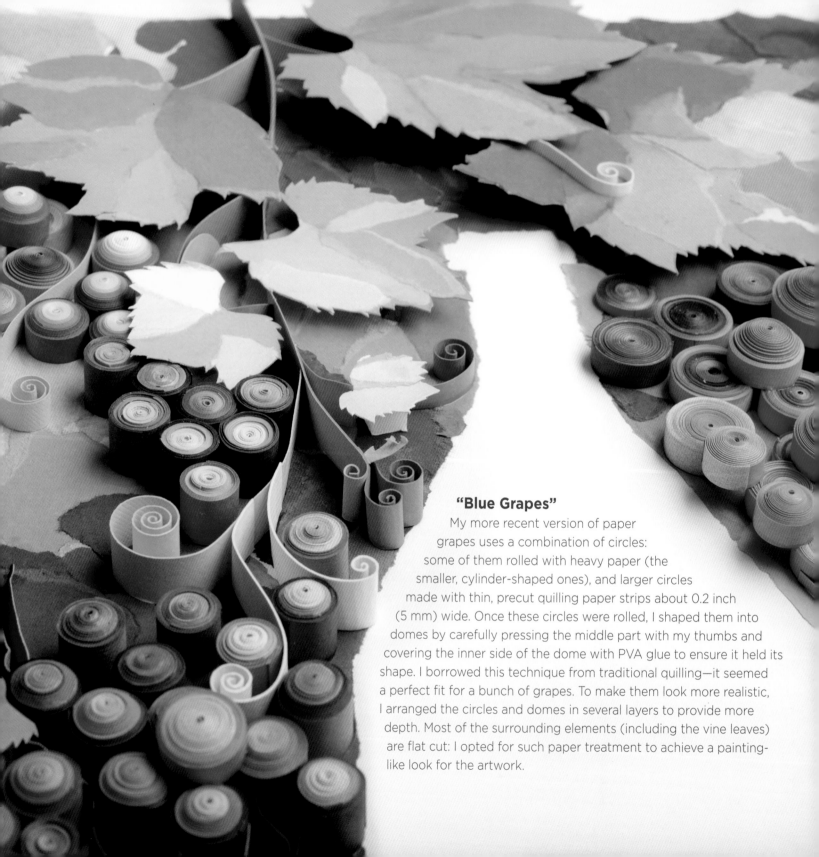

"Blue Grapes"

My more recent version of paper grapes uses a combination of circles: some of them rolled with heavy paper (the smaller, cylinder-shaped ones), and larger circles made with thin, precut quilling paper strips about 0.2 inch (5 mm) wide. Once these circles were rolled, I shaped them into domes by carefully pressing the middle part with my thumbs and covering the inner side of the dome with PVA glue to ensure it held its shape. I borrowed this technique from traditional quilling—it seemed a perfect fit for a bunch of grapes. To make them look more realistic, I arranged the circles and domes in several layers to provide more depth. Most of the surrounding elements (including the vine leaves) are flat cut: I opted for such paper treatment to achieve a painting-like look for the artwork.

The initial design left a blank wine-bottle-shaped space in the middle, because the artwork was commissioned for a magazine cover of an issue dedicated to wine making. The blank space was used for digitally set lettering announcing the issue content. After finishing the project, I loved the grapes so much that I decided to keep working on them and get rid of the now-unneeded blank space. I filled the gap with paper pieces glued flat, and added a few extra leaves and grapes on top to bring the whole thing together. I am very happy with this reworking because the blank space in the middle has vanished and now nothing distracts the eye from the lovely bunch of blue grapes.

I often go back to old projects and recycle them by making them into something new; there is something satisfying in this kind of project. The process usually feels quick and fun because anything goes—there's never a sketch or a definite plan of action, so it works great as an exercise in creativity. Because of this, a successful outcome is never guaranteed, but it is still nice to see a long-forgotten project become useful and exciting once again.

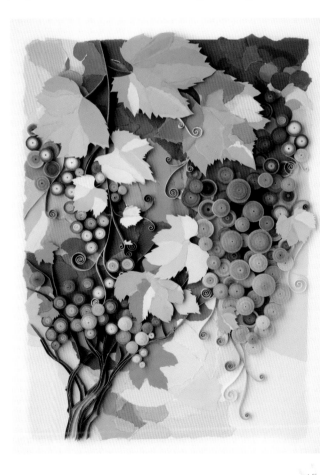

Hybrids

"Butterflower"

When in need of inspiration, the first thing I do is open my folder of visual references—such as photographs of nature— and simply look through them, remembering the reasons why I decided to hold on to them in the first place. I often find myself drawn to several at the same time, and this inspires my hybrid ideas. I enjoy creating realistic designs, but at the same time it is so much fun to play creator and imagine new species that live only inside my head. And what's wrong with being inspired by a flower and butterfly at the same time? So, here is a new hybrid: meet "Butterflower," a flower with petals inspired by butterfly wings.

As a practical tip, it helps the composition to preserve at least some of the contrasts existing in the original photo reference. Here I kept the reverse curled side of some of the petals blank (so you see just the white background there) and replaced only the darker areas of the flower with new patterns borrowed from the butterfly reference.

The blank elements inside the design also allowed the whole shape to "breathe" and look more unified with the plain white background. Any time a shape is completely filled with color or pattern, it can look just randomly stuck to the background, as if it lives a completely separate life. Allowing blank areas inside a design brings the composition and background together. All the small elements and circles bursting out of the larger shape play exactly the same role: they help with the transition between the main object and blank space. I use this method constantly in my art to make the designs look harmonious within an empty background.

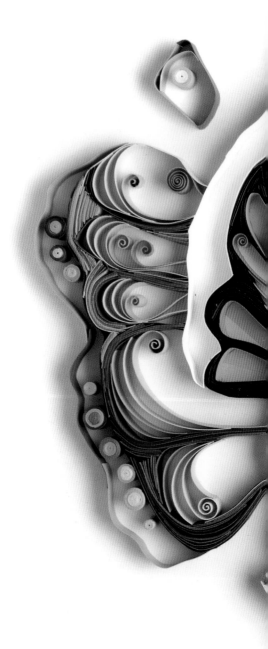

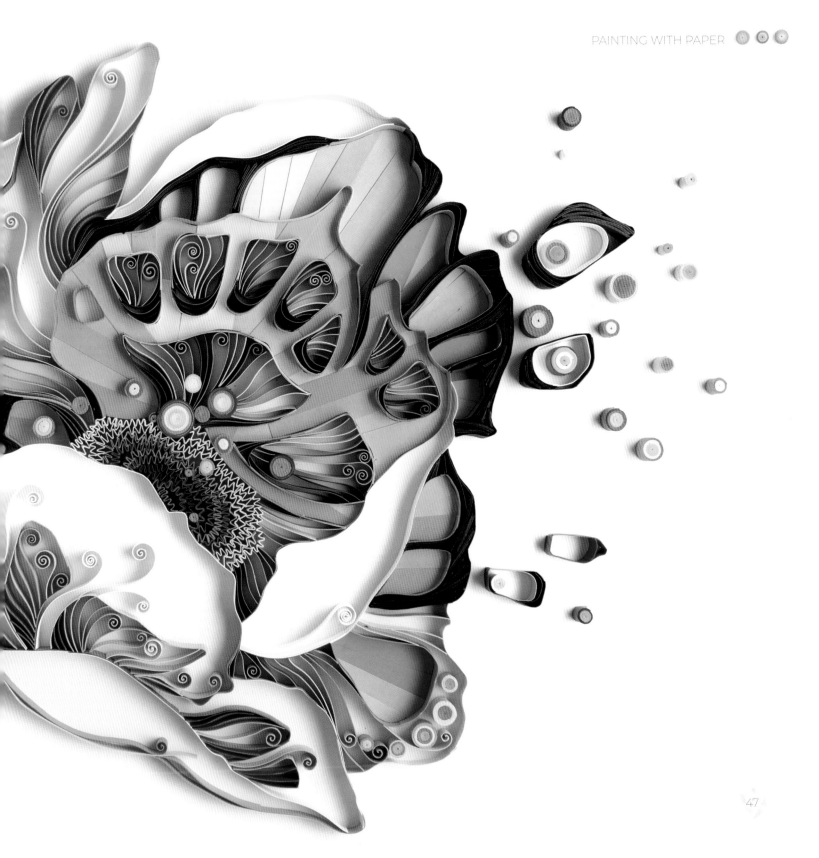

"Feather Rose"

This is a hybrid that was conceived in my mind after I was looking through photographs of birds and feathers. I knew I wanted to make feathers out of paper strips, but I wasn't sure what kind of composition to go for. Finding a photo of a rose on a black background, with only the edges of the petals emerging from the darkness, made me think that it would be interesting to substitute the elongated petal shapes for feathers. I made a quick pencil sketch in my notebook to test the idea, and it seemed to work!

As a first step I glued flat pieces of paper onto the black background, roughly following the photographic reference for color, contrast, and position of rose petals. Creating this flat layer is important because the dark background visually dominates and absorbs edge-glued paper strips, so they appear as very thin lines, much thinner and less noticeable than the same papers placed against a white/light surface (mainly due to the absence of color reflections). I would need to glue the strips densely together to have any chance of creating enough contrast between the colorful paper feathers and black background. However, using a flat color underneath the edge-glued strips effectively solves this problem and allows me to vary the distance between each paper strip forming a feather.

TIP: Wider strips drop a longer shadow whereas narrow strips won't show much visible shadow. To make the feathers I trimmed back one end of each paper strip to create a gradual, smooth transition and give the illusion of the strip blending into the background. I often use this little trick. It is even more noticeable against a white background because the shadow gradually becomes shorter toward the end of a trimmed paper strip, creating a smoother transition. It is analogous to applying less pressure on a pencil or pen when drawing, in order to achieve a lighter, finer line toward the end.

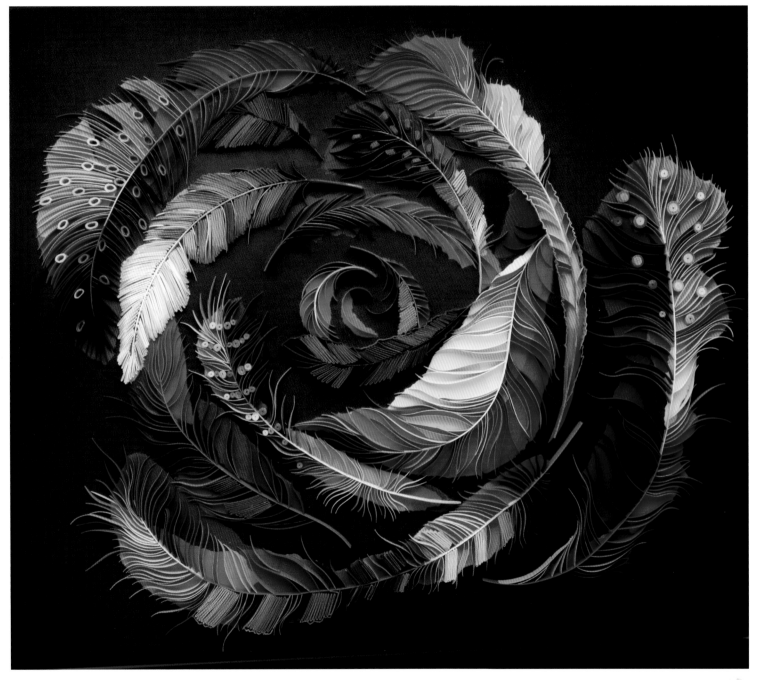

"Feather Rose in Lavender"

Over the years I have received many requests to create a particular design in multiple copies or replicate an existing artwork. My answer is always no to making multiples of the same design: I don't want to work on the same artwork more than once within a short period of time. I often feel emotionally drained after completing a piece, and the mere thought of starting the same thing from scratch is unbearable!

The only times I have agreed to go back to an existing artwork is when the following conditions were met: a big chunk of time has passed since creating the original, I have worked on a number of other tasks in between, and, most importantly, there is no requirement to precisely replicate the design. In fact, that's impossible, because when paper design reaches a certain level of complexity, it becomes impossible to re-create it and make an exact copy. A new version might be similar, but never the same.

This, however, is one such exception: a new version of "Feather Rose," but this time executed with a pink and lavender color scheme. Overall, both "Roses" look very similar since I followed the same basic composition, but on closer inspection, all the individual feathers are different, and not just in color. I deliberately avoided copying the original line by line, to make the working process easier, faster, and more interesting for me personally.

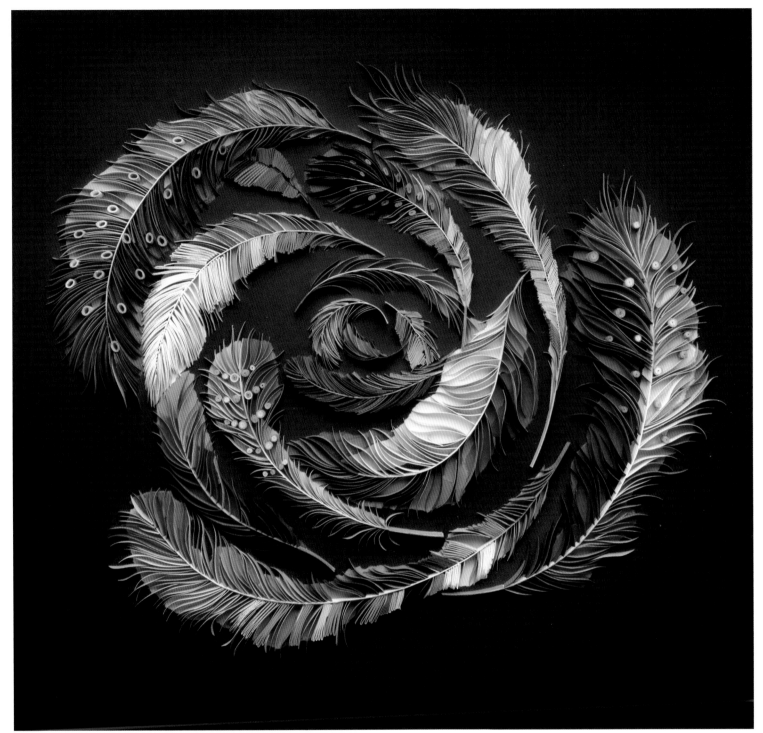

"Poppy"

This is another example of executing the same concept twice. Originally, I created a relatively small "Poppy" artwork measuring around 15 x 18 inches (40 x 45 cm). I used overlying pieces of tissue paper to create a colorful background layer, and then for the central element I cut a paper pulp ball in half, covered it with yellow tissue paper, and glued additional small paper details on top to make the center look just like a real poppy.

Several years later, I accepted a commission for the same design, but for a larger version. Making something bigger is not straightforward in paper art: it is easy to cover a larger area with tissue paper, but when it comes to edge-glued paper strips there is no way to make them bigger; the edge of a paper strip doesn't vary that much. So the only viable option was to use more paper strips: doubling the area requires approximately twice the number of strips. My new "Poppy" measures 31.5 x 31.5 inches (80 x 80 cm). Comparing the two versions next to each other makes it clear how size visually affects the look of paper artworks.

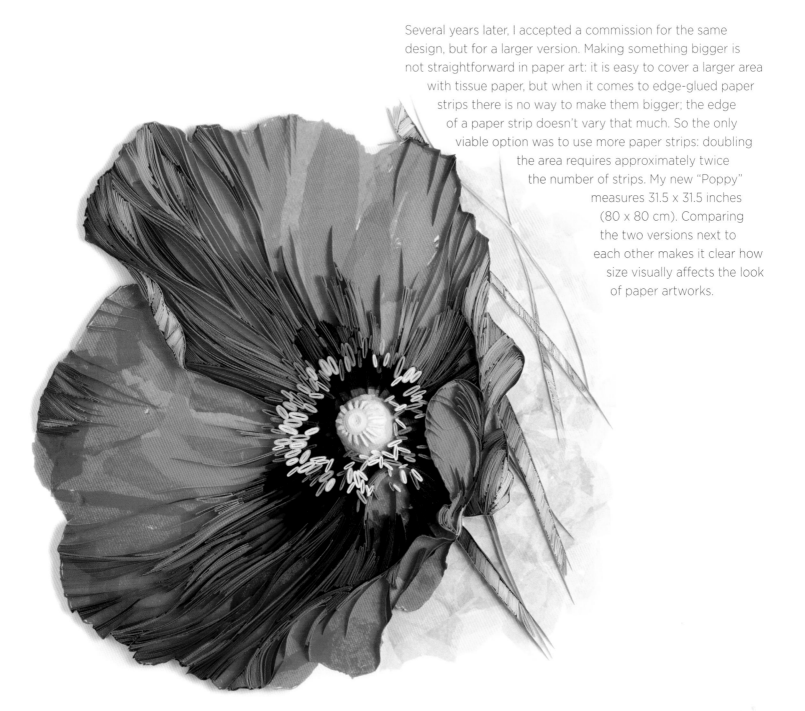

"Light Flower"

This piece is inspired by beautiful magnolia flowers and a couple of new techniques that I'm experimenting with. The base of the central spherical element is again a halved paper pulp ball (different-sized compressed paper balls can be bought from arts and crafts suppliers), which was then covered with tiny oval paper rolls to achieve the desired texture.

The first novelty implemented in the petals is a layer of white tissue paper that I glued on top of the paper strips. Tissue paper is very light and semitransparent. What it does is soften the contrast between the lighter paper strips and darker gaps between them, and as a result the areas covered with tissue paper look smoother and help convey the lightness of the flower.

Another technique I used was to curve the edges of triple-thick mount board at an angle for a sculptured 3-D look for the bent inner petals. I use mount boards of different thicknesses as a background surface for all my artworks, but here I'm using pieces of it as an important component of the flower itself.

TIP: To make oval-shaped or elongated elements I used strips of heavy paper. Start by bending one end (instead of rolling it) as if making a tight circle; the longer the initial bended section is, the more elongated the element will eventually become.

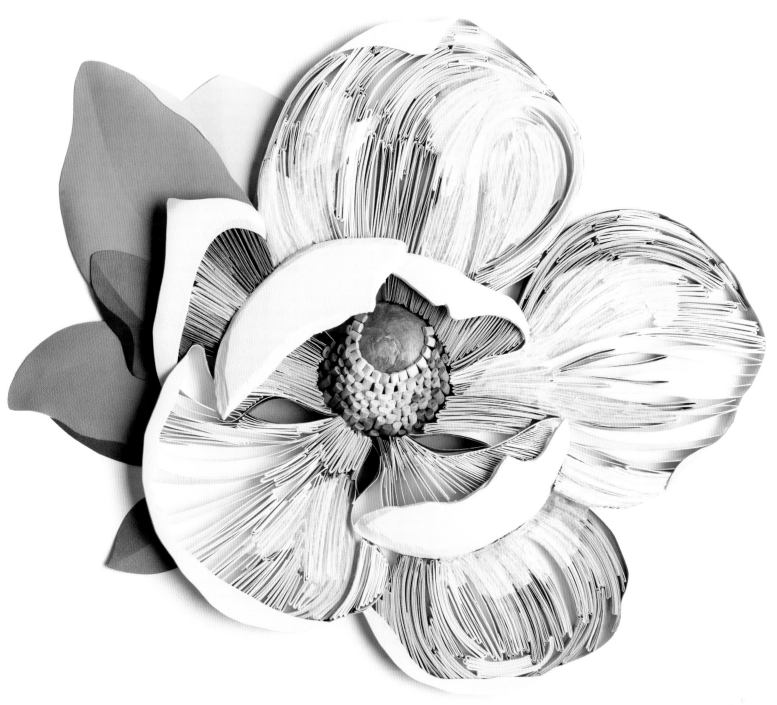

"Van Gogh's Irises"

Van Gogh's paintings have always been a background inspiration for my own work, something to be studied and admired, but I never planned to replicate any of his paintings in paper. That was until I took on a commission for a magazine cover: the task was to interpret Van Gogh's famous *Irises* by using my own style. I decided to give it a try, mostly out of curiosity, and to prove to myself that paper can do justice to Van Gogh's masterpiece. What he cared about, as much as anything else, was color—that is ultimately what draws me into his work.

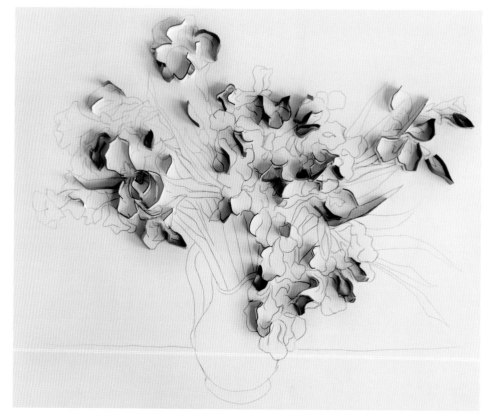

Obviously, there was no need for a sketch, so I dug through my paper collection to put together a palette of the best-fitting color strips and began to glue them down, starting with the darkest segments of irises. I always jump from one area to another—as you can see (*above*). It may seem logical to work methodically and not tackle another element until the current one is completed, but I strongly believe that's not the best way. First, practicality: it takes time for the glue to dry completely and for a paper strip to get permanently attached to the surface and any neighboring strips. This is even more important when a strip is bent or coiled in places. Multiple manipulations of a paper strip increase its natural tendency to uncoil itself and not to stay in the desired position. Moreover, any strip attached to it or placed directly next to it is likely to cause more movement unless the whole area around it is completely dry. By alternating the working areas, I allow enough time for the first strip to attach properly and not be affected by any further manipulation. This method ultimately speeds up the whole process.

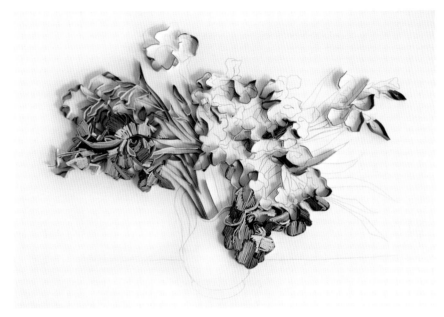

However, an even more important reason is that it is crucial to constantly compare and juxtapose all the elements of the artwork while working on it. Any component of color (its brightness, saturation, and exact hue) is altered according to the context in which you see it—a trick of the eye—working to make sense of its surroundings. In practice this means that you won't know if the color you used for the darkest area is dark enough, until you introduce midtones and lighter colors to be able to see how these groups work in relation to each other.

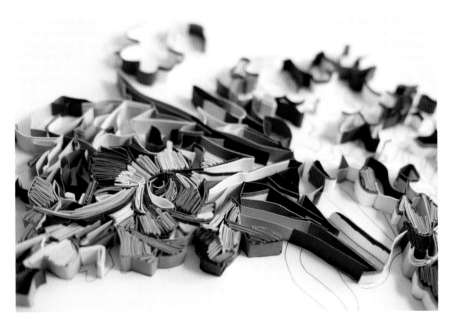

Jumping from one area to another allows constant evaluation and easy adjustments between the different colors present in the artwork. Whereas fully completing one element after another won't allow you to see the whole picture early enough to make necessary corrections along the way. This method of working is an important tool of many professional artists, regardless of the medium they work in. No matter how well you can envision a completed art piece in your mind, transferring that vision onto canvas (or mount board in my case) is a process of making hundreds and thousands of mini decisions, each of them affecting the final outcome. Thus, testing different areas without fully completing them straight away makes it possible to minimize any mistakes that simply could not been seen until much further into the creation process.

Van Gogh added a graphic quality to his painting by using thicker brushstrokes of dark color to create outlines around the leaves and some of the flowers. In order to achieve a similar effect in paper, I had to use a very thick card (approximately 500–600 gsm) that I ended up coloring with marker pens, because the only card I could find was pure white.

My final decision was how to create the green table area. In painting, one of the effective ways to visually describe an area is to vary the way brushstrokes are applied. In the original *Irises*, Van Gogh used wider, less distinctive brushstrokes for the table, almost blending the whole surface into one smooth greenish gradient. But if I made the table surface with edge-glued paper strips in a similar way as I made all the flowers and leaves, there wouldn't be enough contrast between the flowers and the table. This absence of contrast would take away the focus from the jug and irises, so I decided to use pieces of flat, torn paper and apply them in a manner replicating brushstrokes. This provided sufficient contrast to make sure that the viewer's eye is drawn to the detailed central area with the flowers, while the table surface serves as a background, just as it should be.

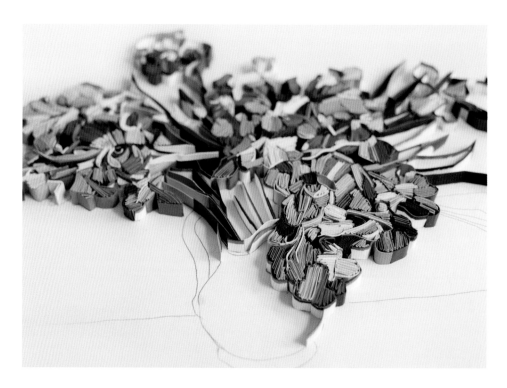

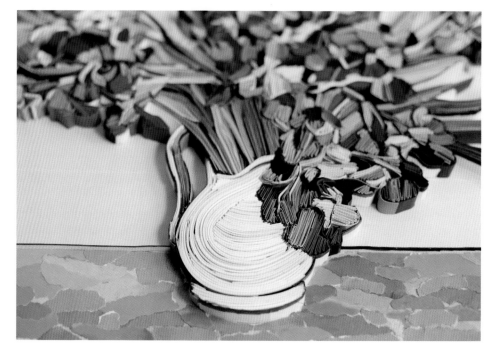

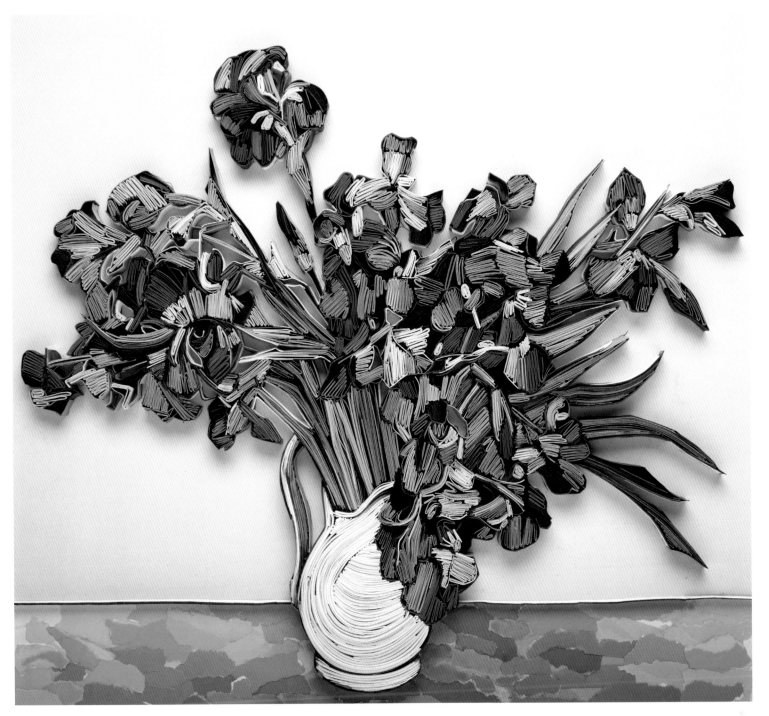

Animals, Insects, and Birds

The total number of animals, insects, and bird species living on our planet is in the millions—meaning that the opportunities to get inspired are endless. Having said this, I have a small number of living creatures that I'm constantly drawn to. I personally find their patterns, textures, and striking color combinations irresistibly attractive.

"Jungle"

After a period of time making designs with predominantly edge-glued paper strips, I began introducing more solid color to my backgrounds. Comparing artworks made exclusively with strips on white background with those that combined strips and brightly colored flat paper underneath made it clear that the latter provides a much-bolder, more strikingly eye-catching look.

The success of such a design is won or lost at the sketching stage: a well-planned colored sketch is important because in this case a paper artwork is merely a 3-D representation of a flat, color-filled drawing. The best sketching method for color-filled designs is to use digital coloring software, although I like to begin by making a simple black-and-white sketch with a pencil.

Once my sketch is ready, I scan the design (or take a photo) and digitally apply color to each separate area—a coloring tool can be found in every artwork software or application. Basically, it is a simple coloring method, but with a custom-designed template.

I find it helpful to save several different versions along the way because it literally takes a couple of minutes to swap some colors around and test various color combinations to find a harmonious and well-balanced option.

When the color mockup is detailed and thought through at the sketching stage, transferring the design into paper becomes almost a mechanical process. The only decisions left to make are about matching your available papers to the digitally selected colors.

The first step is putting together a flat background layer of cutout paper shapes following the exact shapes from the digital mockup. I traced each colored segment onto a sheet of paper of a corresponding color, cut the shape out, and glued it down into the position. This is how initial flat cutouts look until they are trimmed and glued into place.

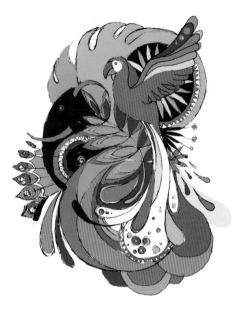

Jungle-colored sketch chosen

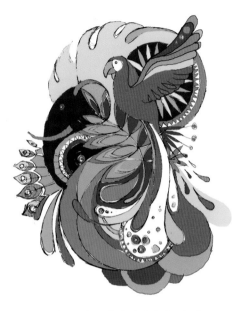

Jungle-colored sketch rejected

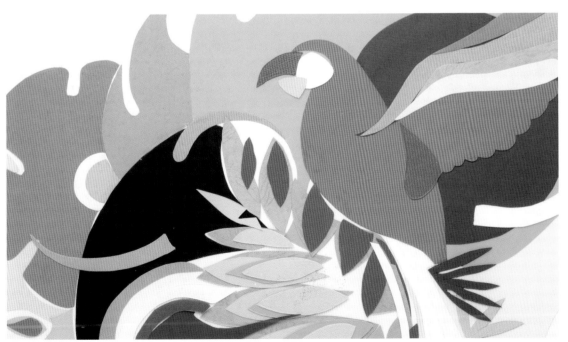

TIP: *I use either embossing tools or carbon paper for tracing sketch elements onto the working surface. Then I cut out the shapes with scissors or a cutting knife. It makes sense to start cutting and gluing the larger segments first and then glue the smaller flat-cut details on top.*

Once the flat paper background is completed, the last step is to add the outlines around each color segment with edge-glued paper strips. For the outline, I usually choose the same or a similar color as the surrounding area. Extra details using edge-glued strips can be added in at the end in order to make the artwork visually more complex and diverse. However, this type of bold design featuring a solid-color background does not require many extra details—the outlines provide enough of a 3-D effect.

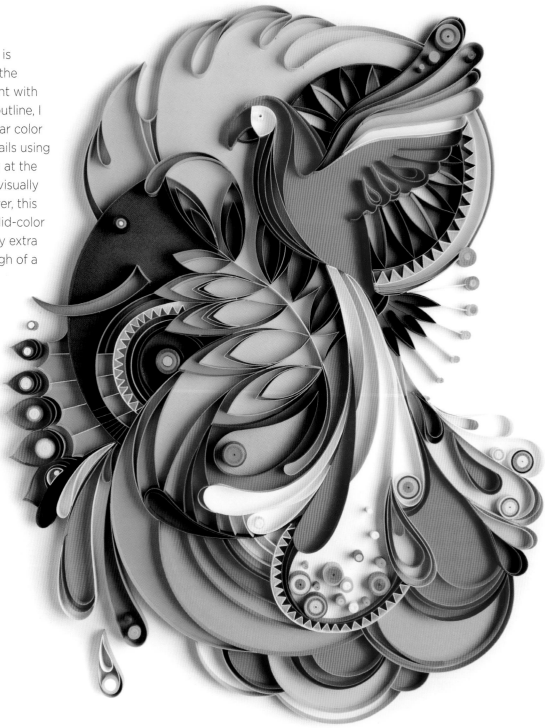

 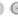

"Pure" artwork is made using exactly the same method, but with more quilling elements added to some of the areas of the design.

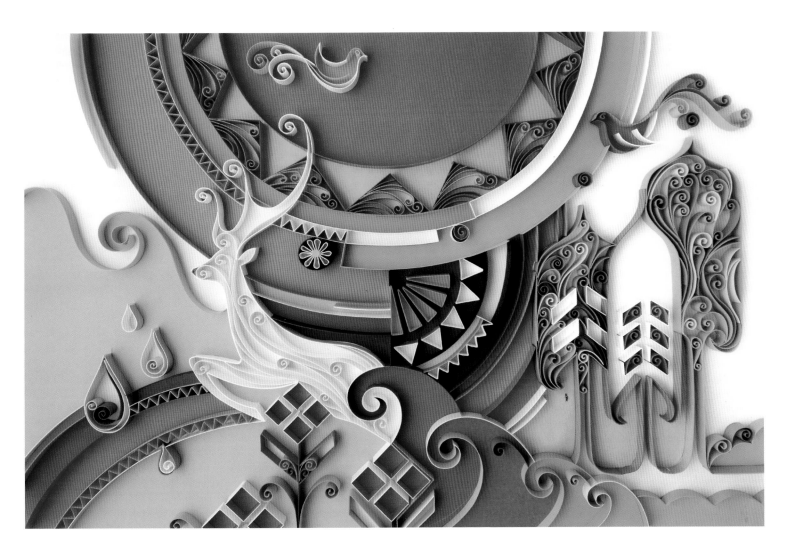

"Tropical Fish"

This is one of my experimental works. I've always admired the almost overwhelming exuberance, diverse patterns, and highly contrasting colors of coral reef fish. My "Tropical Fish" artwork is an imaginary creature that embodies my cumulative inspiration collected from reef fish: it combines the shapes and patterns of more than one species.

One aspect I experimented with is a protruding 3-D shape that would stand out from the surrounding environment and make the design more dynamic, as if the fish were swimming toward the observer. For the body shape I used a sheet of old newspaper that I repeatedly squashed in my hands until it became soft and wrinkled. Then I formed the crumpled sheet into the desired shape and secured it in several places with adhesive tape. Next, I covered it with layers of contrasting flat-cut paper and, finally, PVA-glued the whole thing down onto the background.

The trickiest thing about incorporating such dominant shapes is to blend them in with the rest of the regular-sized paper strips and make all the elements work together as one unified composition. To complement the bold patterns of the fish, I tried another experimental technique: undivided packs of multicolor quilling paper. The idea was to create bolder, more striking lines and patterns for the tail, which would be very difficult to achieve with individual strips.

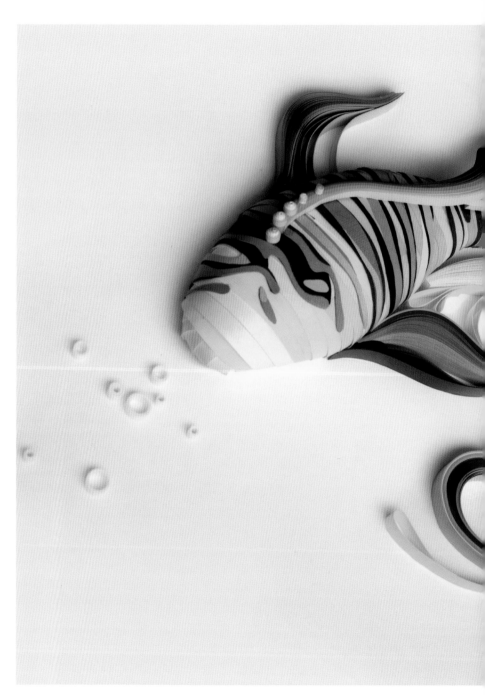

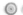

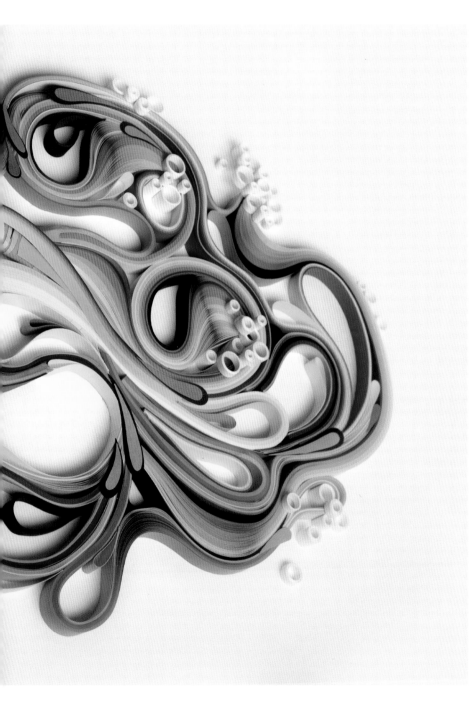

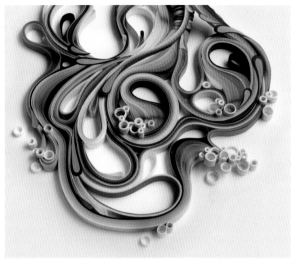

These multicolor quilling packs are widely available, but the main challenge is to find the ones that are packed as a harmonious range, rather than completely randomly.

While trying to work with undivided quilling packs, I discovered that it is extremely difficult to control and manipulate them: they will coil only in a specific way, and the thicker the bundle, the less flexible it is. In the end I gave up and let a block do its thing instead of forcing it. This made the process a bit easier, but not exactly effortless: to make the blocks stick to the surface, I dipped the bottom of each quilling pack into glue but had to hold it in place for quite a long time until it stopped uncoiling itself. I added small, flat-cut elements on top to cover the chunky ends of the quilling packs and make the tail visually flow.

Although I like the bold look that this method provides, I do not use it often because I prefer to have more control over my paper strips.

"Party Lion"

Another way of achieving an enhanced 3-D effect is to use raised-paper details. This simply means that certain elements of the design (usually cutout segments of a paper sheet) form a new raised level above the background surface. I used this method in "Party Lion," which is a happy explosion of pretty much every paper craft technique that I have up my sleeve.

The lion face in the center holds all the craziness together. It's a flat-cut paper sculpture that has depth, thanks to several layers of raised paper. The highest level is the nose, raised with pieces of foam board hidden underneath the paper and secured in place with PVA. This is a simple but powerful trick that not only helps the lion's head look more realistic, but also stops it being visually overwhelmed by the colorful mess around it.

The lion's mane is extremely busy, but it is controlled chaos. There is an obvious direction for the party elements explosion—from the center outward. Additionally, the color volumes are clearly defined, with the hues of pink, red, and orange dominating the color palette. Basically, you can hardly go wrong with whatever happens inside "a crazy mess" so long as there is a clear direction or flow of the component elements, and there is an interesting color story.

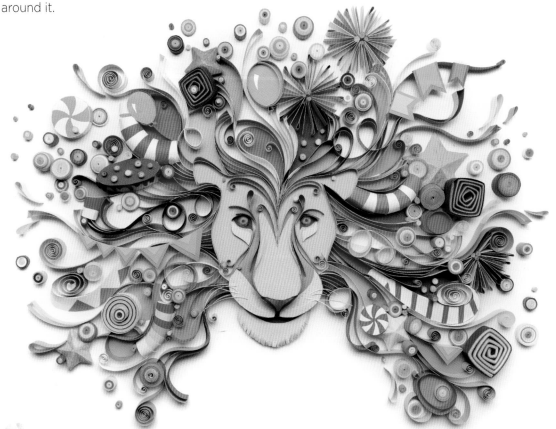

TIP: A simple guide for making a radial explosion look harmonious is to place bulkier elements closer to the center and arrange lots of small elements, such as rolled circles, along the outer perimeter, spreading them out a little unevenly.

"Simple Butterfly"

The idea for this minimal design came from calligraphy and elegant script fonts. I started with a pencil sketch outlining the two interlacing shapes, then roughly shaded one of them to make it darker. Then I replicated the pencil strokes with paper strips, making a nice gradient along the whole wing line.

None of the oval and rounded shapes in the thickest part of the wing shape were initially planned; the truth is that I simply got tired of the painstaking process of measuring and fitting the bent strips into a narrow space. There is nothing wrong with being flexible and amending the design halfway through, even if the change is caused by fatigue or boredom, just as long as an alternative solution makes sense and seems viable. In the end, no one will know that this wasn't the exact plan from the beginning.

TIP: I created the oval/round corner shapes by rolling paper strips around various elongated objects, such as a flat lid of a marker pen or the end of a chopstick. It's also possible to start with a round shape and then squeeze it into an oval.

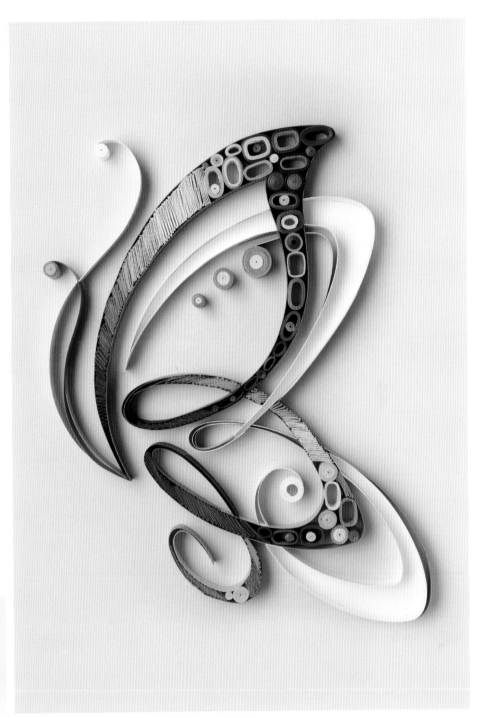

More Samples

All the following artworks were created at different
points in my career, but they all share the same basic
principle of making a simple decorative design sit
harmoniously on a plain white background.

The way I approach my projects is by following
my own rules:

- Use a search engine to find black-and-
 white silhouette images of the animal/
 bird/object that you are planning to
 make in paper. Silhouette shapes are a
 quick and easy way to get a basis for the
 design that you can then further adapt. It's
 easy to fill it with details and patterns without
 being distracted by the abundance of visual
 information that a photograph would provide.

- Choose the shape that feels most dynamic
 or has a flow to it, and always test the final
 position by rotating the shape in relation to the
 background. A diagonal position always feels more
 dynamic. It also helps to change the direction within
 the shape: for instance, if a bird's head faces one
 direction, it's often worth trying to counterbalance it
 with a tail pointing the opposite way.

- Leave plenty of blank white spaces inside the design:
 for instance, by spreading out the patterns and lines in
 some areas instead of filling the whole shape equally.
 Introducing a limited number of minor decorative
 elements around the main shape also helps balance
 the busiest areas of the design with the empty white
 background.

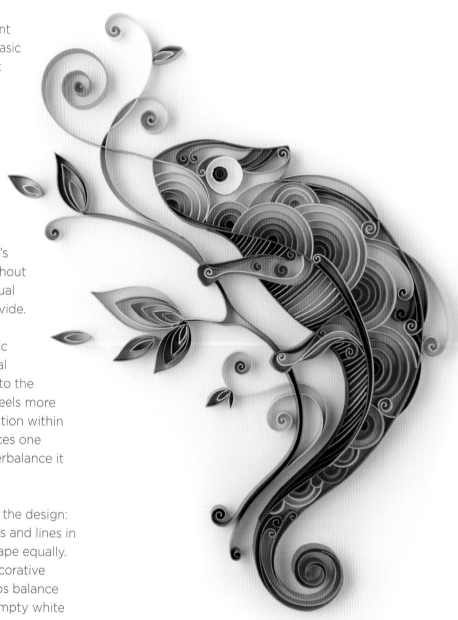

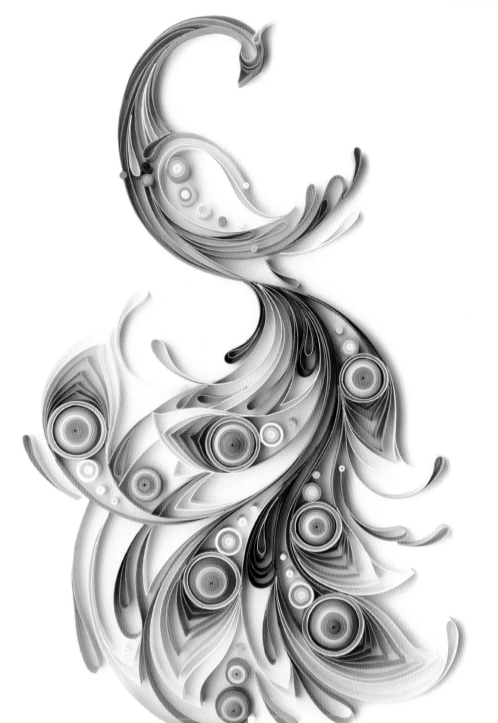

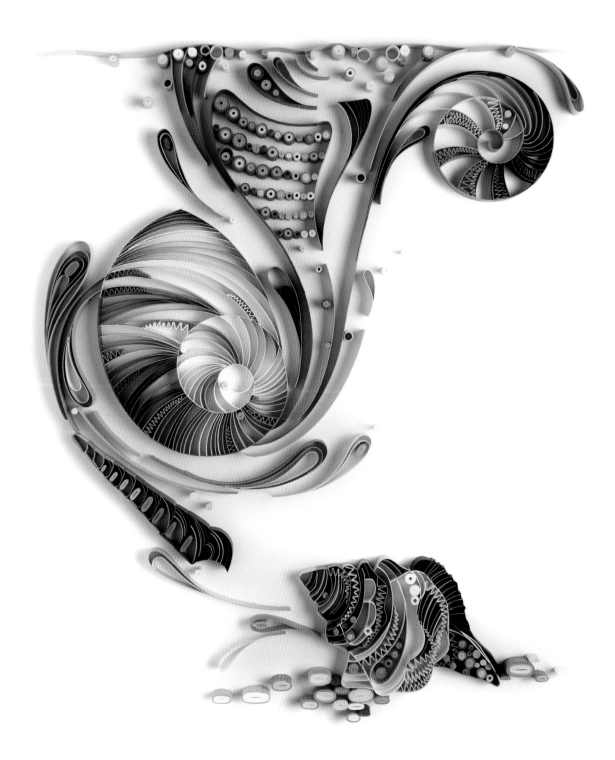

I know I've barely touched this inspiration category.
I'm yet to explore the animal world further myself.
I am interested in following a less decorative
approach to depicting animals, insects, and birds,
so to be continued . . .

Composition

I am not the first artist to be intrigued and inspired by Japanese art. The impressionists were captivated by the use of flat decorative shapes, bright colors, and the dynamic compositions of traditional Japanese woodblock prints. For me personally, Japanese art (and traditional Chinese paintings as well) is all about composition. Composition means putting together lines, shapes, masses, and colors in order to achieve harmony and balance.

Good composition skills are impossible to master and improve just by studying the rules and principles only. Trying to absorb the various theories of composition outlined by different authors can be overwhelming, even for an experienced artist. While reading and studying the principles is never a bad thing, it is possible to develop the ability to compose harmonious designs by practice only. Thus, any guidance or practical advice for achieving a successful composition might not be of much help until it is practiced and experimented with.

The importance of practice for developing a particular skill is not a new idea: according to neuroscientists, our brains are constantly being shaped by experience. With every repetition, we reinforce a neural pathway: these small changes, frequently repeated, lead to changes in how our brains work. Over time, the action or skill becomes effortless, basically automatic. I believe that the way I developed (and am still developing) my composition skills is an example of such processes.

I believe that the best way to improve composition skills is to keep practicing, by creating multiple sketches and compositional variations for each new project or idea that you decide to make. Even the quickest roughs consisting of a few lines or outlining major masses; their positions and angles will make a difference. There is no need to be afraid of frequent erasing and changing the elements that are already there in order to see if there is a better way of arranging them—at the end of the day that's what sketches are for. It doesn't matter if some of the quick sketches won't end up as 3-D paper artworks; feel free to be selective. Since paper art is so time consuming, only the best designs are worth spending the time and effort required to bring them to life.

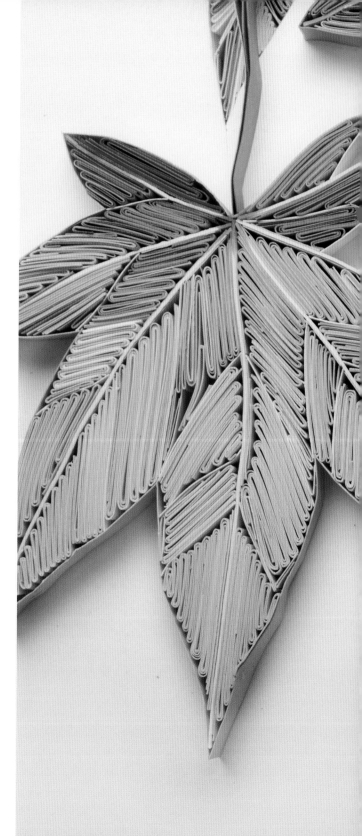

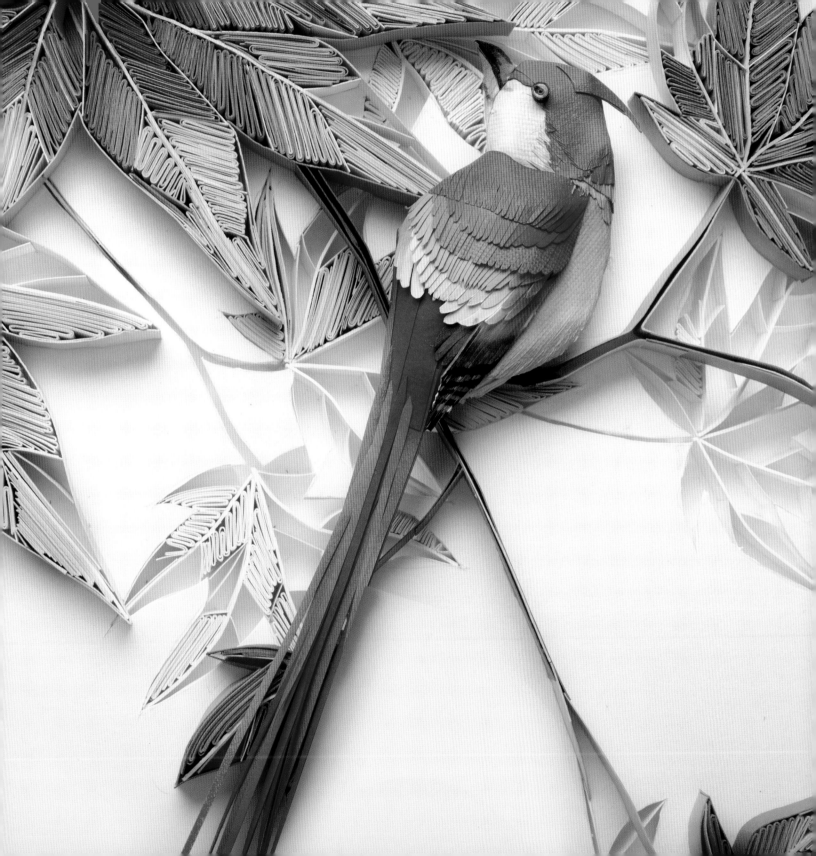

"Fall Leaves"

Successful composition is like telling a story with lines, shapes, and colors instead of words and sentences. It attracts the viewer's eye and holds their attention, directing it where the artist wants them to look.

Lines are one of the most powerful structural elements of composition. A line can mean a continuous mark across a surface, or it can be implied by the edges of shapes and forms. The concept is the same whether it's a drawn line or edge-glued strip of paper, which is basically a three-dimensional line. Lines provide a path for the viewers to follow, holding and directing their attention.

When sketching "Fall Leaves," I began by drawing the branches, looking to define the right directions and angles at which different branches will join together. These branches provide the "skeleton" for all of my following elements. This didn't happen quickly: I drew and erased plenty of different variations before settling on this dynamic composition that I feel gives viewers an entry point at the top left corner and directs them to the central area with the bird.

In order to bring attention to the bird and make it the focal point, I directed the lines toward the bird: notice that multiple branches are effectively pointing to the bird; even its own tail serves as an additional implied line.

After creating a skeleton with the branches, the next step was to place the leaves. It's rare to find orderly arrangements of leaves in nature, so I looked at lots of photographs of Japanese maple trees for the inspiration and visual reference. I kept adding leaves one by one, starting with the largest ones and then moving, rotating, and scaling them up and down, until the composition looked natural and well balanced. It takes a lot of effort to make something look effortless!

Technically, this artwork contains three levels:

- Bottom layer—a raised sheet of card with leaf-shaped cutouts partially filled with light paper strips. This sits on top of a foam board.
- Foreground—colorful leaves are placed on top to form a middle layer.
- Top layer—contains some of the hanging berries. These are placed on top of each other to make them higher than the leaves. Also, the bird's body is made of shaped crumpled newspaper with several layers of flat paper on top, then trimmed with scissors to imitate rows of feathers.

> **TIP:** When arranging several elements in a composition, such as these leaves, make sure they either do not touch or definitely overlap each other. Barely touching shapes are confusing and make viewers pause and mentally assess whether there is indeed a connection point or it is a trick of the eye.

The fact that the bird is the most prominent element of the artwork plays a big part in drawing the viewer's attention; however, there is another basic principle of composition in play that helps reinforce this effect. It is called the rule of thirds—the idea is that if you divide any composition into thirds, vertically and horizontally, then the key elements of the image should be placed along one of these lines or at a junction point.

The main function of the rule of thirds is to help create asymmetry. If the elements in a composition are centered and equally balanced, it becomes too static, even boring. The asymmetry and counterbalance of elements create a much more dynamic picture. However, I never draw an actual grid when sketching; it is more of a helpful hint to keep in mind. In fact it doesn't matter whether the picture is divided into thirds or fourths or fifths. The point is to create a less expected visual path of interest, inviting viewers to spend more time traveling around the artwork.

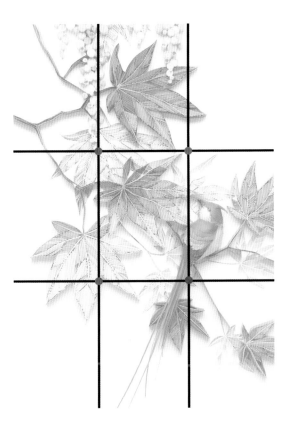

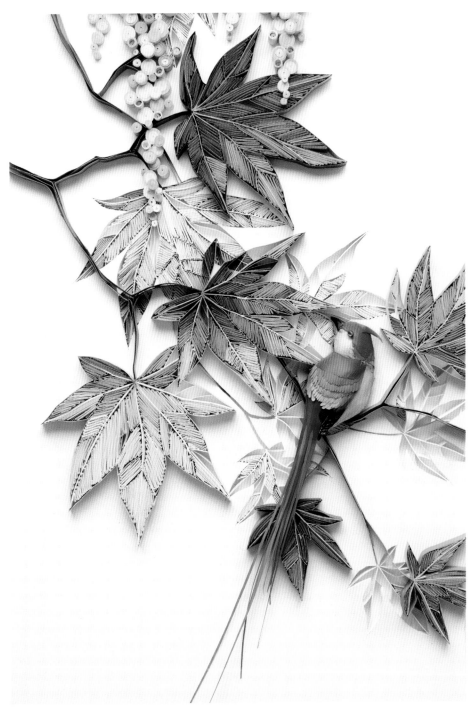

Oriental Trio—"Peony," "Peacock," and "Lucky Knot"

There are times when I need to put aside my personal artistic desires and create a different style of project. These are usually commissioned works, especially designs created for advertising campaigns. Publicity images use a straightforward centered composition to provide a single, eye-catching focal point. The reason is to attract immediate attention and communicate the idea as quickly as possible. The three designs here all feature a clear central placement of the main elements, and from a distance they appear quite symmetrical. However, perfect symmetry is not my thing, so I still looked for little ways to bring a sense of movement even into these static designs.

"Peony" (*right*) is the least symmetrical work, with all the various elements being positioned differently around the main flower, but since they counterbalance each other, there is still an overall sense of calm.

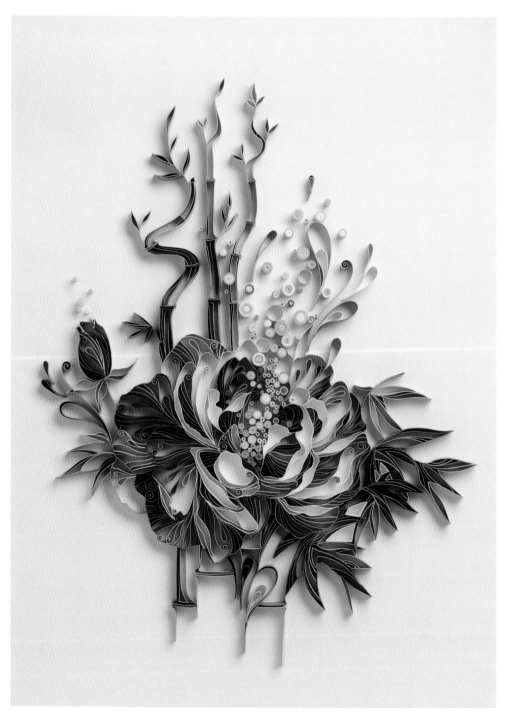

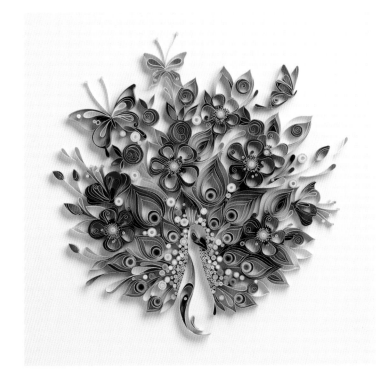

For "Peacock" (*left*), the head and body are turned slightly to the right, and although the overall mass of the tail is confined into an almost perfect circle, none of the elements are placed symmetrically. Blossoms, butterflies, and circles all are different but spread out in a way that, again, gives a sense of balance.

"Lucky Knot" (*below*) differs from the other two because of its geometrically perfect knot shape and the koi carp mirroring each other. But even in this rigidly symmetric composition, I've managed to add a little diversity in the waves and koi patterns. This is my least favorite design of the three, but the challenge of any commercial commission is to find a balance and happy compromise between the artist's own vision and the specific requirements of the project. In that respect, I consider this oriental trio pretty successful.

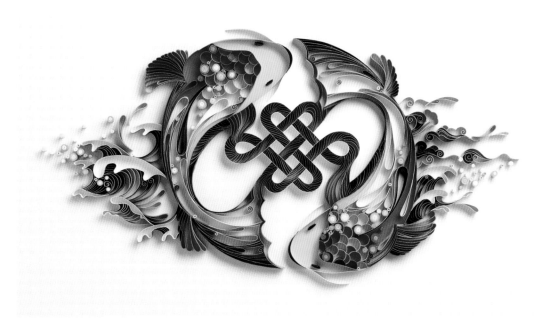

"Fish & Water"

Using a grid as a rough guide for placing elements in a composition is just one way that the rule of thirds can be helpful. The same principle of creating imbalance applies to other aspects of composition such as color and volume. For example, by altering the sizes of the fish in "Fish & Water," I created a sense of motion: disparity between the shapes gives the viewer the opportunity to compare these shapes. By making the fish on the left larger, I gave it more significance in relation to the other two; however, the central fish is "fighting" for the viewer's attention by overlapping the larger fish. Thus, the area of their intersection becomes the main focal point, which is positioned roughly on one of the rule-of-thirds lines, rather than in the very center. In this way the grid can be helpful for practicing and developing your compositional skills.

Another important element here are the reflections on the water. The patterns seem to live independently from whatever is happening below; however, things are rarely accidental in my works. I took Japanese *anime* images of water for inspiration and then carefully considered where to place the central point of the ripple and which areas of the fish to lose by covering it with reflective patterns. Had I placed most of the ripples in the empty spaces around the fish, it wouldn't look realistic enough.

I made the outline of the ripple with edge-glued strips of very heavy paper, but the novelty treatment here is the layer of semitransparent tracing paper that I carefully glued on top. It adds a new texture and a slightly mysterious feel to the artwork that is better observed in real life than in photographs.

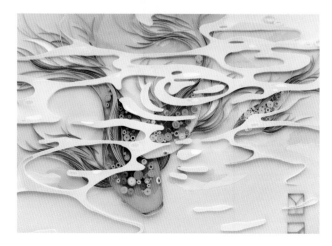

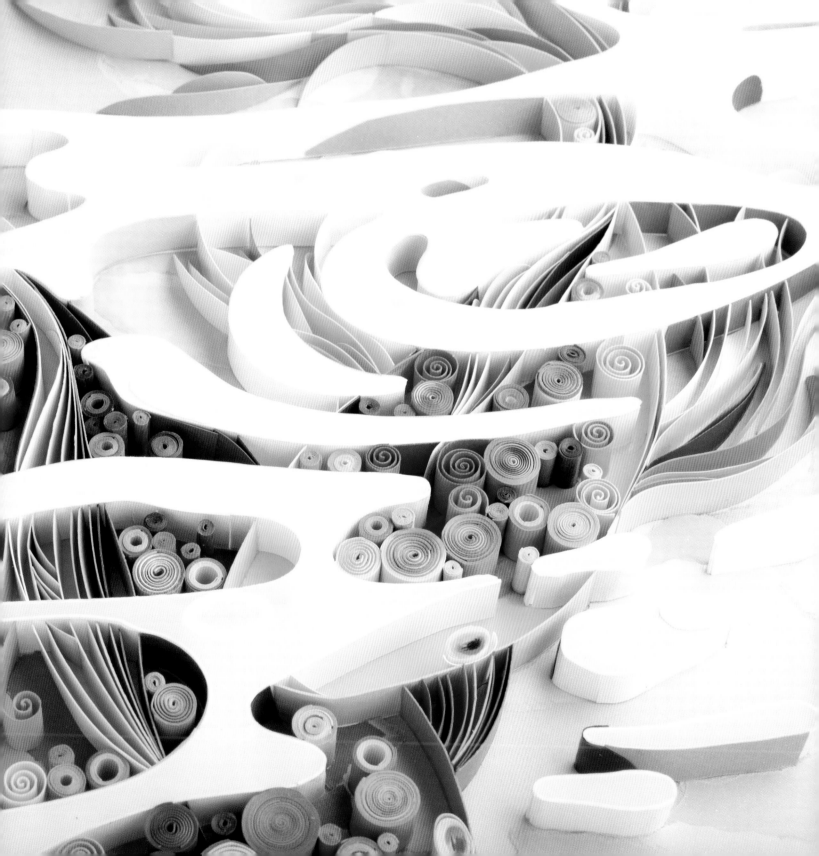

"Wisdom"

I often find myself coming back to the fish motif, and koi in particular, rethinking and reworking it in different contexts. "Wisdom" is one my earliest attempts to capture movement and the reflections on the water. To reinforce the Japanese influence in this piece, I incorporated Japanese characters that translate as "wisdom," a lotus flower, and several different lotus plants. It is a compilation design that became a starting point for a further, more focused exploration of individual elements of this artwork.

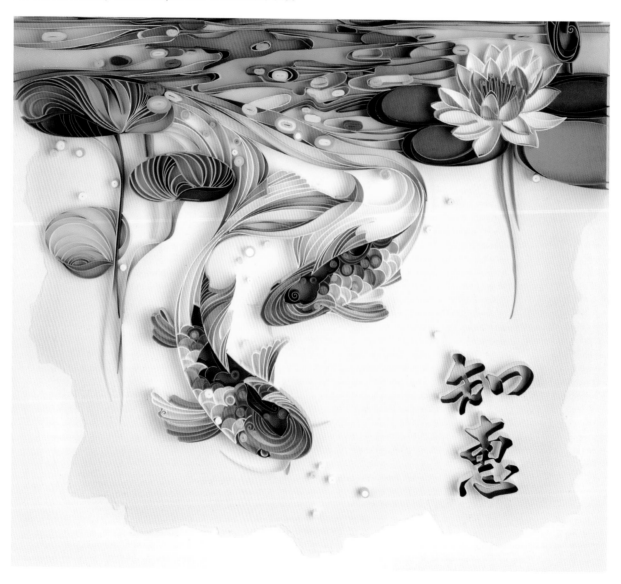

"Pond Leaves"

The idea for "Pond Leaves" originated from the lotus leaves in my previous "Wisdom" design. I was totally inspired by amazing Japanese art depicting pond plants, all executed with great care and noticeable admiration for every bend of lotus leaf, flowers, stems, insects, and fish—all thriving together in the spacious universe of a pond.

I wanted to use this idea of a little universe, so my initial sketch was very busy, with lots going on even before I added any of the creatures that I wanted to include. But not seeing harmony in this initial sketch, I realized that I was trying to cram in too much, so I made the decision to simplify my composition.

One thing I particularly disliked in the first sketch was the lack of contrast. Contrast is a powerful tool—any area of contrast (dark tones next to light or white) will immediately draw attention to that area. So, I reworked the sketch by getting rid of some of the leaves and flowers, clearing more space in order to make the design breathe and, more importantly, I increased the level of contrast by introducing areas of solid dark color.

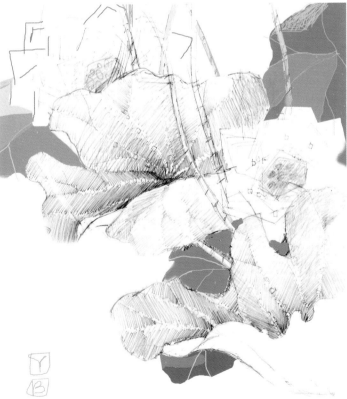

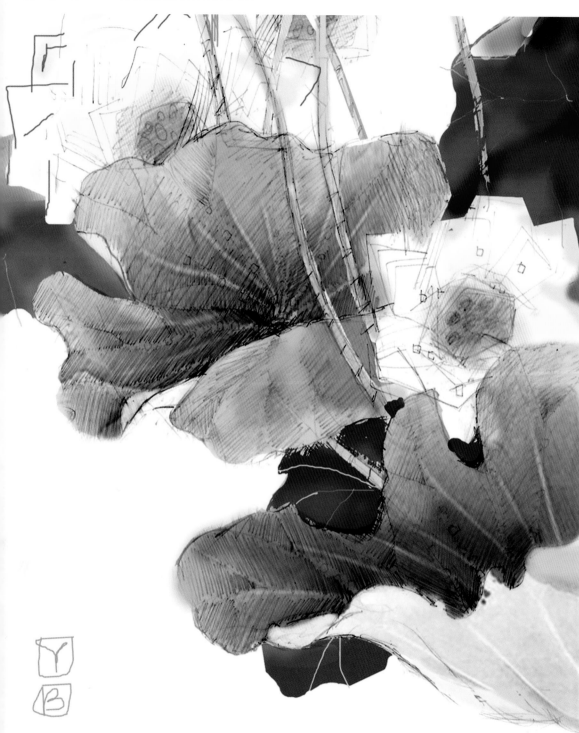

These simple changes brought much-needed balance into the sketch, so I felt happy to color the sketch on the computer.

In the finished paper artwork, I used contrast in several different ways. For the lotus flowers, I used densely glued bright circles to make a center, and then glued pure white paper around, leaving plenty of blank space inside the petals to make them look light and airy. The yellow centers of each flower became a focal point, achieved thanks to contrast, and with minimal means.

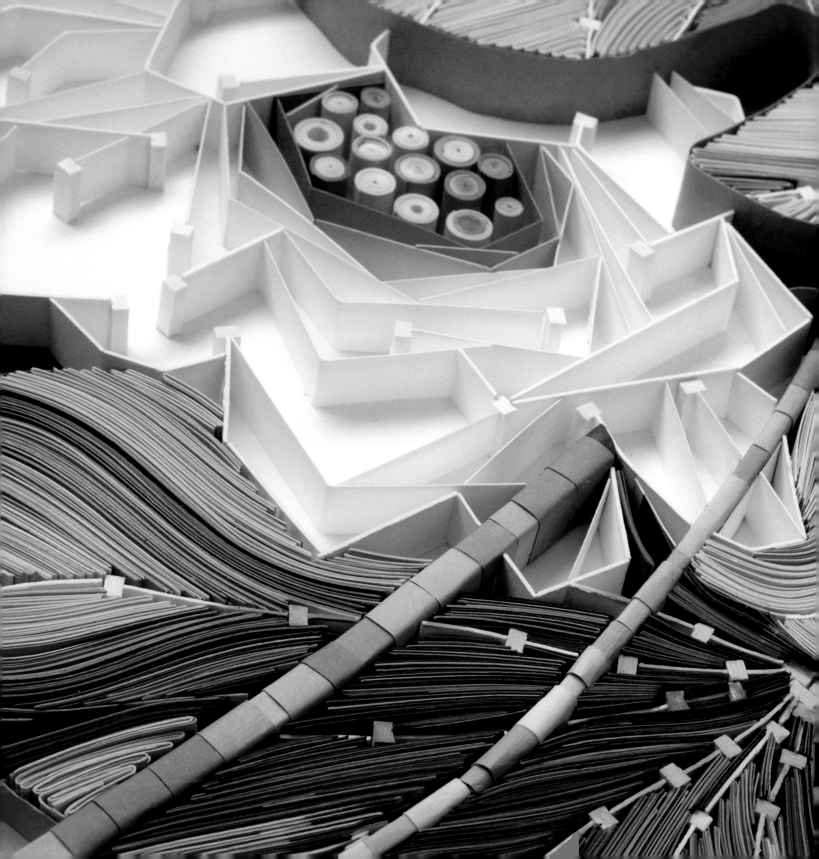

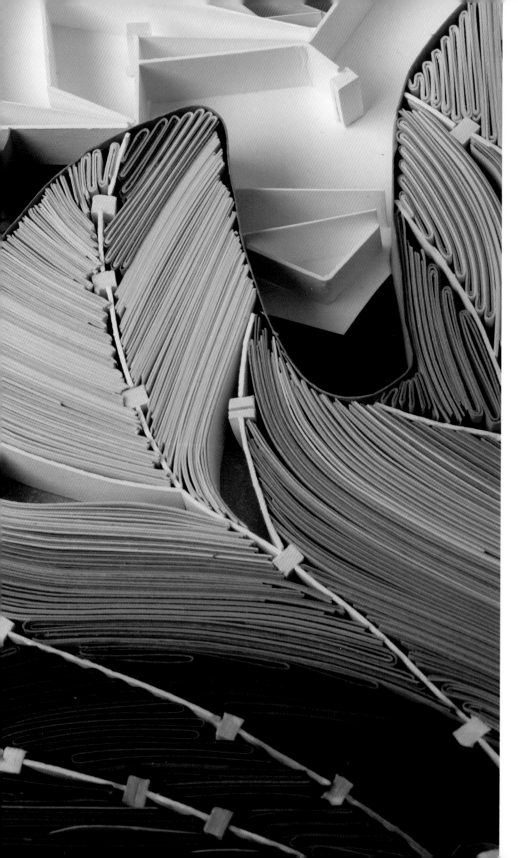

Another example of contrast can be seen inside the large leaves, where the difference is not about color tones, but rather texture. All the curling leaf edges are made with pieces of flat paper, including the large leaf area at the very bottom. This creates an important contrast of textures—smooth versus dense, edge-glued paper "strokes."

Filling the whole artwork with exactly the same texture throughout is an easy option, even in spite of the lengthy work time, because the process can become semiautomatic. It doesn't require as much mental attention as usual, no constant pausing and assessing to decide how to treat each element.

Monotonous texture without breaks is tiring for the human eye; areas of solid/flat color provide a relief (a welcome break from the monotony of texture), regardless of whether the artwork is filled exclusively with identical coils or strokes or tightly rolled circles. Even small areas of contrast, including the change achieved by simply leaving enough blank spaces in the design, will make the artwork visually more interesting and harmonious.

It was to create just this contrast that I decided to make the stems with strips of paper wrapped around a thick carton: this way they stand out from all the surrounding texture. Thinner stems have a single strip of carton inside; for the thicker ones I glued several layers together and then wrapped them in different-colored strips. These stems also add motion and a more dynamic feel to the composition.

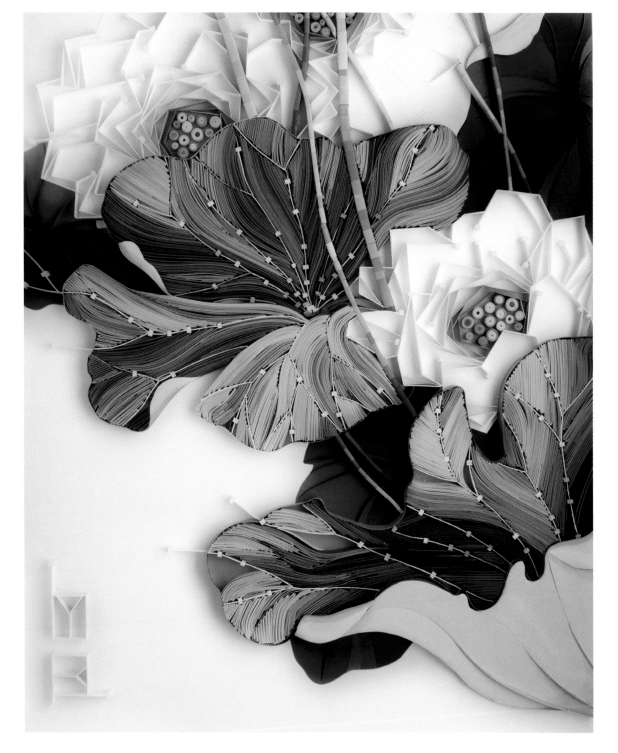

TIP: For the little squares inside the leaves, I used a very thick, cotton-based mount board (available from framing-supply stores). First, I cut the mount board into regular size strips, then cut a tiny portion of each strip to get the cuboid shapes. It is a slow, painstaking process that gave me blisters after just an hour of cutting! However, it lets me introduce a small square shape into my art, which is a nice contrasting element to all the circular and rounded shapes. Perhaps I'll find a better method at some point—the idea is to experiment and utilize any paper/pulp products that can add a novelty element into my existing library of shapes and methods.

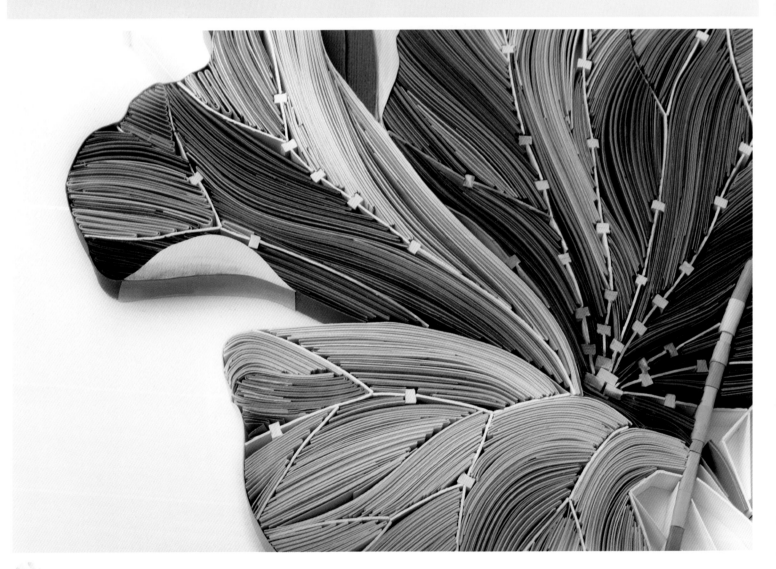

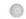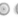

"Pine Tree"

When planning a composition, it's only natural to assess what is in front of you—the object you have chosen to depict. However, there is often just as much meaning in what is absent—where there is clutter, even valuable things lose their importance. In traditional Japanese art, the use of empty space is essential. Emptiness is the pure, absolutely elemental void between all things in life. According to this aesthetic, empty spaces in artwork are not simply an absence of content; they are their own content and carry their own meanings.

I've always admired the minimalism and powerful use of negative space integral to Japanese compositions; however, I struggled to successfully apply the same principles to my own work. Like everything in life, such mastery of blank space requires practice and restraint. The "Pine Tree" artwork is my practical exercise, with the only difference being that it takes much longer to make than exercises with ink and brush.

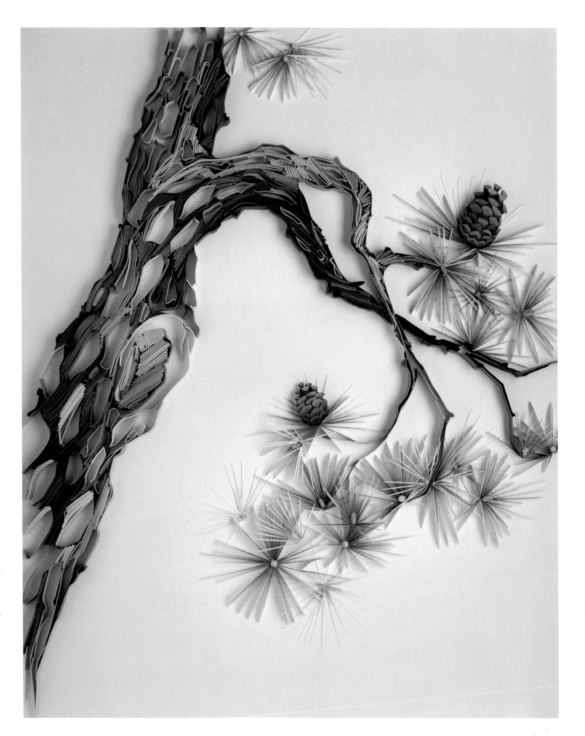

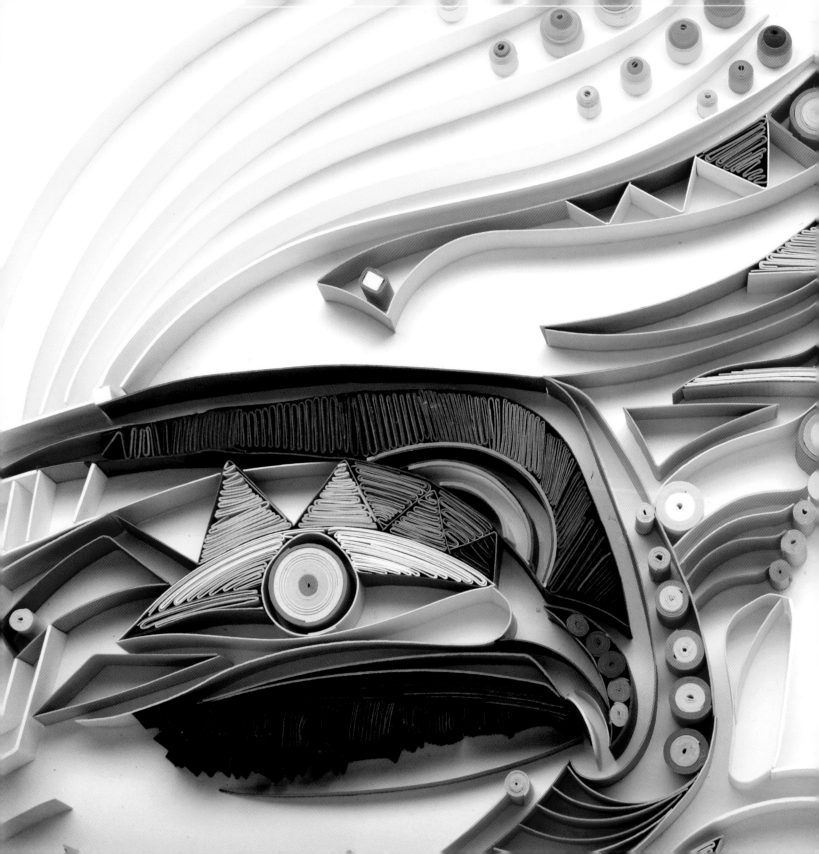

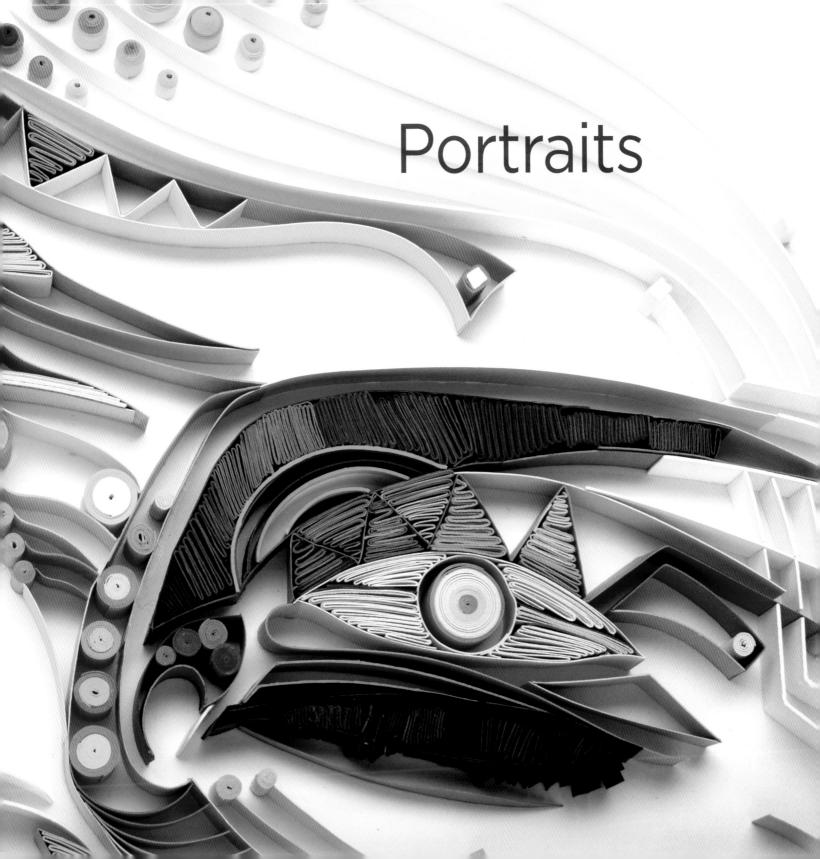

Portraits

Portraits

About a year after my paper career began, I was working on a commission for a large paper-manufacturing company and they asked me to create a side view of paper sheets stacked into a large pile. What could be simpler? But I told them that I couldn't do that with edge-glued paper strips. The problem was that I was too rigid in thinking about what can or cannot be done with my technique: being used to coils and curved shapes, I was reluctant to think outside the box and give a new challenge a try. Edge-gluing a bunch of straight strips to depict a stack of paper seemed too much of a stretch.

In these early years I refused to incorporate a number of perfectly sensible clients' requests, because I wasn't flexible enough in my thinking about paper. However, gradually I started to change, becoming less constrained by the limitations that I thought were integral to my paper-manipulating techniques. Over time I introduced flat paper elements inspired by traditional quilling, and various methods borrowed from other paper craft techniques such as decoupage or papier-mâché, until I decided it was time to approach one of the most challenging tasks for any artist: to portray a face.

I'd been brewing this idea for a long time, procrastinating and being unsure about how to approach a portrait. There were too many uncertainties—whom to depict, which size to go with, how to make particular facial features with paper: nose, eyes, and lips simply intimidated me. I was stepping out into uncharted territory. With each new portrait I tried out one new little idea after another, creating my own library of paper treatments and methods. But even after several years of working on the series of elderly people, I still avoided younger subjects, believing that it wasn't possible to achieve an appealing skin texture with edge-glued strips of paper.

More time had to pass before I gained the courage to prove myself wrong and begin exploring ways of portraying young faces. My current focus is all about large-scale portraits, and, at some point in future, I might even tackle the challenge of portraying children. I see art as a journey; it is also a reflection of an artist as a person, so when you grow and change, it is always reflected in the art. I'm not the same person now as I was ten years ago, when I first made my name with paper strips.

My series of "Old People" portraits became the first major step on the journey of breaking through my self-inflicted feeling of being constrained by the very medium that I love so much.

Anytime you experiment with new materials or techniques, the experiment can go either way, but I still believe it is important to go for it, because that's the only way to find things that do work. Experimental methods should be tested on personal, not commissioned, projects though.

"Old People" Portraits

So, for my very first portrait adventure, I decided to show someone who had lived a long life, with every wrinkle telling a story. There is a lot we can "read" in an elderly face, which is unique in its imperfection. Apart from being convinced that paper strips would work well only for depicting a wrinkled face, there is another reason that I thought going the elderly route was the one for me. It's hard to age well in this culture, which too often focuses on the negative aspects of growing older. In my old-people series, I strive to portray my characters with bright, captivating colors; to explore the movements that wrinkles create on their faces; and to find unexpected situations and viewpoints that show that life goes on and can still be new and exciting. Ultimately, I do my absolute best to treat every subject with great care and respect.

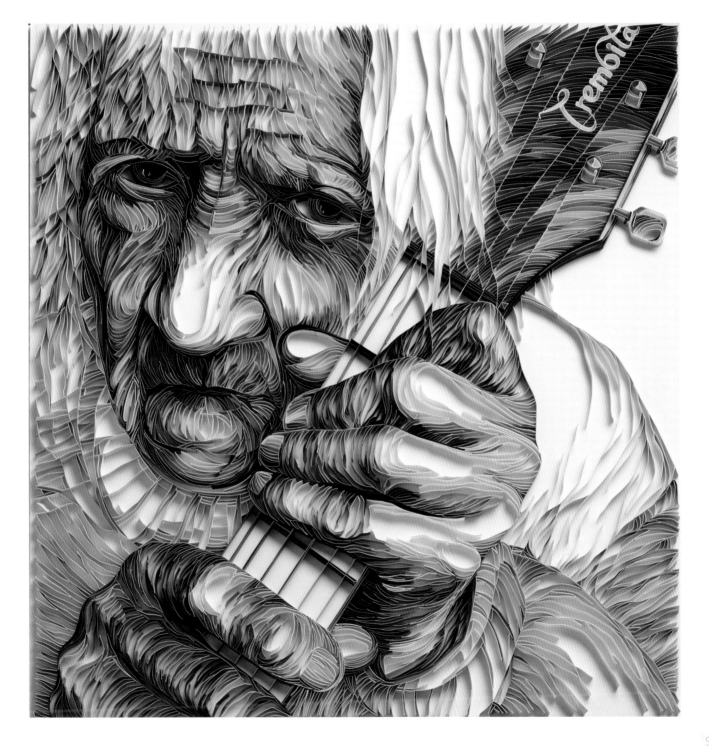

"Babushka"

I'd been collecting photographs for visual inspiration long before I started to work with paper. I just like browsing through them from time to time, thinking about what it is that draws me into a particular image. Sometimes I spend hours searching the internet for photographs to add to my collection—I believe it is similar to any kind of collecting hobby. I collect images that move me. However, a black-and-white photograph of an old woman holding the neck of a guitar was the one that I kept returning to. There was something in the way she clenched that guitar, as if holding on to it for dear life. I decided to use her and call the project "Babushka," which can either mean grandma in Russian or be an affectionate name for any old lady.

When using a photograph as your primary reference, some of the creative decisions have already been made for you, but there are plenty of other important things left to consider. The main pointers I take from a photograph are the basic facial features and the contrast between the highlights and dark areas, because that's what ultimately defines the face and makes it individual and recognizable. Everything else is open to creative experiment and variation.

For "Babushka," one of the important decisions to make was to choose a color palette. I decided to go with a limited scheme of all my available brown, beige, and cream papers just to make the task ahead a little easier. Interestingly, the more color hues you introduce, the more challenging it becomes to manage

and balance them out. The addition of muted greenish tones for the sweater came much later, when I realized that I had to differentiate the clothes from the skin; otherwise all the hard work that I put into the face and hands would be lost by overly similar surroundings.

I started by laying out the darkest outlines of the right eye and the nose, gradually filling in the surrounding areas. The lighter the area, the more spread out the paper strips. For every paper strip added, I carefully considered which color to choose, how it needed to be positioned in order to make sure it naturally followed the facial features, how spread out the nearby strips needed to be, and so on. I measured, cut, and tested every segment of the strip before finally gluing it down into position. It took me several hours just to get a 2 x 2 inch (5 x 5 cm) area of the face done. Overall, I didn't time how long this artwork took me, because I worked on it during the breaks between commercial jobs. But looking back, the whole period from start to finish stretched for around five months.

At this point I should say that I don't work like that anymore—with experience and practice, I've grown more confident and found ways to speed up the working process. This technique requires considerable patience, which I have, although this doesn't stop me from looking for shortcuts. I experiment with the techniques in the hope of finishing a project faster, so I can move on to the next.

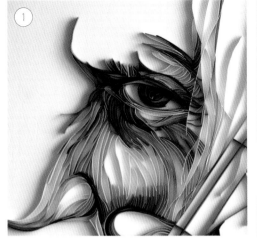

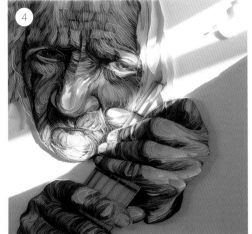

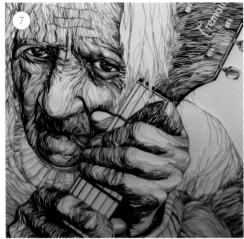

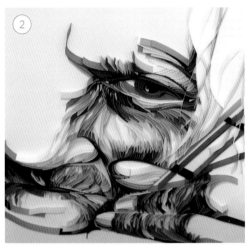

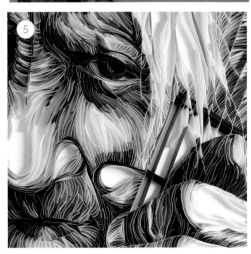

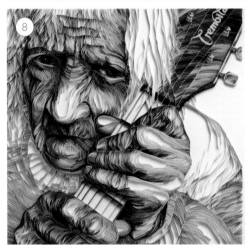

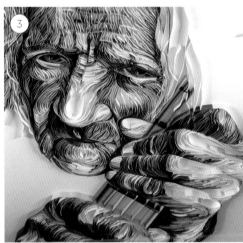

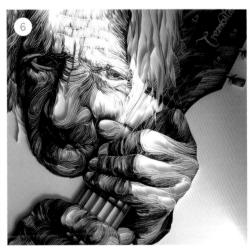

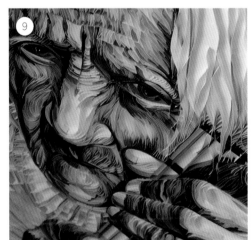

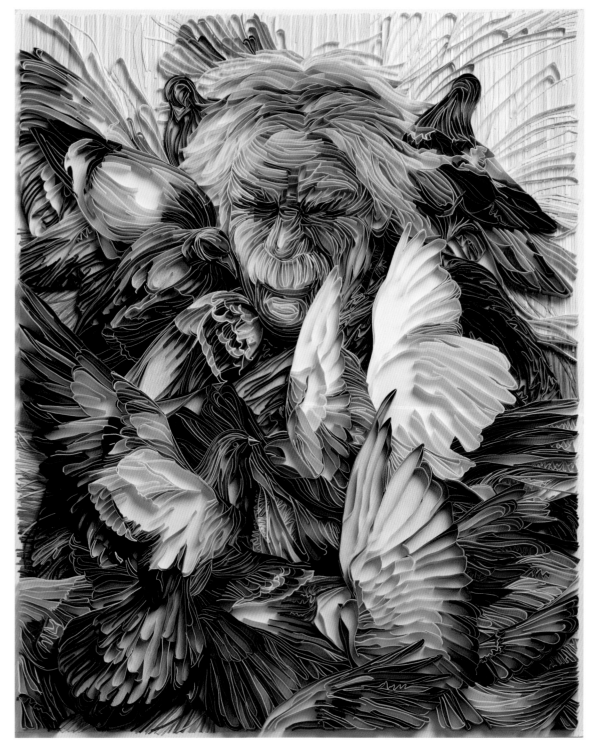

"Loves Doves"

Seeing how a technique works for one design always helps visualize the next idea more clearly. That's why I have a list of potential future projects inspired by something I have previously made. I might not start working on them straight away, but I always keep a record of any ideas or thoughts that come to me during the creative process— you never know when and how it might become useful.

There was an old French gentleman I first saw in Paris feeding pigeons. I didn't take a picture of him, but some time later I found him on numerous photographs taken by other tourists. I put together a dynamic composition with massed pigeons taken from a variety of photo references. For such projects I usually work on my sketch in Photoshop or other digital artwork software that allows the easy rearrangement of elements: I might cut out a pigeon shape from one photo, then use another photo to copy/paste a different pigeon into my digital sketch.

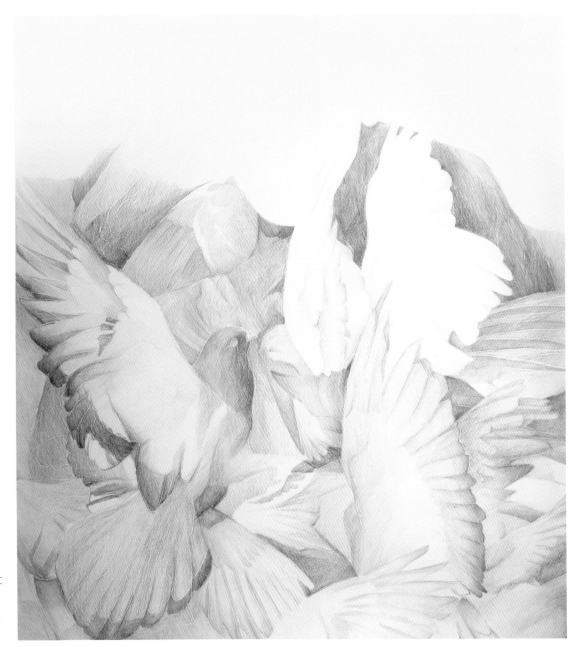

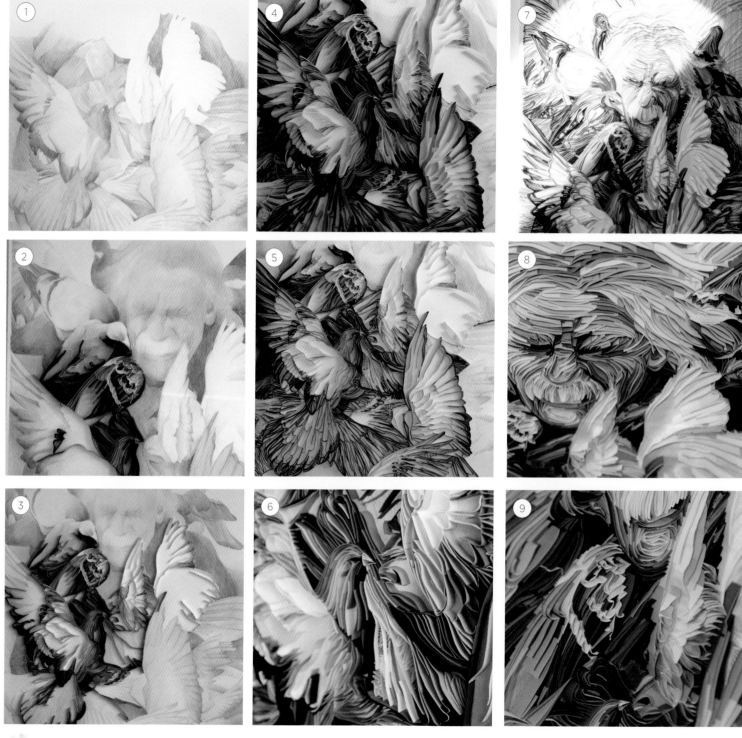

This time I've made the palette more complex, confident that I can handle more colors. It is richer than my first portrait attempt, but still very controlled, with dominating shades and tones of blue contrasted with a few warm accents.

One thing I was certain about, though; I had to find a way to work faster. I decided that the solution lay in advance planning: drawing the whole design on the background with colored pencils before gluing the strips of paper on top. This would, I hoped, shorten the decision-making time. For example, if a detail were shaded with a particular color, I'd use roughly the same color of paper strip and follow the direction of the pencil marks.

If predrawing the artwork to make the process faster seems illogical, I must admit this method didn't work too well for that reason. I still spent a few months working on this portrait but have never used the predrawing method since. However, the reasoning behind it was sound and eventually led me to the method of blocking in large areas with flat-torn pieces of paper. I'll explain this further later.

"Melting"

All the while I continued my commercial art practice, collaborating with different brands and accepting editorial commissions. I can't overstate the role that these projects played in gaining exposure for my paper art. Nevertheless, with every finished portrait I felt the urge to dedicate more time to the personal pieces of the Old People series. The next few portraits I made, including the "Melting" piece, are explorations celebrating the later stages of life.

In "Melting" I'm playing with an old man's features in an attempt to put the photographic reference aside and create a portrait that exaggerates the decreased elasticity of the skin, in order to show the effects of gravity on aging human tissue. The old man is trying to prop up and support one side of his face with his hand, but he fails, and his skin is still melting and falling off. The aging process is inevitable, so eventually the old man surrenders to the natural course of life.

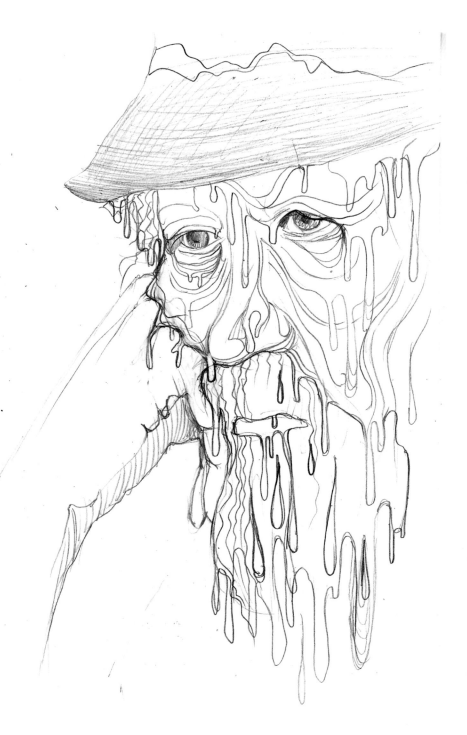

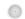

"Gypsy"

This is the first portrait that I decided to treat in the same way as any of my other decorative designs—by incorporating tightly rolled circles, drop-shaped elements, and other patterns often found in my typographic art. My only consideration was to make sure the patterns complement the facial features, since the face still needs to be read as a face.

I went all out, covering the head with hundreds of tiny rolled circles in an attempt to achieve a lace effect with quilling. Looking back, I would probably use a simpler treatment for the fabric, simply because the highly detailed head cover doesn't add as much interest to the portrait as the time it took to roll all those circles! But in the end, this is a personal choice and I have to respect the decisions I made back then. It helped that this artwork is quite small, only about 12 x 16 inches (30 x 42 cm).

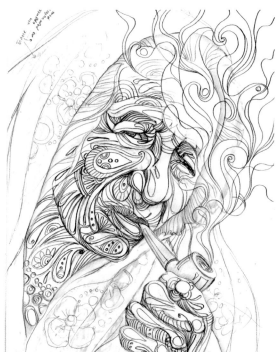
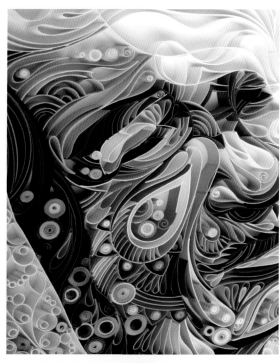
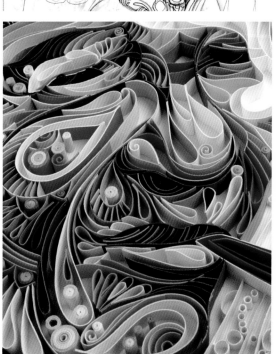
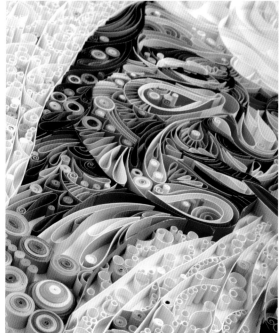

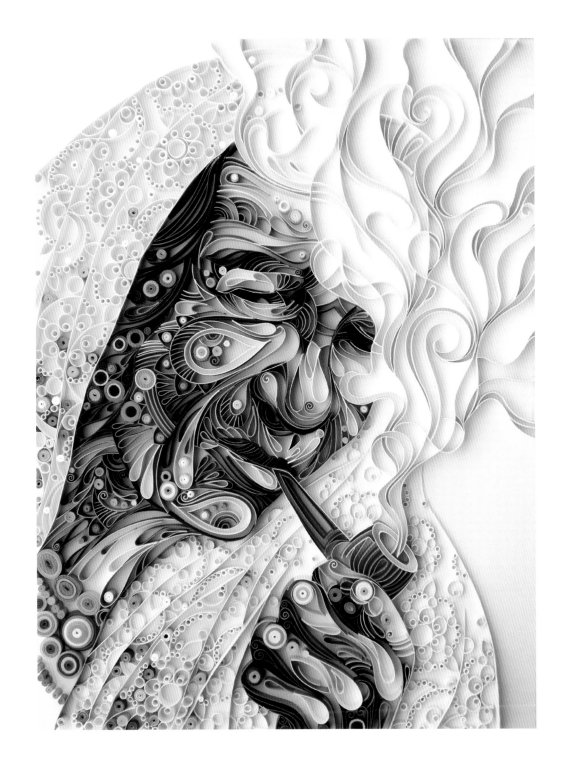

"Coins" and "Old Hat"

New paper treatments tested on commercial projects and nature-inspired pieces often found their way into the portraits that I created around this same period of time. My experiments with undivided blocks of store-bought quilling paper that I started in "Tropical Fish" continued with the "Coins" and "Old Hat" portraits.

"Coins" shows an old lady bending over to pick up some small change she noticed scattered on the ground. Although the preface of this action can have a negative tone—an old person has to go to this trouble just to get a tiny amount of money—at the same time this is a joyful moment: she found some coins! I have a special place in my heart for this artwork, for various reasons. I like the simplicity of the figure, the unexpected pose, and the psychedelic feel to the background. Sometimes it feels really nice to take a slightly different approach and just play with the subject.

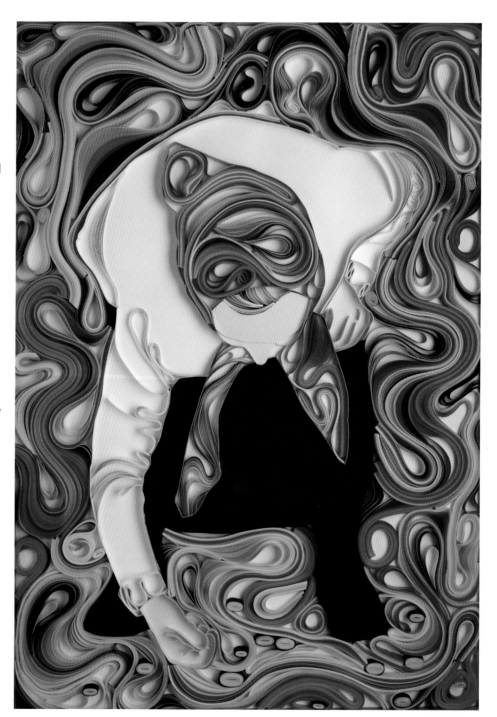

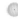

For the "Old Hat" portrait, I tried to make the face out of the same blocks of ready-to-use quilling paper that I used for the eye-catching swirly background in "Coins." This proved to be quite a challenge because I struggled to control the quilling blocks and make them fit the features properly. Many of the areas look rough and a bit tortured. Undivided paper blocks can bring wonderful quality to the artwork when used correctly, but they don't work as well in the designs where precision is crucial. They are an altogether cruder way of paper folding, so the subject needed careful consideration.

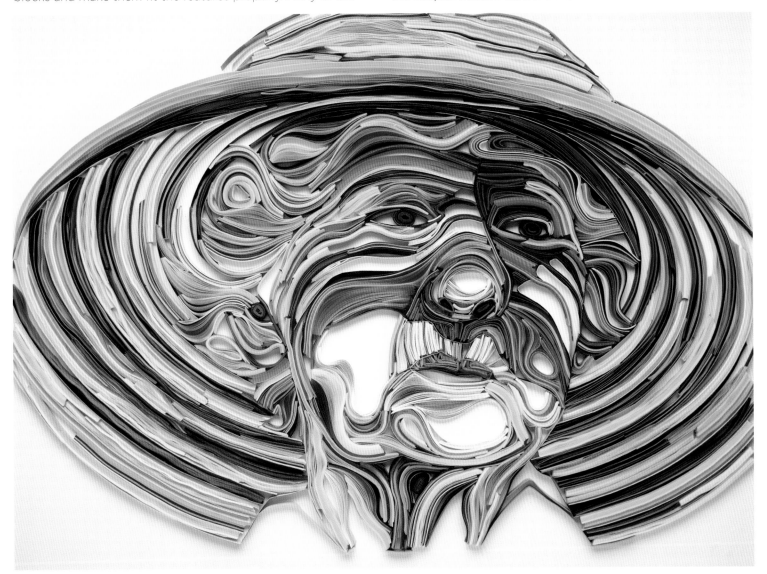

"Suction"

This work is my metaphorical take on "the beginning of the end." At some point this old woman feels an inevitable pull into nothingness: it starts slowly, but hair by hair, her life is being sucked into the black hole of nonexistence. Yet, I didn't want to show any fear in her facial expression, just acceptance with a tiny bit of visible sadness in her eye. Regardless of my initial intentions behind this portrait, I think it is still open to different interpretations.

I used white pencil to bring softness to some areas of her face and help to visually blend the white strips into the black background.

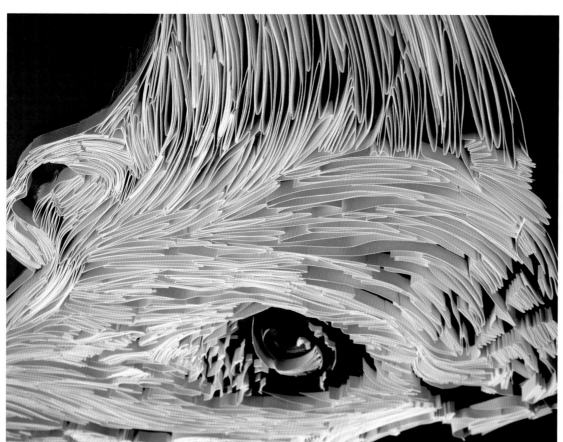

 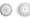

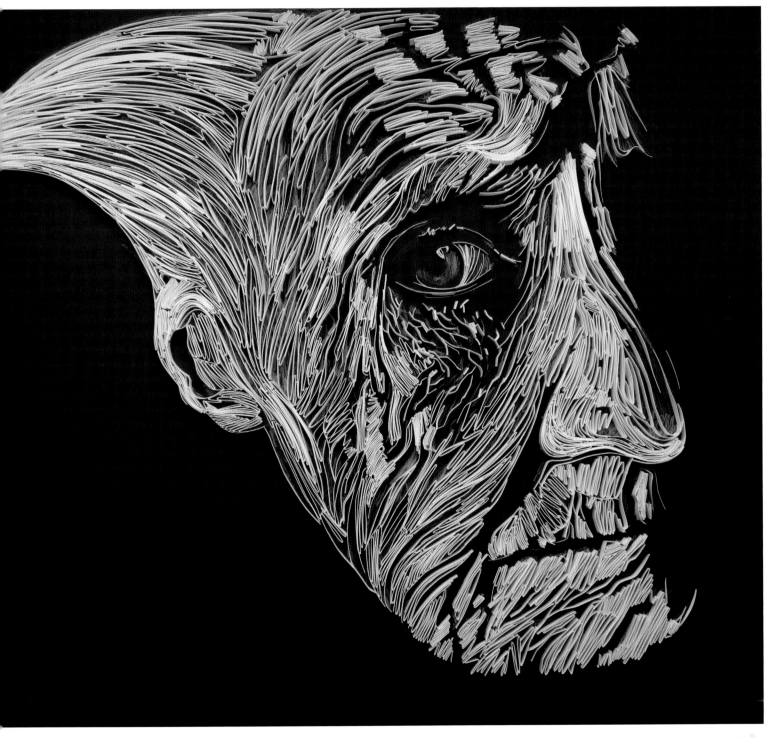

"Headscarf Left Behind"

I don't often use a black background because, like a black hole, it tends to pull in and dominate the edge-glued paper strips. So it takes a lot more effort to make a design stand out. However, some creative ideas can benefit from dark surroundings, but it always helps to incorporate brightly colored, flat-cut paper to achieve enough contrast.

The thinking behind "Headscarf Left Behind" is my reflection about the things people leave behind when they die. When it's someone close to you, it can be unbearable to look at their abandoned possessions. Yet, you don't want to let any of it go, because these things are the tangible remains of a person. People can fade away and disappear, but an item of clothing left behind tells you that you were not imagining the person who left, but that he or she was once alive, warm, and breathing.

My idea was to make the headscarf as bright and eye-catching as possible, and to juxtapose it with the hardly noticeable features that are disappearing into the darkness; eventually only the headscarf is left behind.

I used a papier-mâché technique for the scarf by sculpting the base out of clay, then covering it with layers of newspaper soaked in water-diluted PVA glue, and then flat-cut strips of paper over the top layer. After removing the clay, I ended up with a firm, hollow headscarf shape. There are many ways to make papier-mâché—it is a versatile technique that complements quilling very nicely.

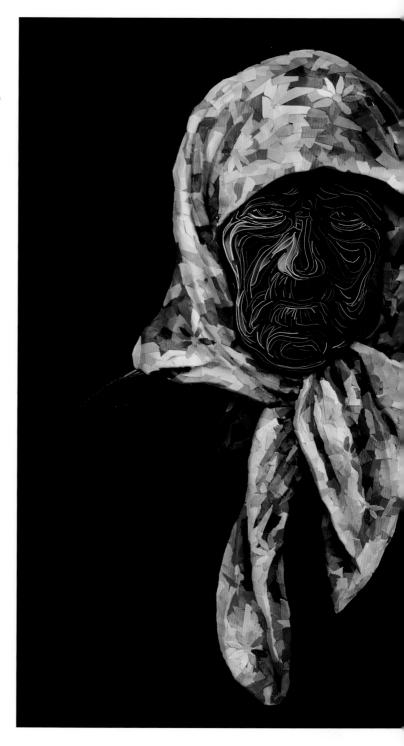

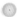

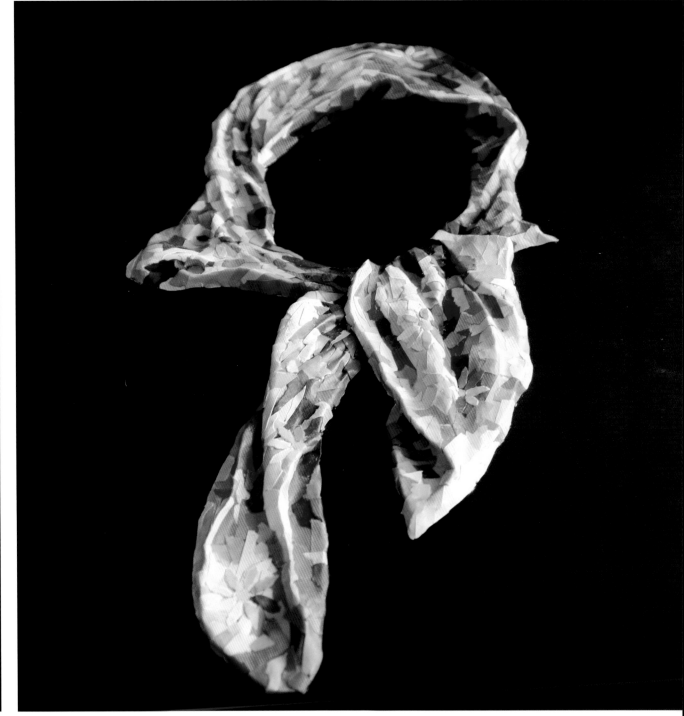

"Black, White, COLOR"

Solid-black color can play a grounding role in a composition. It gives an impression of stability and creates a nice contrast to any crazy, colorful mess that might be happening elsewhere in the artwork.

With this paper mess I wanted to create an organic universe that is full of energy—an energy that is invisible, yet it is there, and might be even more exciting than the world we can see.

I started with a simple black-and-white sketch of the old woman's profile, but the "COLOR" universe evolved organically as I worked. My only preparation was to create a raised pyramid structure out of mount board in order to add extra dimension to the piece. Elements glued to differently inclined surfaces are seen from a slight angle, and once the whole area was filled with circles and other elements, the underlying structure became barely noticeable.

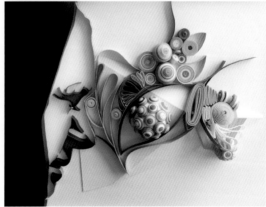

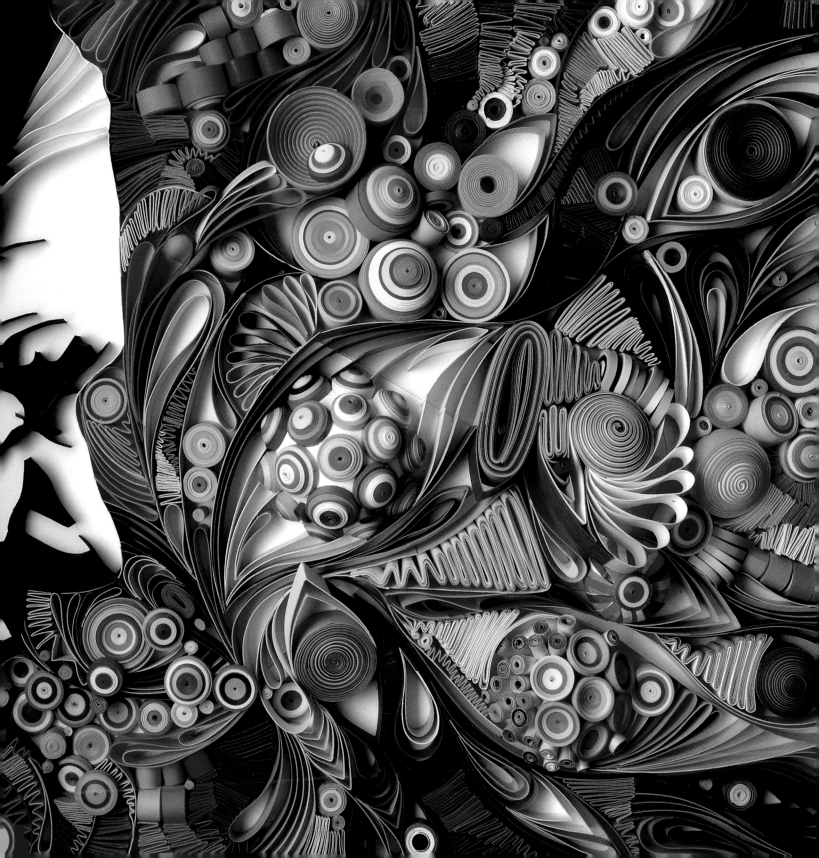

"Funeral Flowers"

This is another example where I didn't sketch, but built the composition straight away on the blank surface. Having said that, I made some of the larger flowers separately, and I used the opportunity to move them around before gluing them down into their final positions. In general, I am an advocate of detailed, well-planned sketches, but to determine the best way that works for you, you have to try different options first and be flexible enough to adjust to a new method if the particular concept needs it. Experimentation was the main intention behind this artwork; it was not the case of having a firm idea from the start.

The concept behind this experimental artwork came from the look of those artificial bouquets often seen at funerals. Quite often they are big and colorful, but not necessarily in a good or tasteful way. There is something undeniably sad about such flower arrangements, to the point that I find myself pitying the flowers themselves.

The first thing I wanted the viewer to notice is the flowers, overwhelming in their artificial brightness, but once the eyes move away from the brightest central area, the pale hands and face are brought to attention, thus putting the garish bouquet into proper context.

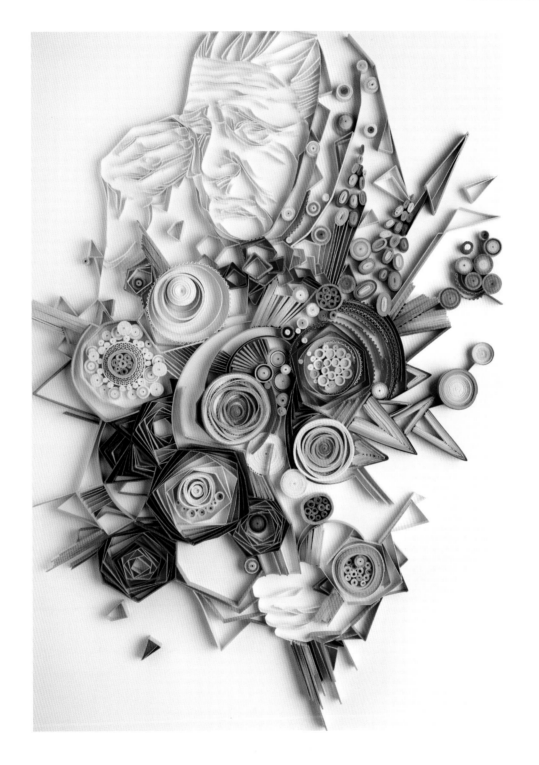

"Lipstick"

Another experimental portrait? Because the face is barely recognizable in the reflection, "Lipstick" can hardly claim to be a portrait.

Still, I thought it would be interesting to show an intimate moment in this series; for instance, an old lady applying her makeup. The obvious first idea was to do a reflection in a mirror, but then I thought it would be more interesting to imagine a situation where she left her hand mirror at home and is forced to use some other reflective surface instead. So I came up with the idea of a glass decanter—an unexpected and quirky object inspired by a lovely still-life photograph in my collection.

This artwork visually differs from my other works: I used sheets of pressed cork and dried leaf skeletons to add a tactile feel and texture to the art. I wanted this piece to have a warm autumnal feel to it. I finished this artwork the day before Queen Elizabeth's 90th birthday—I looked at it and thought that I had unintentionally made this lady resemble the queen.

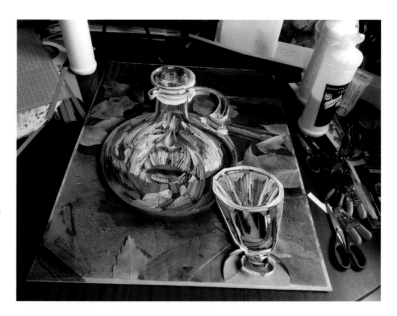

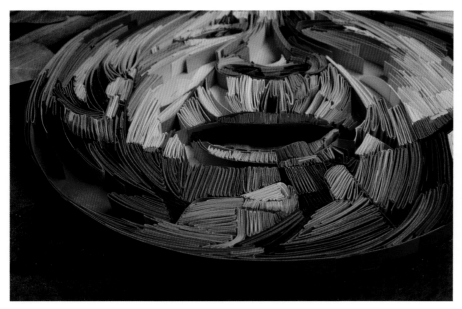

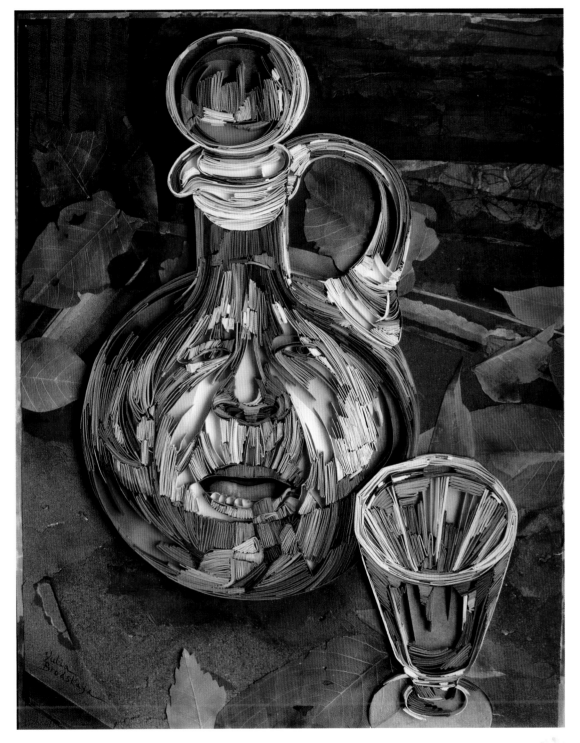

"Textile Market"

For quite a while I've been pondering the idea of creating an artwork featuring a market scene. Even though I don't like being in a large, noisy crowd, I very much enjoy the visual abundance of colors and textures. There are dozens of photographs of markets in my photo collection—especially spice and textile stalls—but for this piece I decided to go with the latter, so I could work with pattern as well. I deliberately avoided specific references—I wanted this artwork to be generic and focus on creating a happy environment for this old lady. She belongs there and draws positivity and optimism from the time spent at her exuberant market stall.

This is the first time I increased the size of the artwork in this series; it might not be that large universally speaking, but it is quite large for edge-glued paper. The final artwork measures 34.2 x 31.4 inches (87 x 80 cm).

Market scenes always mean explosions of color packed within a relatively small space. On the basis of that vision, I knew there was no way I could rely solely on edge-glued paper strips—there had to be a solid color underneath. So I chose to introduce a layer of flat-cut paper to the background, before adding the strips over the top. Basically, I used the same method as in my "Jungle" and "Pure" nature-inspired pieces, but I didn't refine the cutout shapes as much: a pile of folded material can have a more fluid, accidental shape to it.

At this point of my creative journey, I believed that there was nothing wrong with unrefined lines in the paper artwork. Today, I deliberately flex and slightly bend straight paper strips to use as a "line" element in my art. This way they look more organic, and expressive, and seem to convey more life and energy than perfectly straight strips. In addition to that, they stick to the surface much better.

I approached the flat paper on the background in a similar manner, by trying to avoid any perfectly straight lines when cutting out the shapes. Flat-cut color paper on the background is just one tiny step prior to my current method of "blocking in" the areas with pieces of torn paper.

The cumulative experience I have gained from all these projects has led me to my method of painting with paper, which I consider my major contribution to the paper art world. Everything I have done previously seems to have been building up to this point.

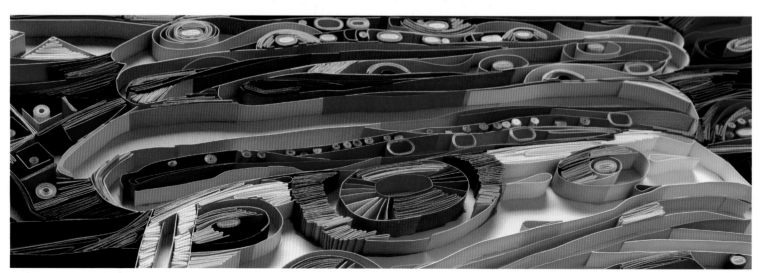

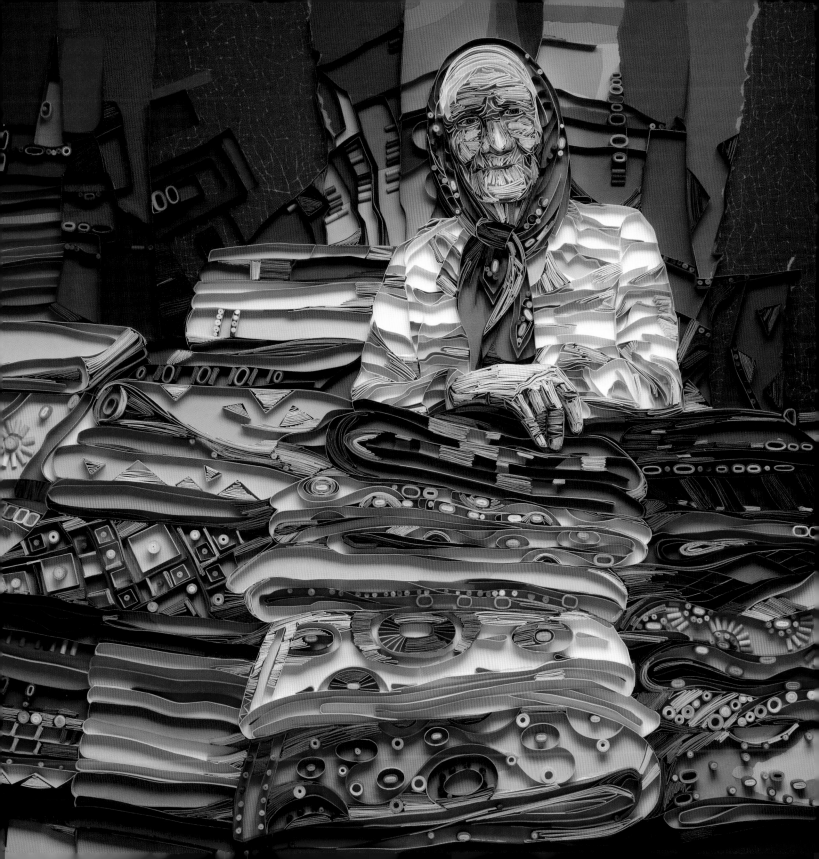

Painting with Paper

I don't normally play favorites with my artworks, because I invest so much energy into every single one of them: choosing a favorite would be like choosing a favorite child. Having said that, "Jade" and the two successive "Topaz" and "Amethyst" pieces (see pages 119–123) ultimately redefined paper art for me. From this point onward, I can confidently say that I have found a way to paint with paper.

Painting with paper means imitating brushstrokes with tightly packed strips of paper, achieved by combining different color strips in a method similar to mixing paints on a palette. This new technique comes as close to actual painting as possible, but with the added quality of a third dimension.

The basic element of this technique is a tightly bent strip of paper. I was initially inspired by a digital font filled with roughly laid internal strokes, so I tried this approach in my typographic work for the first time. I used paper strips to imitate this rough, freehand feel, which I called a "sketchy" style. Over time I found I was incorporating it more and more across all of my projects, usually in small amounts as a complementary technique to add different textures. At some point I decided it would be faster if I bent several paper strips together, instead of folding them one by one. While doing so, I noticed that by combining two strips of different colors and bending them together into a single tight little pack, I achieved a new color—an interesting blend between the two.

Such a mix of paper is not a smooth new color that you get when mixing paints; it is more of an optical illusion explained by the limits of the human eye's ability to perceive alternating color stripes. After a certain distance the eye struggles to discern individual stripes and begins to perceive the new blended color as a whole.

Simply speaking, if you mix red and yellow paint, you'll get orange; similarly, if you take a red paper strip and bend it together with the yellow one, you'll get a tight little pack that will be perceived as a unifying orange—an intermediate color

between the initial two. It is possible to control this in-between color by using thicker paper for the strip of the dominant color. For instance, by using heavier paper for the yellow, I tip the balance of the color scale and end up with a new mixed shade that is yellower than the one made with the equal-weight strips. This effect helps deal with the issue of not having enough variety of colored papers, because now you can "mix" the strips in order to create much-smoother blends and transitions from one color to another.

TIP: *This method works better with heavier paper or card (e.g., from 150 gsm onward).*

It is also possible to create color gradients; for instance, from pink to white. The smoothness of the shade transition will depend on how many of the same-colored strips are used before introducing a lighter color. In this example I used two strips of each tone of pink, adding the next color before the previous one ran out, and bending them together at least for a couple of bends (more for a smoother transition).

TIP: There's no need to make the bent sections of strips the same size—a perfect rectangular pack shape is not the goal; in fact, it is easier to work with more random/uneven, tightly packed strips.

Creating a tight stroke-like shape (or pack) is simple: bend a strip of paper multiple times, alternating the direction of the bend (if you let go of the strip at this point, you'll get a zigzag shape). The main challenge of this method is that paper will always unfold itself as soon as you let go of it. Certain pressure needs to be applied on the creases to ensure that the pack is not too loose (squeeze the ends together); then, tightly holding the pack, dip the bottom in the PVA glue puddle and place into position, securing with a clip or peg. I use all sorts of clips— both small and large—just to have options for choosing the right size and grip strength required for securing a particular pack in its position. I always try to attach a new pack to some element that is already there and is permanently attached to the surface. Pegs and clips allow you freedom from having to wait for the glue to work while holding a pack in position with your fingers. Instead you can move on to the next element straight away; the only requirement is that the next pack needs to go to a different area of the artwork where glue has already dried. After five to ten minutes, clips can be removed and used again for the next bit.

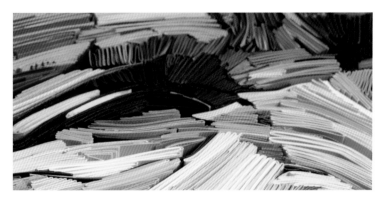

As already mentioned, alternating the areas you are working on also helps you see the whole picture and be able to work out the contrast between the areas of lightest and darkest color early in the creative process. Having said that, some adjustments are always required along the way; so far I have come up with two ways of adjusting the colors:

1. Coloring the top edge

For lighter areas, I use brush markers to color the edges. This method should be used with care because it is very easy to go overboard and do more damage than good. I usually choose a marker color that is quite similar to the color of paper that I'm about to adjust, or just go for gray markers, which simply darken or mute the existing color of the paper. The rule "less is more" definitely applies here—I use markers only when it is apparent that adjustment is needed.

Markers work well for darkening the colors or introducing brighter color to a light paper; however, they don't work for adjusting dark colors.

2. Inserting single strips

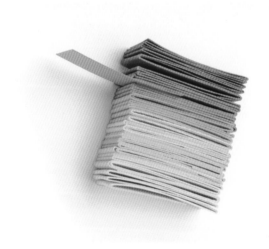

For darker areas, tightly packed strips are rarely so tight that it is impossible to squeeze in some more strips of paper—usually you can add to it, because only the bottom edge is glued to the surface. Thus, new color strips can be introduced in the larger gaps of a tight pack. It is also sometimes advisable to trim a new strip to make it narrower, so that it doesn't reach the bottom; this way it will be easier to insert with a minimal amount of PVA on the sides.

This method won't change the colors dramatically, but it can add just enough difference when you need to make some area a little lighter or a color transition smoother.

"Jade," "Topaz," and "Amethyst"

The visual inspiration behind this miniseries of three portraits—details of "Jade" (*below*), "Topaz" (*right*), and "Amethyst" (*below right*)—is the work by the contemporary French artist Françoise Nielly, who is known for painting vibrant and colorful close-up portraits. Her paintings are bold, expressive, and full of energy. I wanted to achieve a similar effect with paper strips.

 To choose the color palette for each portrait, I picked one feature "star" color, on the basis of the semiprecious gemstones that also became their titles. I then selected a secondary color to accentuate the main, on the basis of the principle of complementary colors. These are pairs of colors that contrast with each other more than any other color, and when you place them next to one another, both colors will appear brighter and grab attention. Complementary colors appear opposite each other on the color wheel and can help create eye-catching artwork full of contrast, but there are some additional things to take into account.

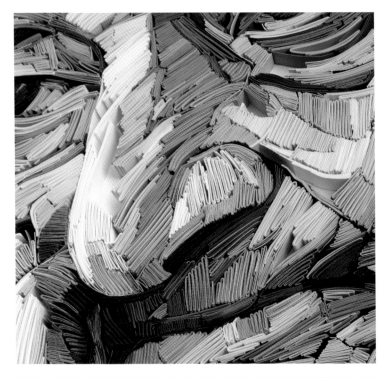

First, it always pays off to choose several tones/tints of each color, For example, in "Topaz" (*right*), I use at least three or four different warm yellows to represent my star topaz color, and two or three different blues for the secondary complementary blue color.

Second, these colors (or color groups, to be more precise) must be used in different amounts, not equal or too similar. This advice is rooted in the same principle as the rule of thirds: imbalance creates interest. A simplified division of color volumes can be two-thirds for the main color group and one-third for the secondary color, plus a little bit for any other colors. This is definitely not a rule—no need to take these proportions literally; however, keeping in mind that color groups should be used in different amounts will help you manage any color palette, no matter how rich and complex.

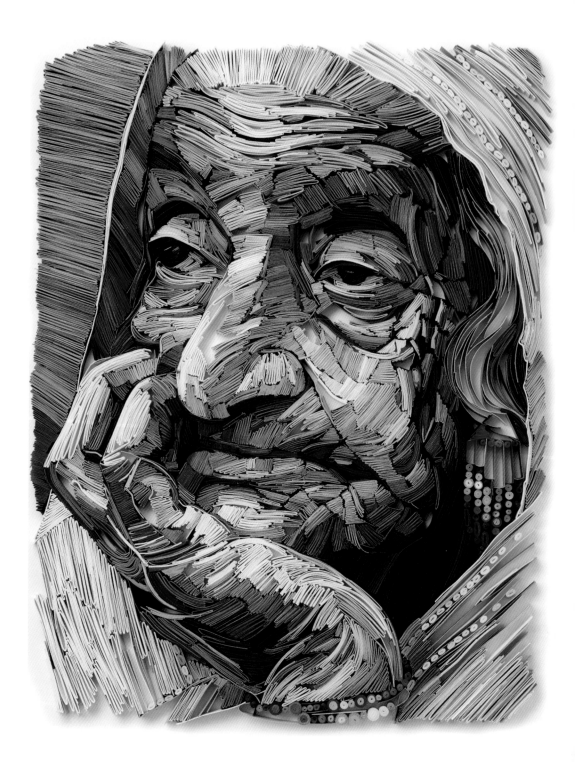

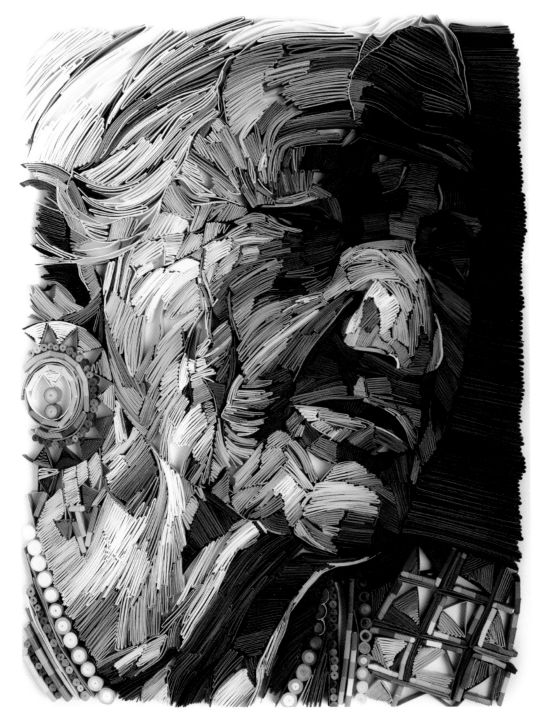

In "Amethyst" (*left*), purple colors dominate the palette, with lime green playing the contrasting role. Again, I picked this combination on the color wheel: even though lime green is not directly opposite my purple star color (and can't officially be called complementary), it still provides enough contrast to the purple. There are plenty of other colors used in tiny amounts; however, I deliberately avoided incorporating blues, warm reds, and yellows—I used hardly any. Still, the portrait gives an overall impression of being extremely colorful, but this is due to the fact that all the palette colors are placed next to each other in different combinations. With the exception of bulk areas of purple, every other color group is mixed and scattered around the portrait in small amounts. The point is that there is no need to use all the colors of the rainbow to create colorful art; the key is to

- choose a limited palette,
- choose dominant/secondary color group(s),
- use plenty of tones and tints within each color group, and
- introduce colors from each color group in different combinations throughout the whole artwork.

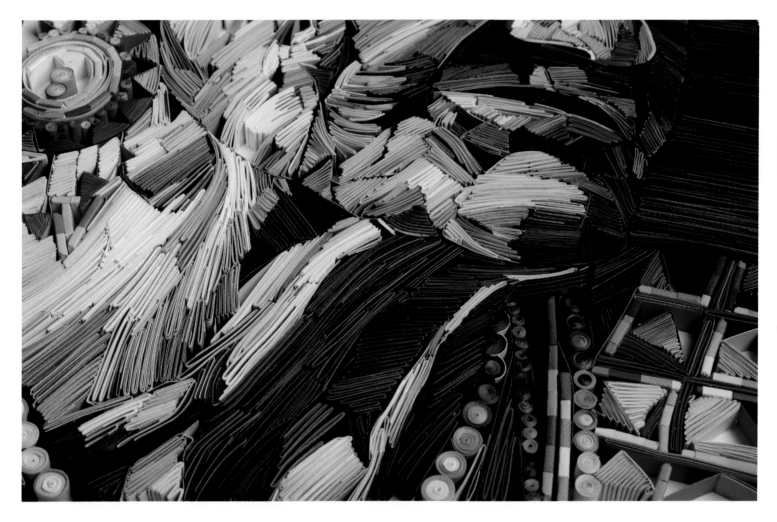

Even when using the same colors, visual diversity can be enhanced by introducing a different texture. Tightly rolled circles, ovals, and thick card strips wrapped in colorful paper—see the textile patterns in "Amethyst" (*above*)—all serve the purpose of breaking through the monotony of the stroke-like texture of bent paper strips. Jewelry or clothes are the most-effective places to use these elements, since this will make those areas visually different and, in turn, help the face to stand out as well.

TIP: Whenever you are unsure of the position or direction of the next tight pack, test it first in different angles without glue, and choose a position that seems natural for the face.

Since the stroke-like textures dominate the "Jade" (*right*), "Topaz," and "Amethyst" portraits, the pattern or rhythm of strokes begins to play an important role. I like to consider one tight pack of bent strips as a 3-D brushstroke; the pack (or "brushstroke") can be made of one color strip or a mix of several colors, and it can be thicker or thinner, shorter or longer. Monotonous texture without breaks is tiring to the eye; that's why I create diverse rhythms of paper strokes within a face: these 3-D "brushstrokes" should follow the facial muscles, features, and wrinkle lines. Larger areas—such as cheekbones, cheeks, or forehead—benefit from larger, longer packs of tightly bent strips, whereas shorter, smaller packs work well for the finer areas (e.g., nostrils, lips, and the areas around the eyes). For the background outside the face, I glue paper strips in a single direction—such monotony helps create vital contrast between the expressive living strokes inside a face and the background area, which is much less important, so it should not attract much attention.

The level of intricacy in these three portraits gives an impression that these are large-scale art pieces, whereas the reality is that each of them measures just around 16.5 x 21 inches (42 x 54 cm).

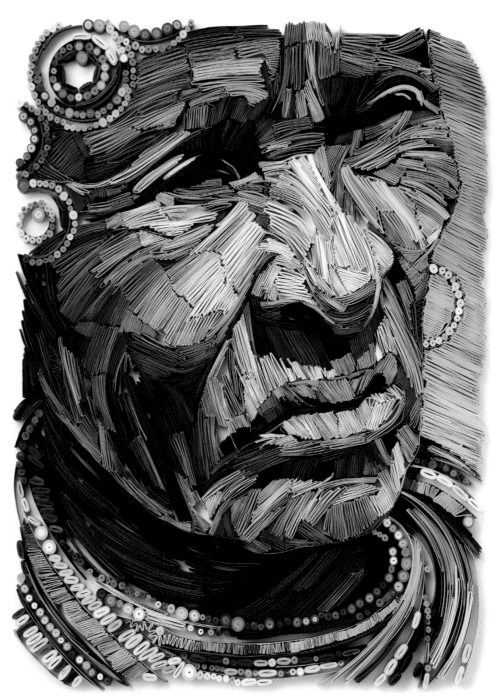

"Native Woman"

In most cases I start a portrait with the outlines of the key features: eyes and eyelids, bottom of the nose, the line separating the lips, chin line and face contour, and the key wrinkles (if present). But I never finish each area completely. It is more of an initial mapping process that provides a basic frame for later, more-detailed work. For these key lines I often use the thickest dark card available, because these serve as a support for the tightly packed strips that later might be attached to them with clips or mini pegs.

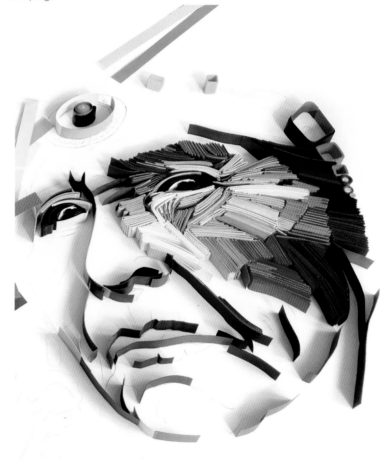

My inspiration for this portrait is an old black-and-white photograph of a Native American woman. She had such a strong presence and proud look about her, and I wanted to find a way to achieve a similar expression in paper.

For my interpretation I chose to make a number of amendments: except for the introduction of colors, the most important one is adding a slight inclination to her head. This is a simple, yet effective, trick that made this portrait look more captivating and intimate, while still keeping that strong, powerful expression and piercing eyes.

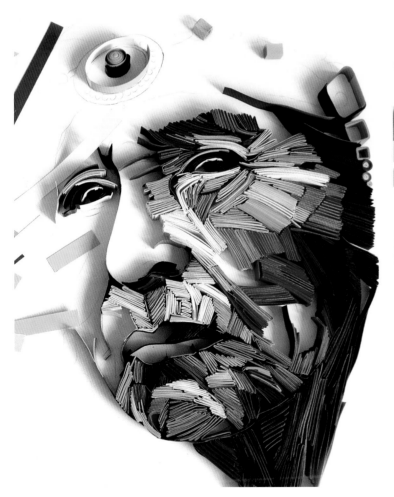
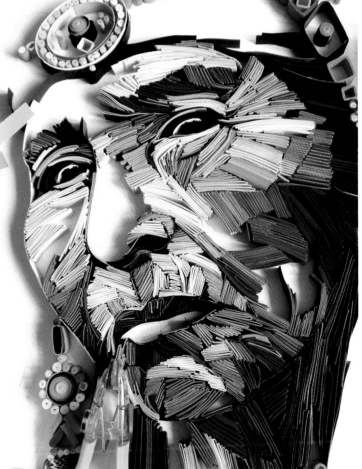

For me, the more a portrait can be taken away from an expressionless passport photo portrait, the more interesting it is. I often avoid a full-face view (when you see equal amounts of both sides of a face) for that exact reason and choose to show a subject from an angle—either three-quarters or two-thirds, or sometimes a profile.

The headpiece and other jewelry are also my additions that help give an ethnic feel to the portrait.

Portraits immediately draw attention to the eyes. However, there is no universal way of making the eyes with paper, but there are a couple of things that might be helpful:

- Add small areas of white or very light paper to the iris to represent light, which is itself a reflection of a light source in the eyes. You will be amazed how a tiny piece of white paper can immediately bring the portrait to life. Sometimes I add this paper "sparkle" as the very last touch, thinking of this as breathing life into the almost ready portrait.
- The sclera (the white area of the eyeball) requires some thoughtful consideration toward the end of the work. It is never bright white, so in most cases I just leave this area empty, allowing the shadow from surrounding edge-glued strips to darken the empty space naturally. However, if the sclera ends up looking too dark, I fix the balance by adding light edge-glued strips around the edges of the blank space forming the sclera. Since the shadow from light paper is significantly lighter than from dark strips, the sclera area immediately becomes lighter, often to the point that I have to tone it back down with some midtone gray paper to get a halfway tone. These details are all about constantly checking the relationship between the dark and light, and not being afraid to make adjustments.

TIP: A three-quarter view is a slight turn in one direction, until the far ear is not seen any more. A two-thirds view is a further turn until the line of the nose is almost touching the outline of the cheek on the far side. A profile is when you see just one side of a face, with the nose pointing sideways.

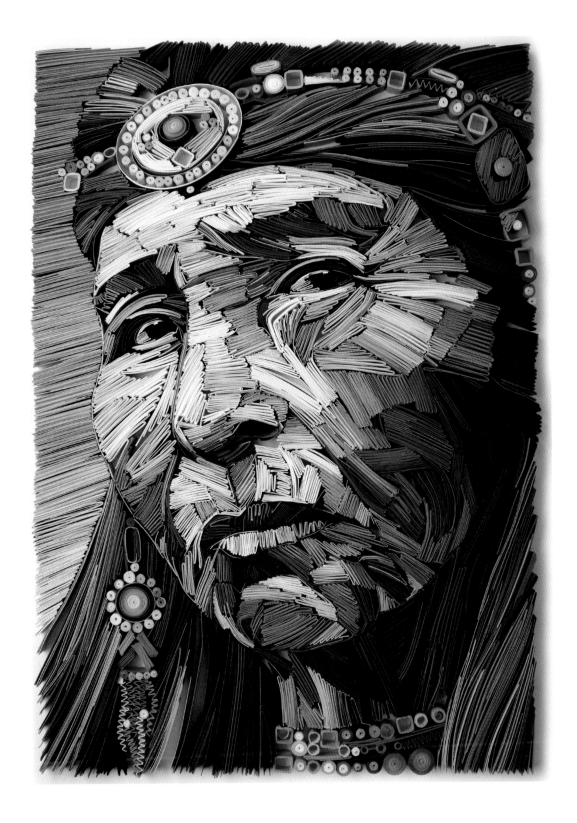

"My Grandmother" Portrait

For years I've been telling everyone that I do my best work when I'm not taking notice of how much time an artwork takes me. Instead, I distract myself with audiobooks, documentaries, competitive TV shows, and so on. While I still resort to these methods, I slowly begin shifting my focus toward staying within the creative process, until I'm paying undivided attention to what I'm doing.

I find it so interesting how different the same physical action can be depending on where your mind is. At one end of the spectrum, I can be rolling hundreds of paper circles or coils while enjoying the almost automatic action, with my mind traveling in another direction, absorbed in its own thoughts. At the other end, there is an ongoing effort of constantly being present with the artwork as it progresses, seeing and noticing how it changes with every single piece of added paper. This alert state of the creative process is what ultimately makes a difference when you see the completed piece. I call it active observation. This means transferring as much of you as possible (your constant attention, your care) into the piece of art you're working on.

Even with audiobooks or TV, I always had them on in the background, so my creative process was never purely automatic: my attention was jumping back and forth from the artwork to the book or program. The first time I consciously tried to be more present in the creative process was when I was making a portrait of my grandmother. She is a wonderful human being, loved by everyone who meets her. I have always wondered how it's possible to stay so positive, to give and attract so much warmth and light. I felt a huge responsibility attempting her portrait, almost to the point of not doing it.

Yet, I wanted to give her this unexpected present, so I began by searching through all her available photographs. Choosing the right photo is crucial; it makes the working process so much easier. Finally I chose the photo where my grandma is not aware of being photographed, so she looks relaxed and natural.

Reference photos like this come with their own challenges; the lighting might not be that great, and there might be elements that are not needed and require editing (for instance, the hand or reading-glasses strap). I always choose a photo that might be challenging but still shows the person as real as possible, over any heavily staged photo. If I can feel the real presence of the person, then I can translate it onto paper.

The next step is finding the right composition and getting rid of any superfluous details that might take the focus away from the face. I use digital software for this step (any picture software should work), which allows me to upload a photo and experiment with it: zooming onto the head, erasing the background and any unnecessary elements.

This time I decided to stick to the natural colors of her skin and use blue as an accent color to draw attention to her eyes and then direct it toward the blue in the glasses and the barely touched background. I wanted to have a feeling of lightness and clear sky without literally depicting the sky and clouds.

While bending and gluing the papers, I went through my childhood memories of Grandma. It was an emotionally charged process that brought me to tears at times as I was overwhelmed by the memories: some of the paper strips in this portrait absorbed a few tears that ended up dripping on it.

After finishing the portrait, I took a break from the Old People series. I will come back to it, but there were other subjects I wanted to challenge myself with.

TIP: *It is possible to avoid digital work—use two corners as a viewfinder (opposite, above right) to decide how much space will be taken up by the head. Also you can lose the background and unnecessary detail with a dark marker so as not to get distracted by it. Having said this, a computer makes the whole process much easier and quicker!*

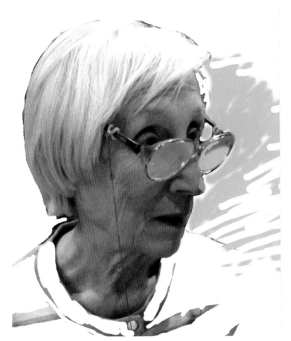

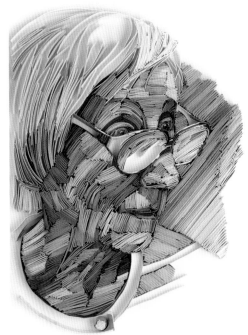

Portrait Experiments

Attempting to portray a young face with edge-glued paper strips was my next milestone in the process of breaking out of self-inflicted paperwork constraints. I was worried mostly about the textural aspect of paper strips, which can easily be seen as wrinkles or poor skin. To make things worse, I tried to incorporate a girl's face into a commercial project I was working on at the time. I used all-natural skin tone paper to make the texture as invisible as possible, but I wasn't satisfied with the end result. The texture was still there, but the whole face appeared overworked, as if I was trying too hard—which I did, but just not in the right way.

Looking back now, I understand that there was no point trying to force the smoothness unnatural for paper strips, but to embrace the texture instead. The alternative was to work on a much larger scale that would ensure that any texture becomes less noticeable when the portrait is seen or photographed from a distance.

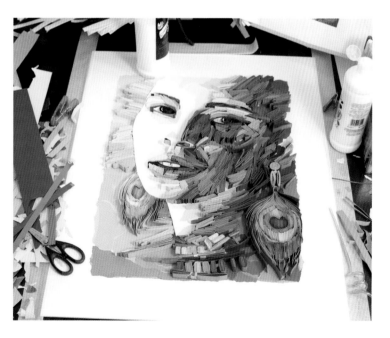

"Girl with Peacock Earrings"

So I approached a young face with a different mindset: no more hiding the texture, but make all marks visible, full of life and expressive energy. In essence, this is the same style of portrait as the "Jade," "Topaz," and "Amethyst" trio, but with a few differences that make this portrait look raw, pushing it into a more expressive realm of creativity.

The first difference is the introduction of flat-torn paper across the background. My early experiments of drawing the design with colored pencils before gluing the paper strips on top, or cutting flat shapes out of paper to add some solid color to the background, both share exactly the same need to block in the large areas of artwork.

Blocking in is a well-known method used in painting: it means underpainting large areas with simple blocks or patches of color in order to make a rough guide for the rest of the painting process. The later layers of paint will serve to refine the details and colors. With the use of paper instead of paints, the core idea is the same. Block in large background areas with pieces of torn paper first, then refine the details by gluing the 3-D paper strips on top. It is important to tear the paper instead of cutting it with scissors or a knife: torn paper provides an uneven, somewhat random, and thus organic-looking edge that blends in significantly better than any straight-cut, mechanical-looking edge.

Having this solid color layer of paper across the background frees you from the need to cover every inch of the portrait with tightly packed strips of paper. Now you can leave some gaps and blank spaces between the edge-glued strips and have the pieces of torn paper visible on the background, supporting the overall color palette. This method provides a more expressive, less refined look for the paper portrait that feels spontaneous and almost created in the moment, even though it still might take a couple of weeks to make.

TIP: Blocking in. For a structured geometric/mosaic look for the background, cut the paper with scissors. To achieve an organic painting background, tear pieces of paper by hand. Paper can be torn either completely randomly or roughly following the same direction: for instance, you can imitate an impressionist-style by tearing small, long strips of paper and make them follow the same direction. Heavy paper or card works best for either option.

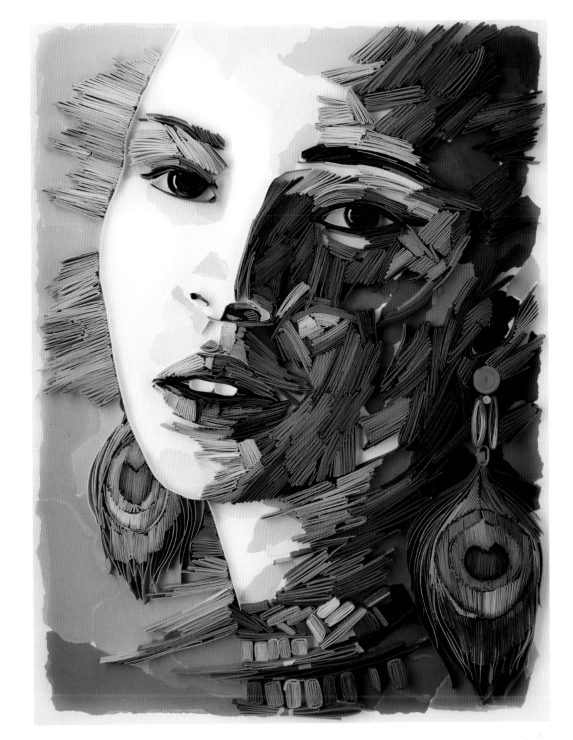

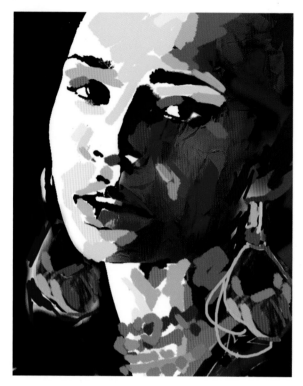

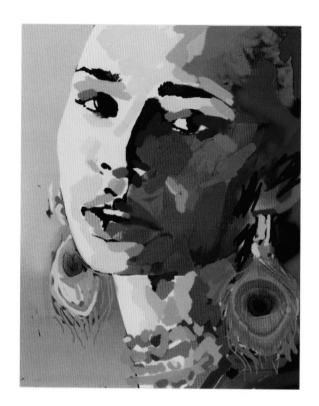

The idea for this particular portrait came from looking through high-contrast photographs, which basically divide the face into just two opposite values of dark and light. The contrast is so dramatic that hardly any details can be seen within the masses. I decided that such contrast allows me to leave the light areas simply blank (to help convey the feeling of smooth, young skin), and to fill the dark areas with all sorts of amazing detail and bold colors, which are crucial for making the face come to life.

The first digital sketch I made had very high contrast between dark and light, not only within the face but between the face outline and the background on the left side of the artwork. Knowing I was going to use mainly flat-torn paper on the background, I was concerned that it might dominate any intricate edge-glued paper details inside the face and accordingly draw too much attention. For that reason, I digitally amended the sketch, making the background much lighter and softer. When I make amendments to a sketch, I always save

both versions, then view and compare them next to each other to see which option seems to work better.

I also tend to leave the final decision for the next day, when I am able to look and assess the sketches with fresh eyes. I find it really interesting how well this little tip works: leaving the sketch for a while and then coming back to it always helps me see the overall design much clearer and fix any issues that were overlooked after ages spent concentrating on sketching. The same applies to working with actual paper art—I don't consider an artwork finished until I get a chance to look at it the next day and confirm to myself either that it is finally completed or needing further adjustments.

I came up with the title quite early, when during the sketching stage I noticed that the turn of the head, with the mouth slightly opened, and her overall look reminded me of Johannes Vermeer's masterpiece, *The Girl with the Pearl Earring*. This thought inspired me to add the earrings and create my own paper twist on that great piece of art.

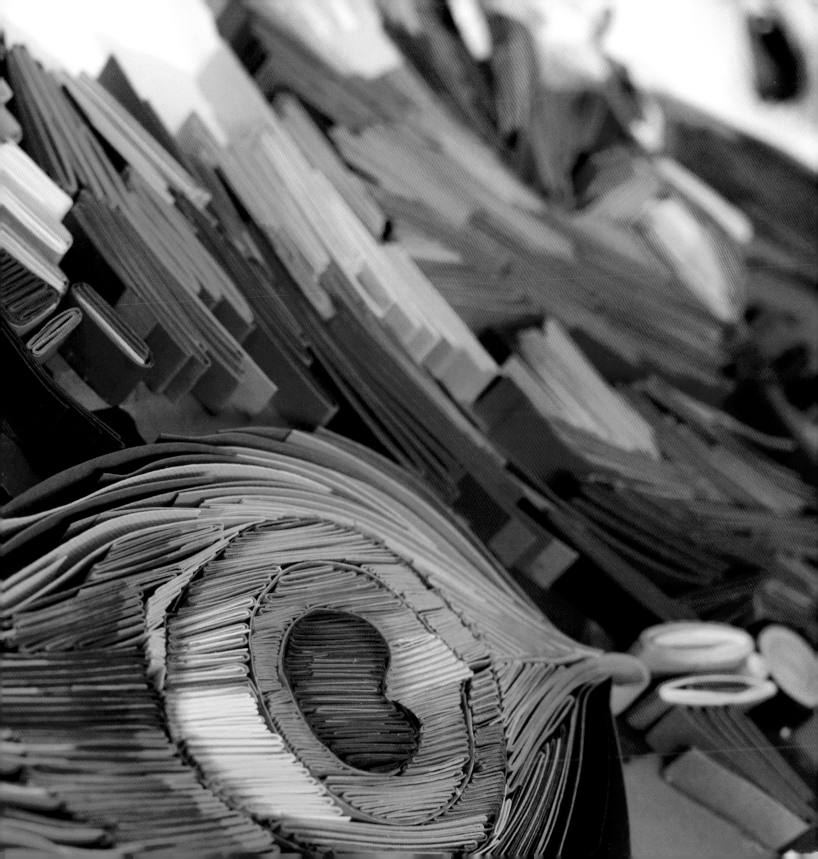

Portrait of "Natasha Hastings"

This is a commissioned portrait of Natasha Hastings. Upon starting I applied the working methods I described previously. Quite often, a chosen reference photo is all that's needed to select a color palette, so I chose Natasha's natural skin tone as a basis for the primary color group—these warm tones are dominant in her face.

In order to create an interesting color story, I brought in a contrasting blue inspired by the color of the ribbon from the photograph (any item of clothes in a photo can become a color inspiration this way). This was introduced into some areas of the face and also the background, varying the color intensity on the basis of the importance of that area. For instance, the background blue is very subtle—I used the lightest blue paper I could find in my collection. All the deep shadows are also made with very dark blue instead of just black. There are hints of other colors as well used in tiny amounts, such as pink and orange—these minor additions enhance the palette but are kept under control by the dominant color groups, so the whole portrait is balanced.

I began the portrait by tackling several areas at the same time: the key feature outlines—nose line, eye and eyebrow, an ear. Then I blocked in the background for the hair, using pieces of torn paper in the similar color tones that I'd chosen for the face. Even though the braided-hair details are supposed to go on top, the darker background can still be visible in some places: the dark color underneath the white braids makes the hair mass look more real than just white on white.

The braids are made with thick, high-quality cotton card. I cut a large sheet into thin strips around $\frac{1}{16}$ inch each (2–3 mm) and made them into a simple three-strand plait, gluing the ends together to keep the strips in place.

Having a small number of braids in place at the early stage helped me visualize how the finished thing was likely to look. This let me concentrate on filling the face area with tightly packed strips, making sure all the time that I maintained enough contrast between the lightest areas toward the contours of the face and dark details around the ear.

Once the face was more or less ready, I did some more blocking in with torn paper, covering the background around the face and also around the neck area. Since the neck is not as important as the face, I didn't use much 3-D edge-glued paper detail in there but allowed flat-torn paper to be seen through the gaps.

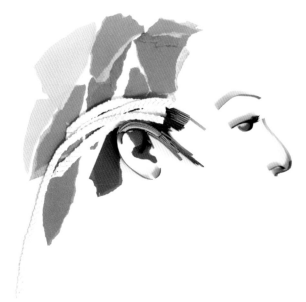

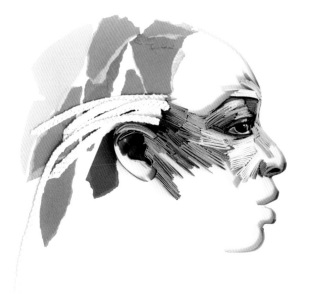

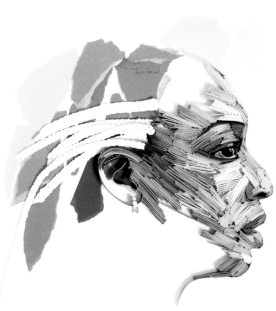

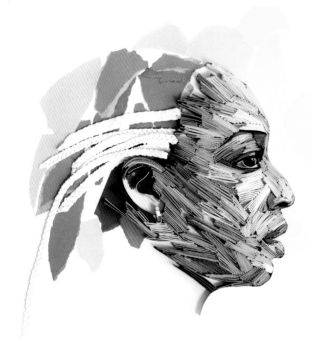

The final touch was replicating the ribbon in paper and toning down the top parts of the white braids in order to blend them in with the face for a more natural look. For this I used a tiny bit of diluted watercolor paint.

"Free Spirit"

I further explored the paper-braiding technique in "Free Spirit" by playing with the different thicknesses of strands, the number of strands used for one braid, how loosely or tightly the strands interlace, and so on. I made a large pile of various braids, using the same flexible, high-quality cotton paper, which doesn't tear easily when used for braiding.

The braids became my starting point for this portrait. Eager to go ahead and use them, I put a very quick sketch together of a girl's profile with a very rough outline for the hair—knowing that I won't be able to plan ahead how exactly the hair volume will look in paper until I start the actual making process.

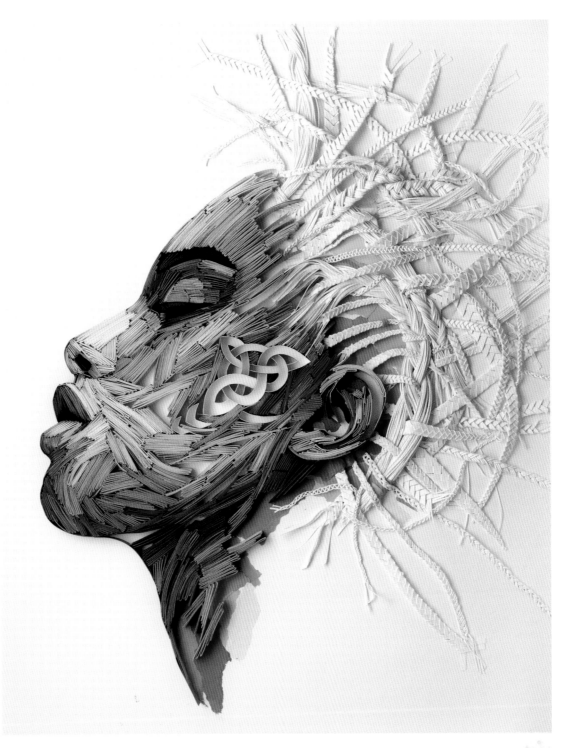

Unexpectedly, "Free Spirit" turned out to be a little bit more special and meaningful to me than many of my other projects; here's what I wrote in my art journal after completing it:

"I like 'Free Spirit' paper artwork that I have recently finished . . . it speaks to <something?> in me; some part that I do not reveal often, even to myself. . . . It's like a tiny dormant fire living somewhere very deep, but it is there and has a potential to come to the surface and overpower all the fears."

I don't feel the need to analyze this artwork too much by trying to understand how and why it turned out the way it did, despite it being inspired by such a mundane element as a paper braid. The whole creative process seemed too easy and natural to begin breaking it down into specific steps and creative decisions. I made most of them on the go. Even the Celtic knot–inspired element came into the picture because I felt it needed to be there as a focal point and connecting element between the braids and the face. For me personally, this work is the closest expression of inner freedom that I ever managed to achieve through my art, at least so far.

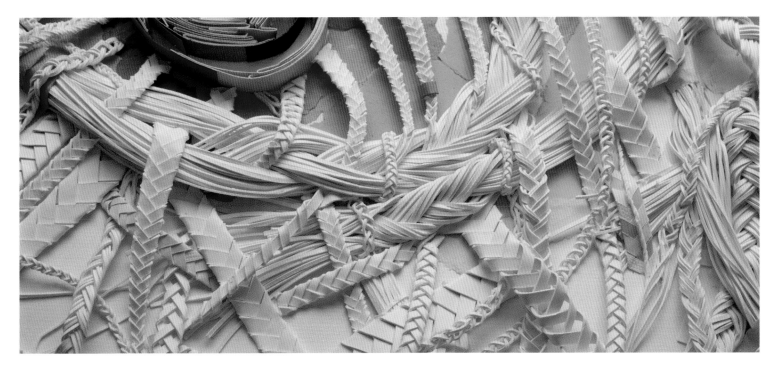

"Spirits"

I always like to do a completely different type of artwork after each project, even a successful one. It can be different in terms of the way I approach the same subject matter, or after weeks of working on a portrait, I charge my creative batteries by making a quick flower or a typographic design.

spirits

"Spirits" is another portrait that's intended to convey the connection with another unseen dimension. This time there is an order and structure to the design elements; the story is pretty much on the surface but is still open to individual interpretation. Comments I've heard about this piece vary significantly; everyone seems to have different readings of what kind of emotions lie behind the decorative patterns.

My idea for this artwork is rooted in the "Gypsy" portrait, particularly using patterns to form the key features as an integral part of the portrait. I started with this very quick sketch, again, planning to decide on the exact details, colors, and shapes on the go. But this time I wanted to think about the features as isolated geometric forms instead of following them with 3-D brushstrokes as when I "paint" with paper.

The main challenge for such a decorative approach is to get the big, fundamental, decorations just right, so as to keep a likeness and not end up with an indistinguishable mess of patterns in the shape of a head. It is similar to how we recognize someone from a distance before being able to actually distinguish the features in detail. If the large masses—such as eye socket areas, cheekbones, nose, chin—are correct in shape and overall tone in relation to other areas, then pretty much any elements and patterns can be incorporated within those masses!

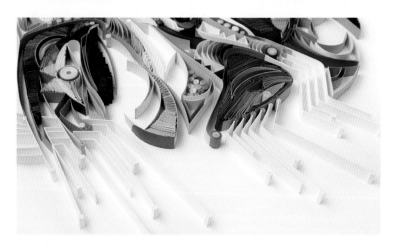

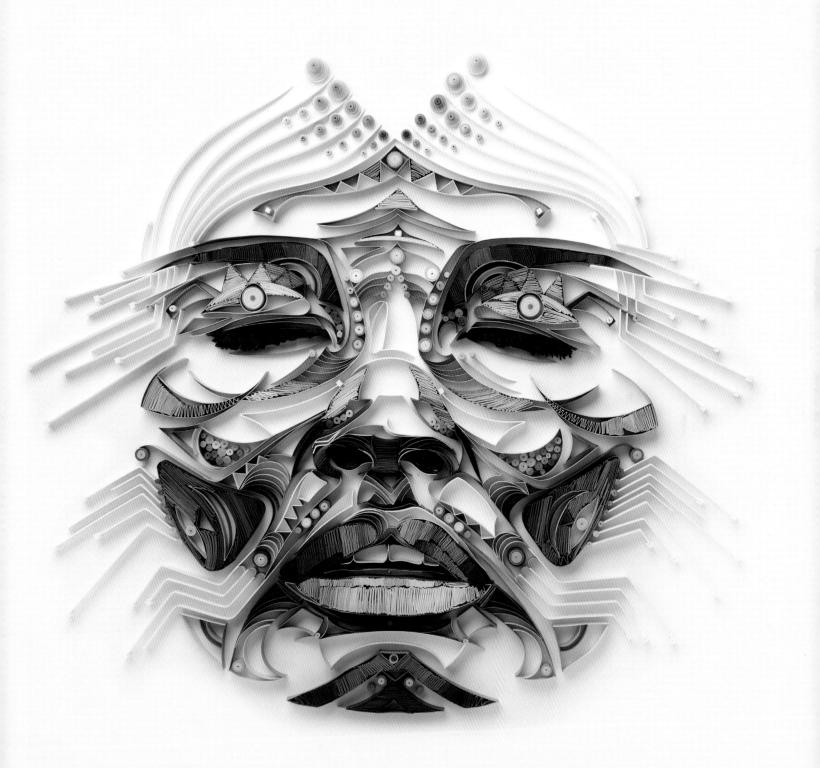

"Nature Warrior" is another piece about patterns, but in this case patterns inspired by nature and the amazing creatures living on land and underwater—and the tempting idea of a human being at one with nature.

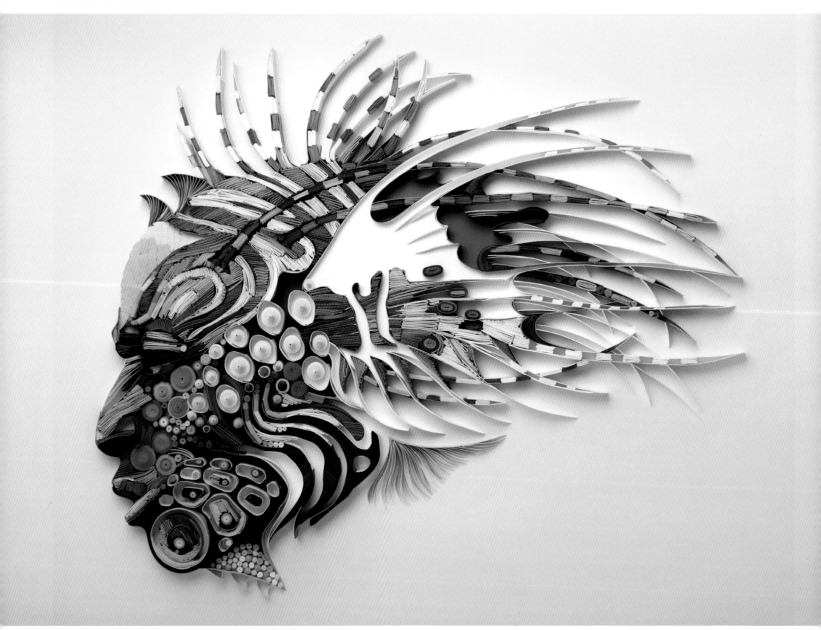

"Nature Warrior"

This is a tribal, aboriginal warrior—a visual, composite character, inspired by the idea of the connectedness of every living thing to every other living thing; he is definitely a force of nature.

By trying to come up with a unique pattern or a harmonious combination of patterns—even simple borrowing of existing patterns already found in nature—one can't help but realize the infinite depth of differences that exists in the natural world. Nature creates an endless multiplicity of living forms. So I humbly did my best to imagine and create this character, and I thoroughly enjoyed the process of uniting different inspirations into one cohesive picture.

With paper art the question of longevity is always present, and it has crossed my mind many times. However, there is no definite answer that I am able to offer at this point. I realize that the time will come when paper artworks will begin showing the signs of time by fading and yellowing; however, these processes do not happen that fast. The very first paper artworks I created ten years ago are still in the same condition as when I made them. Not enough time has passed since I began working with paper to know what exactly is going to happen; I can only make guesses based on the general qualities of paper as a medium.

Having said all this, there are certain steps I do take, depending on the project, to ensure that the paper art is preserved as well as possible.

- Storage: Most of the artworks that I still have are stored and laid flat in boxes to avoid any possible exposure to light.
- Framing: Glass box frames are the best way to ensure paper art longevity. This is a frame with a space between the art and the glass. The glass should be UV protected and, ideally, nonreflective.
- UV-protective spray: I have coated some of my artworks with a thin layer of UV-protective spray.

Again, only time will tell if spraying makes a difference; all I can say is that I haven't noticed any just yet. However, there is a disadvantage: not every artwork can be coated, because spray can show up on flat paper areas. Additionally, achieving an even coating can be a challenge, and it could ruin the artwork.

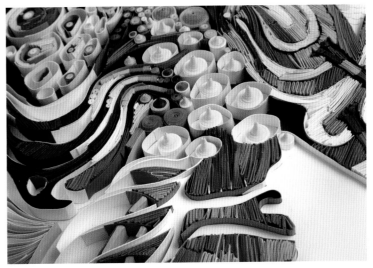

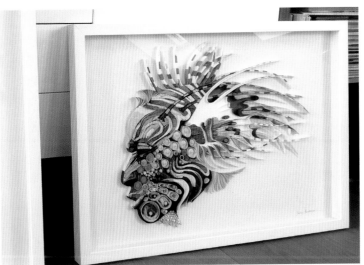

"Tough"

While "Nature Warrior" draws his power from all things natural, the young man depicted in "Tough" is a man of the modern industrial world. He is definitely very human, quite vulnerable in fact, but the man-made environment has significantly affected him in many different ways. Everything about him and his life is fragmented. He struggles yet somehow manages to keep it together—that's why I called this portrait "Tough." This character has to toughen up and push through challenges—both real and self-inflicted—until he realizes his lost connection to his true self, his true essence, and finds a way to become whole again.

The sketch I made for this work is quite precise, and I followed it really accurately with paper. There are little notes and a photo references in the corner of the sketch—this actually works as a mood board for me. I not only follow the sketch but also use photos in my collection as an inspiration for a color palette or texture to provide character to the portrait.

Technically there is nothing difficult about putting this artwork together. I created the industrial-looking plates by cutting the desired shape out of a piece of mount board around ¼ inch thick (about 1.4 mm). I covered this with small pieces of torn paper, then punched the holes and colored the edge with markers. I raised one side of each plate with a bit of a foam board in order to ensure that the edge of the plate is visible, and so the viewer can see that there is some thickness to it. I also added some texture to selected areas by using pieces of perforated silvery card on the background.

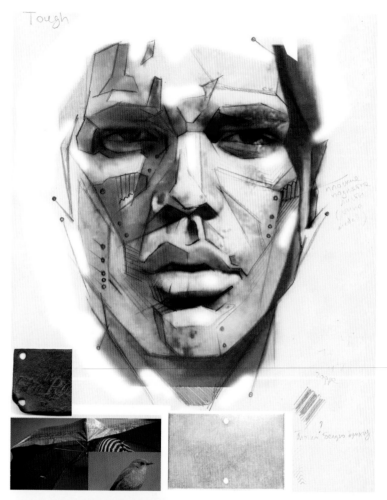

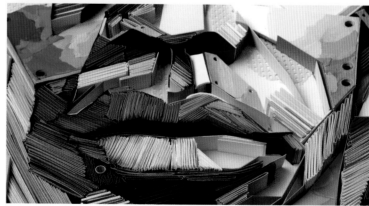

TIP: Unusual kinds of creative paper and card are readily available in arts and crafts stores. This includes all sorts of metallic, highly textured, or embossed paper, and paper with various inclusions and so on—new, exciting kinds are released all the time. Such unusual paper works well as accent texture (especially when used flat), so it is always worth getting a sample in case it inspires an idea. Some of these papers might stay in my drawers for years, until just the right project comes along, but they can make such projects even more special.

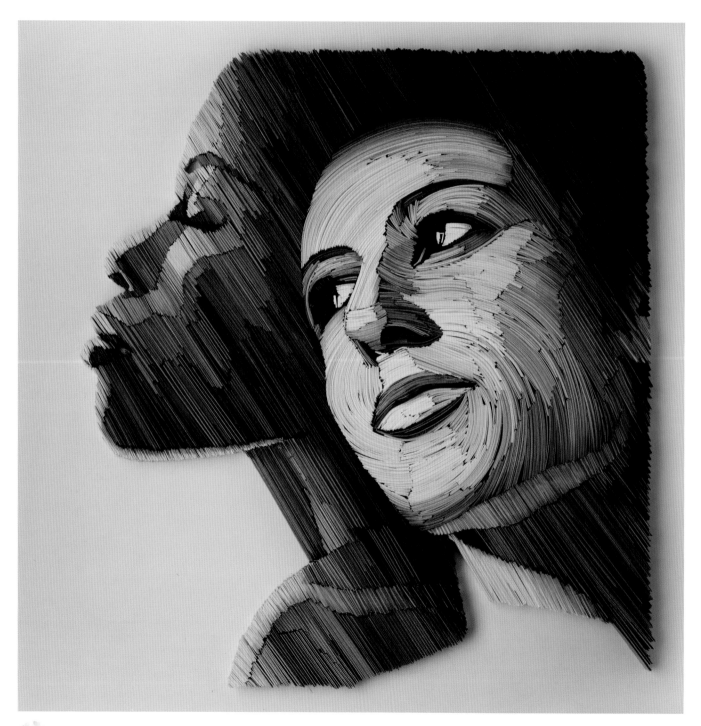

"Embrace"

I am always drawn to color, and I believe working with colored edge-glued paper strips pays out twofold, thanks to the beautiful reflections and the color shadows produced by 3-D strips. Also, color blending effects happen in tightly bent packs of strips when I use my "painting with paper" method—color is attractive in a really magical way.

Having said that, there are occasional times when I go against my own likes and preferences, and I'm not talking about commissioned work here. Sometimes I need to take a step in a different direction either to reaffirm an opinion or potentially discover something new. "Embrace" is that kind of project, which doesn't necessarily mean that it is worse or less thought through than my other work. It is just a little different.

At the core of this artwork are the direction and movement of the paper strips: the movement starts from the woman's profile on the left and circles the head of the other woman. The paper strips then gradually become more curvaceous, culminating in a full circle around her mouth area.

The profile face is made with parallel paper strokes only, but there is a gradation in tone that helps define the features. So we recognize the details, but it is clear that another dimension is missing—this is the variation of strokes around the form they are supposed to describe. To simplify, a 3-D shape will always look more real (more 3-D) when it is shaded with strokes that follow and describe its form.

This is my visual interpretation of embracing, which is the disguised idea of this piece. This artwork is also an unintentional demonstration of the principle I tried to explain earlier; namely, that strokes and marks should follow the facial features rather than go against them, or in a random direction.

A human face is much more complicated than a sphere, but the same principle still applies. The face of the woman on the right is made with paper strokes that consciously follow her features, which helps achieve more depth. This is as compared to the much flatter look of the woman seen in profile.

Case Study—Three Portraits

The following project is a good opportunity to walk you through my process of creating a portrait from start to finish. At the core was a short documentary movie made to educate women about a test created by Agendia. This helps determine the right treatment for breast cancer patients. Their aim is to ensure that women are treated individually, on the basis of the most personalized and detailed information about their tumors and prognosis.

The documentary has all the people involved (including researchers, surgeons, breast cancer survivors, and their loved ones) sharing their stories and writing pledges on paper, which were eventually incorporated into the paper portraits of three of the breast cancer survivors.

Since paper portraits take time to make, I worked on them off camera for the majority of time but documented the process with a time-lapse camera setup. The women knew that their portraits were being made, but had no idea who the artist was or what medium was being used. I was provided with the background story of each survivor and their favorite color, which I decided to use as a starting point for choosing the color palette for each portrait. I also asked for a selection of their portrait photos, taken with the following guidance in mind:

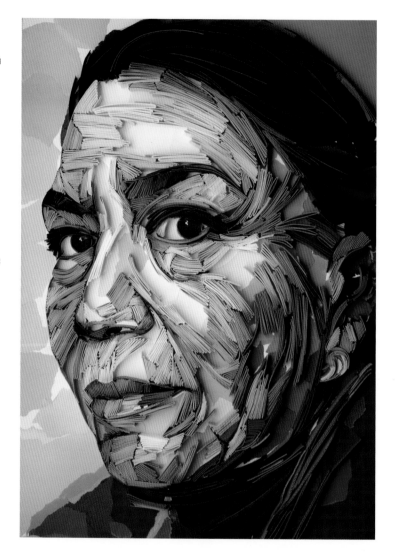

- Dramatic side lighting (preferably natural) with clear definition between the light and dark areas of the face. I can increase the contrast later, but it always helps to have a photo that doesn't require too much adjustment, especially when I haven't met the subjects.
- I asked for a variety of head positions and different photo variations, with eyes looking directly into the camera and then not looking at the camera.
- No big smiles or lipstick (more about this later).

I had around eight days to spend on each portrait before the main filming event, when all the portraits would be revealed.

TIP: There are different ways of transferring a design onto the surface; for instance, using a projector or grid method (although the latter is great for simple objects, it can be particularly challenging for portraits).

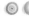

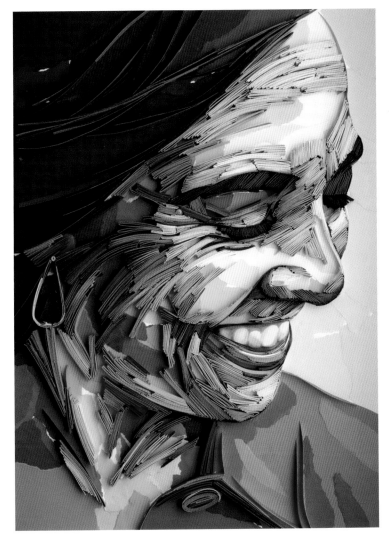

"Carmen"
Favorite color: purple

Since the entire project involved three portraits of three different people, I had to make sure I didn't just choose the best photo reference from each of them. It was important to provide enough variety between the three when they are seen next to each other.

For "Carmen," I chose quite a neutral photo, a three-quarter view with her eyes looking straight into the camera. The lighting is not very dramatic, but there is still enough contrast to work with. I think the photo was taken before my "no lipstick" request. In an ideal situation it is best to avoid lipstick, because a natural mouth is a soft form, especially the bottom lip, which is usually defined by the shadow underneath it rather than by any clearly visible contour. By applying lipstick, we draw a contour and thus define the mouth shape with a possibly unnatural outline. Of course, every face is different and should be treated individually, and this is definitely not a rule, just something to consider during the working process.

When making the sketch for Carmen's portrait, I zoomed in slightly on the reference photo and also lowered the line of her coat on the left shoulder in order to focus more on her face and chin. Making sure the shoulder line is not too high will help "ground" the portrait and give it a slightly more formal look. This is not always needed, but again, something to pay attention to when sketching.

I used various tones of purple as the key color group scattered throughout the face and also across the background, in order to visually emphasize its significance. Carmen was born in Mexico, so it felt right to introduce plenty of other colors to reflect the vibrant visual culture she comes from.

When I begin a paper portrait, I like to have two references in front of me:

- For the color palette and preliminary look of the future paper art, I refer to the sketch that I created by digitally manipulating the chosen photo (with color marks applied on top of the photo). A small printed picture of the sketch is enough to use as a guide.
- The second reference is a photo printed out to the exact size of the intended artwork. (For larger artworks I print out the photo in several parts and attach them together with adhesive tape.) I use this print to trace the facial features onto the mount board, using either an embossing tool or transfer paper. During the next step of the creation process I constantly refer to this real-size photo to make sure the area I'm making with paper is translated as accurately as possible, regardless of the new vibrant colors that I choose to bring into it.

With "Carmen" I started by outlining the darkest feature lines and blocking in the background color almost simultaneously. Jumping from gluing down flat-torn paper pieces to edge-gluing thick strips of dark card around the eyes and jawline, then moving on to colored details of the cheek area.

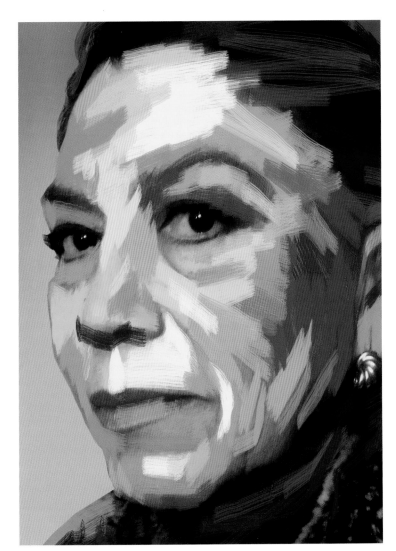
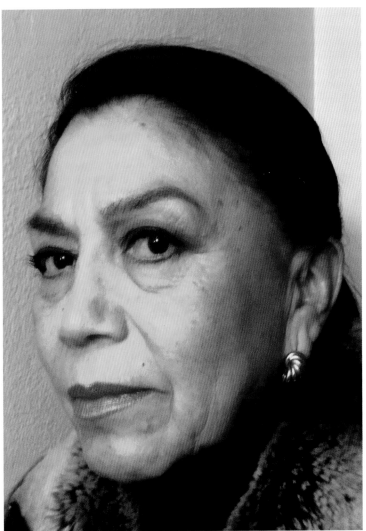

151

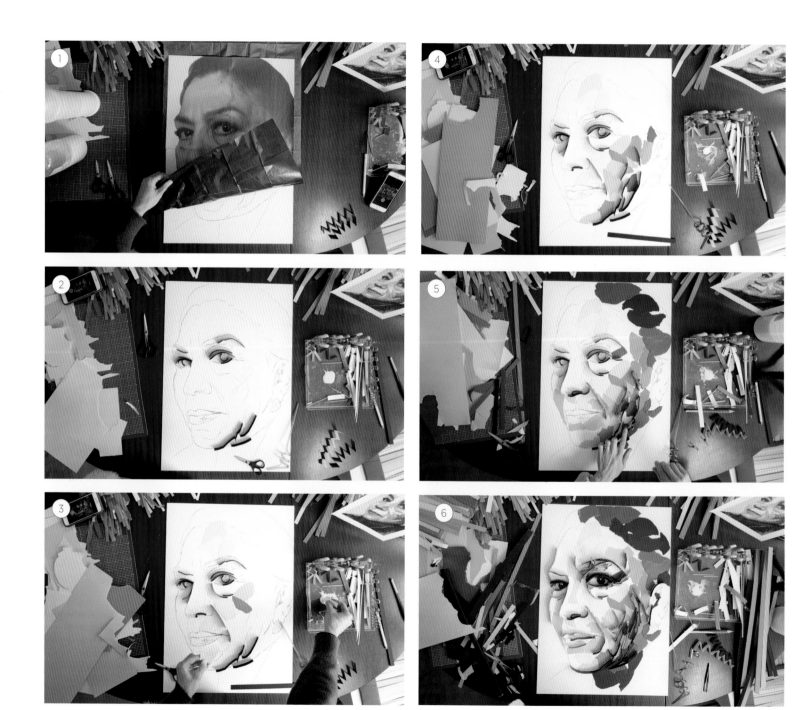

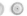

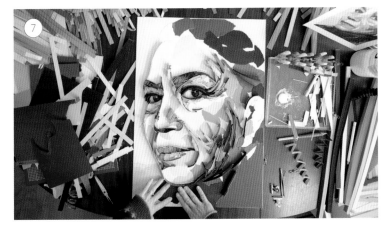

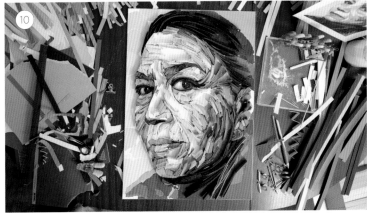

When I start to work, I like to have my papers and tools in order, but during the creative process my working area gradually gets conquered by countless paper pieces and scraps. Out of this mess the portrait eventually appears. At the end of every project I go through the messy piles, sorting scraps by color and size, and put everything back in order. I throw away only the tiniest pieces that are impossible to use in future projects.

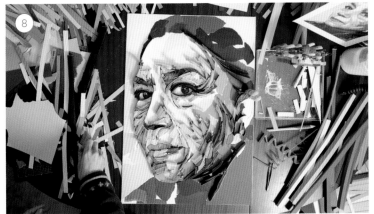

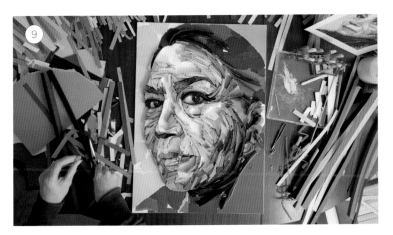

"Angie"
Favorite color: red

I received a huge variety of photos of Angie taken in different settings and light. From one point of view, having that many makes it more difficult to choose one; however, it also helps to get a better understanding of the person in the photo because you get to see more of her.

On the basis of all the photos, I got a feeling that smiling is a very natural thing for Angie. There were photos when she tried not to smile—as per my guidance—but those shots didn't seem natural at all. Thus, once again, as with the lipstick, I had to go against my own stated preferences and take on the challenge of making a smile in paper.

Showing a smile is a challenge for a portrait in any medium; many portrait artists never paint their subjects smiling, especially if the smile is wide enough to reveal teeth. Smiling involves muscle contractions that can produce uncomfortable tension in the portrait. Even more importantly, there is a contradiction related to time. A photo is taken in a fraction of a second, and smiling for a moment of time is normal: that's why photography is the best way to capture a smiling face. A painting or portrait made with paper requires much more time to make, so there's an underlying feeling of the smile lasting too long, which is unnatural.

However, while a smile is a challenge, it is not a taboo. When creating a portrait from a photo, it is crucial to look for that special moment—that split second of genuine emotion coming through, when you can feel the real person from a photo. If this energy can be felt in a photo, there is at least a chance to translate it into a portrait. In the photo I've chosen, Angie has a wide smile and wears lipstick, and although we don't see her eyes, there is so much life and warmth in this picture that I couldn't choose any another option.

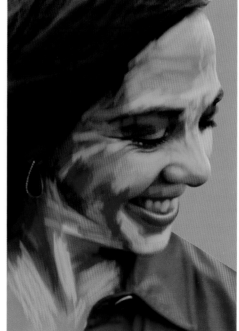

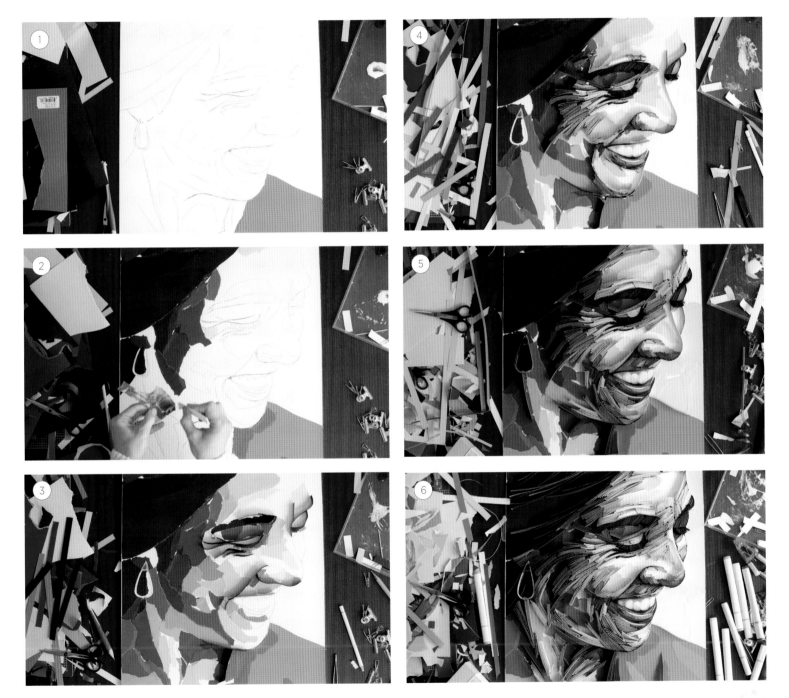

This time I started with blocking in only and didn't add any edge-glued strips until at least three-quarters of the total portrait was covered in pieces of flat-torn paper.

The two key areas I most concentrated on were creases around the eyes and mouth area. The first is important because of the need to convey the right emotion: Angie is smiling, and what we can't see in her eyes we can read in the laughter lines of her wrinkles around her eyes.

Teeth are tricky to make with edge-glued paper because paper strips introduce an unnatural looking texture that looks weird. Accordingly, every time teeth are shown they deserve an individual approach. For this artwork I decided to draw the teeth with brush markers, and I also raised them slightly from the background level to highlight the fact that this area is a part of the face rather than the background.

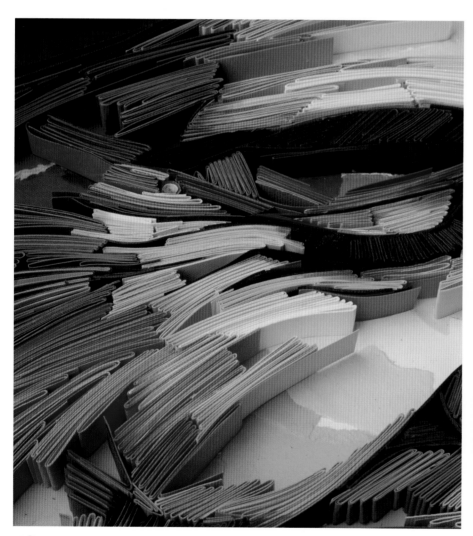

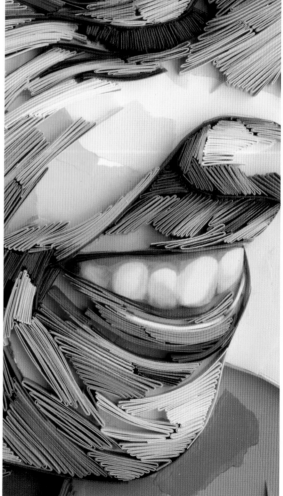

"Aleseia"
Favorite color: red

To make Aleseia's portrait different than the others, I chose a face view very close to a full profile and decided not to zoom in on the face too much. Each of the portraits was supposed to differ via the color scheme, in order to highlight the concept of uniqueness and individuality of each of the women, but two of the survivors naming red as their favorite color added a tricky hurdle. Instead of going back to the women and asking one of them to change their color, I decided to focus on different hues of red. I picked cherry red for "Angie," inspired by the color of her blouse in the photo, which left "Aleseia" with a warm, fiery red that seemed to be a good fit for her.

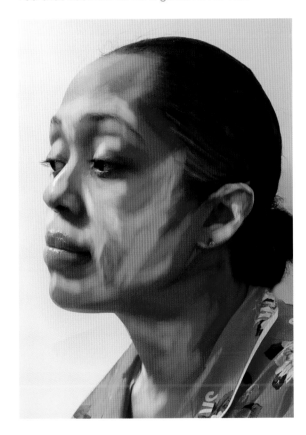

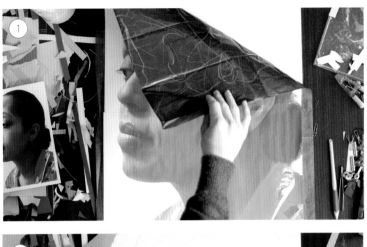

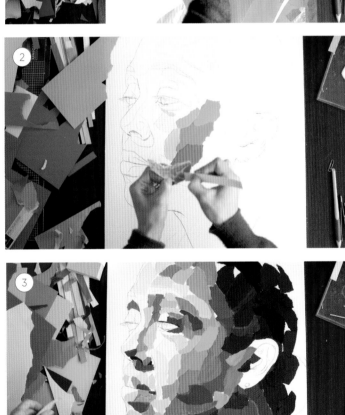

By the time I got to Aleseia's portrait, I confirmed to myself that blocking in colors on the background before moving on to the edge-glued details speeds up the working process quite a bit. So, as a first step, I covered the whole surface with pieces of paper (except for the lightest areas, which I intended to be left blank).

Gluing pieces of torn paper onto the background surface with PVA glue often causes it to curve out of shape, especially when using a mount board as I do. There are several ways to deal with this issue:

- Use a firmer background, such as hard engineered wood board or similar (personally I do not use them, but it is a matter of choice and specific project requirements).
- Glue some paper to the reverse side of the background surface. No need to spend much time on it: for instance, use a single large sheet of old/recycled paper. This creates a surface tension on the back side as well and helps counterbalance the tension on the main side.
- Use heavy objects to press down the edges that curve up—this is the method I use most of the time while working, and then leave for a few days after the work is completed. This method won't make the surface completely flat, but flat enough for easy handling. Once a paper artwork is framed, all surface curvature and bending goes away thanks to the stiff backing inside the frame.
- Work on an artwork inside a no-glass frame right from the start.

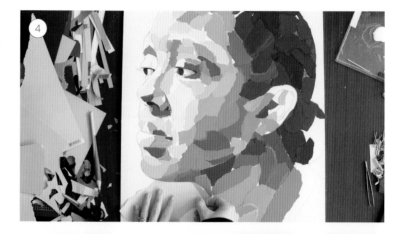

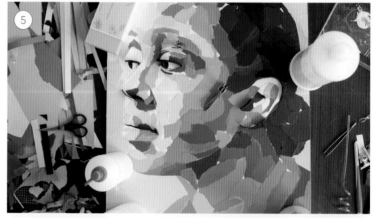

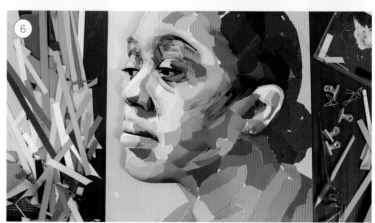

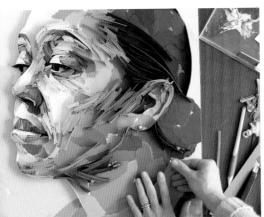

During the day of final filming and revealing the portraits, I had a chance to see two of the women before they saw their images. I couldn't help but stare at their faces and mentally compare the portraits to the real people; there was a feeling of them being very familiar—as if I knew them well already.

After meeting the women in person, I felt that I had managed to capture their likeness and individuality in my paper portraits. The audience and the women's reactions to the revealed portraits reassured me in that feeling. It was an emotional experience inserting the handwritten pledges and personal declarations about what people believe and hope for in relation to ways of improving breast cancer patients' quality of life and survival. I made sure that many of the words are visible in the portraits when you look at them from a slight angle and notice that there is writing on the sides of some of the paper strips.

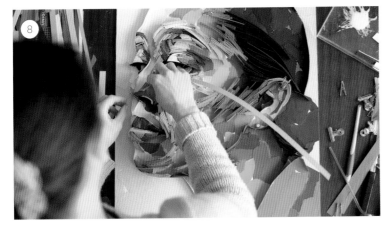

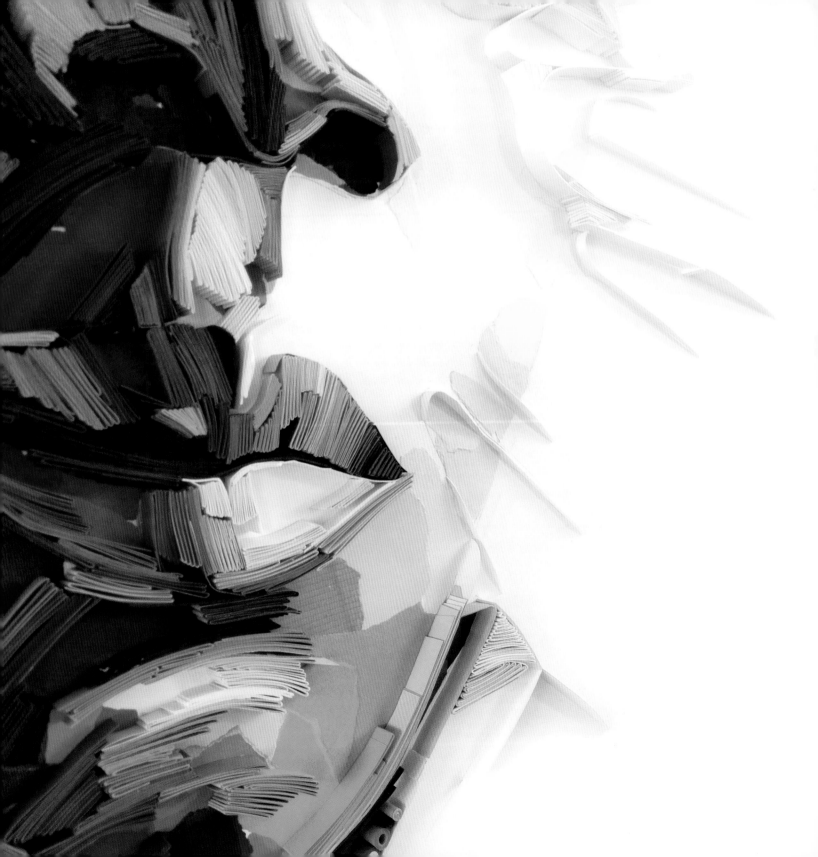

Larger
Pieces

Larger Pieces

I can't say how many times I have been faced with the curious fact that after seeing my paper artworks online, many people assumed that they are really large scale—at least several times larger than their actual size. I suppose that is because of the high level of intricacy of this technique and also the fact that we are so used to large-scale art. Large-scale works immediately attract attention; they have a tremendous effect on human perception, arguably more powerful than any other— no wonder why so many artists take advantage of this size.

I'm no exception and often find myself drawn to large artworks, and I can't help but wonder how different experiencing my 3-D paper art would be on a larger scale. Of course, it is possible to fill in a large space with hundreds of tightly rolled circles or coils; however, my personal interest lies in conveying a deeper emotional complexity into larger paper artworks, ensuring that the larger scale does not become a goal in itself. That's why my process of going bigger is so gradual and stretches over so many years.

My very first paper designs all were A3 size (11.8 x 16.5 inches; 30 x 42 cm) or slightly bigger. I clearly remember being intimidated by A2 (16.5 x 23.5 inches; 42 x 60 cm) and strongly believed that A1 (23.5 x 31.5 inches; 60 x 80 cm) was as big as it would ever get. It's not that long ago that I first approached a paper artwork larger than 39 inches (1 m), and at this point I'm still experimenting and adjusting to these formats, which, in reality, are not that large when compared to an average painting seen in modern galleries, but definitely huge for quilling and edge-glued paper.

The main challenge comes from using edge-glued paper strips; the key word here is edge: the top edge of a strip is the main thing we get to see. It is extremely thin and looks increasingly thinner and less distinctive the larger the size of the artwork. I compare it to a thin line drawn with a pen—you need a lot more lines to fill a larger space, and there is no easy way around this direct correlation between the size and quantity of paper strips. You can take a wider brush if you are painting, or choose a pen with a broader nib to get thicker lines when drawing, but how to do a similar thing with paper strips? Yes, there is heavier paper and card, but the difference in edge thickness is still tiny. For instance, an edge of a regular paper strip that I use can be well under a sixteenth of an inch thick (0.5 mm), whereas the thickest card that is still possible to bend into a tight pack has an edge just around an eighth of an inch (1 mm) thick; such difference is minimal and doesn't help much for artworks that measure over 39 inches (1 m).

This is when such methods as blocking in with flat paper and the introduction of other paper craft techniques can become really handy, but not just that. On the basis of my experience, going larger requires a slightly different approach to the creative process; in general, I would describe this as not being afraid of blank spaces, rough edges, or understated details. Such artistic bravery might come easy to some artists, but I have to tell myself, "you have chosen to go large scale—make sure you are not intimidated by it!"

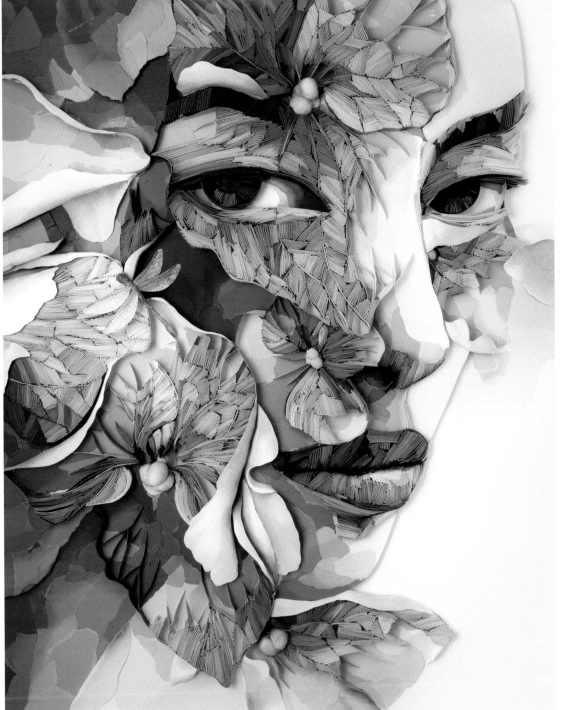

"Special Girl"

This is the first large-scale portrait I attempted. It measures around 31.5 x 39 inches (80 x 100 cm); not that big by any standard, but I still consider it a large piece in relation to my other paper portraits. I have had a close-up photograph of a hydrangea flower for several years in my inspiration library, but the photo was too perfect. I felt that it wasn't worth re-creating in paper because I wouldn't be able to make it any better than it was already. (By the way, that's the main reason I'm not interested in doing beautiful landscapes in paper.) But something clicked in my head when, after looking at the hydrangea photo for a while, I accidentally opened my sketchbook to a page filled with people's faces—and saw a girl's face there—and somewhere in the back of my mind I superimposed that perfect hydrangea over her.

Whenever I am unsure where to begin, I start with the part of the design that I'm most excited about. In this case I was really drawn to the second-largest flower in the bottom of the artwork, and specifically its prominent central area. In order to achieve the same 3-D effect, I took egg-shaped pulp balls (which I bought in an online craft store), cut each shape in half, and piled the halves on top of one another, then secured everything with PVA glue.

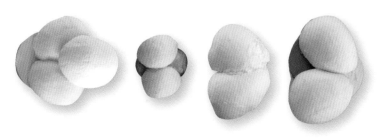

I glued down the dried centerpiece and began working around it, first blocking in the colors with torn paper and then following with edge-glued details on top. It may seem that flat paper on the background is a waste of paper and time, when the area in question gets completely covered with paper strips glued over the top; however, this is not exactly true. Flat paper helps quickly establish the color and tone relationships, which in the long run speeds up the working process and also allows you to leave gaps and blank areas between the edge-glued details without them looking unfinished. In fact, gaps play an important part in perceiving the depth of this 3-D art form: we can better appreciate the edge-glued details that are there when there is an empty space next to them, and we can see the sides of the papers as well as the top edges.

For the curled-up petal details, I used a thick, lightly textured card that I shaped and curled slightly around the edges. This large, smooth petal surface works great next to the busy texture of tightly packed strips of paper: the contrast brings

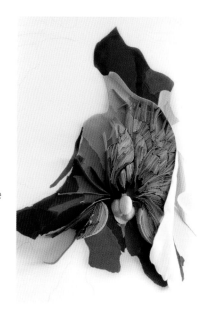

everything into life. In addition there is the contrast of light and dark. Toward the end of the creative process, I softened the contrast a little bit by lightly coloring the flat, curled petals with blendable brush markers.

These contrast adjustments are part of the final stage of the creative process, which I call "bringing it together." This is a crucial stage for finishing every artwork but becomes even more important for a large-scale piece. During the working process, you work on one small part of the artwork, then switch to another, then another one, and at some point come back to almost-finished areas—little by little a whole thing progresses. But it might not come together as a whole until you pause, view it from a distance, and begin targeting specific issues that seem out of place.

By stepping back a distance you become an observer, a watcher. Constantly stepping away

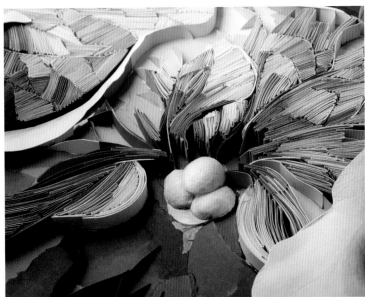

(as well as looking at the artwork while squinting) is a great way to see the artwork as a whole, and to notice and address the details that either attract attention for the wrong reasons or, to the contrary, need to be brought into focus.

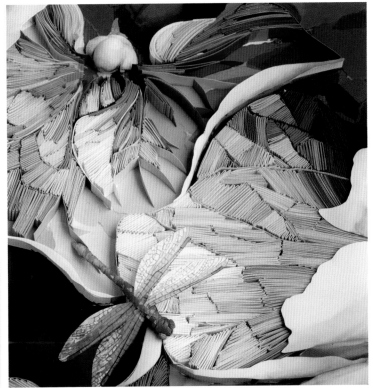

TIP: *Another way to distance yourself from the artwork and see it more clearly as a whole is to take a quick picture of it and view it on a screen.*

"Special Girl's Sister"

I have already mentioned that I never repeat my designs exactly. Even when I am asked to create a new artwork based on an existing one, I try to approach such a commission as an opportunity to bring about a new aspect of the same initial inspiration. It is obvious that "Special Girl's Sister" is closely based on the previous "Special Girl" portrait (hence the sibling reference in the title); however, it has a totally different feel to it. "Special Girl" is quirky, edgy, even ambiguous, whereas her "sister" seems a lot lighter, girly, and prettier in a mainstream sense.

The working process felt quite different as well. Starting the original "Special Girl" portrait, I couldn't anticipate the amount of time I would end up spending on looking at the artwork, trying to decide which element to tackle next. I kept moving my gaze from one part to another, while making mental notes at the same time—thinking about which color to introduce into a certain area, and whether to add more details or leave as is for the time being. The notes list kept growing every time I moved my eyes. I had to stop myself from creating the artwork in my head and actually get on with it. By the time I started the new Sister portrait, I had trained myself not to get lost in the process of gazing and planning the multiple steps ahead, but just to take one step at a time.

It is not that I discovered anything totally new for myself; I always believed that being caught up in a straightforward, repetitive, almost automatic action is not the way to achieve the elevated quality in paper art. It is crucial to pause and observe the evolving art piece as a whole entity, constantly adjusting to its current state.

Being used to working on smaller designs and then jumping into a large-scale portrait overwhelmed me initially: there were too many decisions to make that were based on the sheer amount of space that needed attention. It became apparent that on this scale it is important to find a better balance between the time spent on looking and assessing the artwork and on pushing ahead with the actual work. I learned that this balance shifts depending on the current stage of the creative process: early into the work, it pays to go faster (that's the advantage of the blocking-in method), then to gradually slow down and pause to assess the piece as a whole, make a note of one thing that needs to be done next, and then work on that right away. That's what I mean by one step at a time.

By the time you get to the final stage of the creative process, the balance between looking and doing will shift significantly. Bringing together a large artwork can be a long and slightly exhausting process that requires the greatest degree of concentration and focus. I find I spend 80 percent of the time looking at the almost finished art, and the remaining 20 percent dedicated to applying any adjustments. Then I step away again to see if these produce the desired effect, I observe the art further, and so on and so on. There is no doubt that this final stage takes a lot of effort, but it is an interesting and essential stage that transforms the fragmented artwork, makes sense out of it, and sharpens the focus.

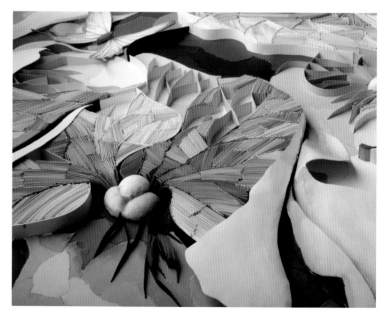

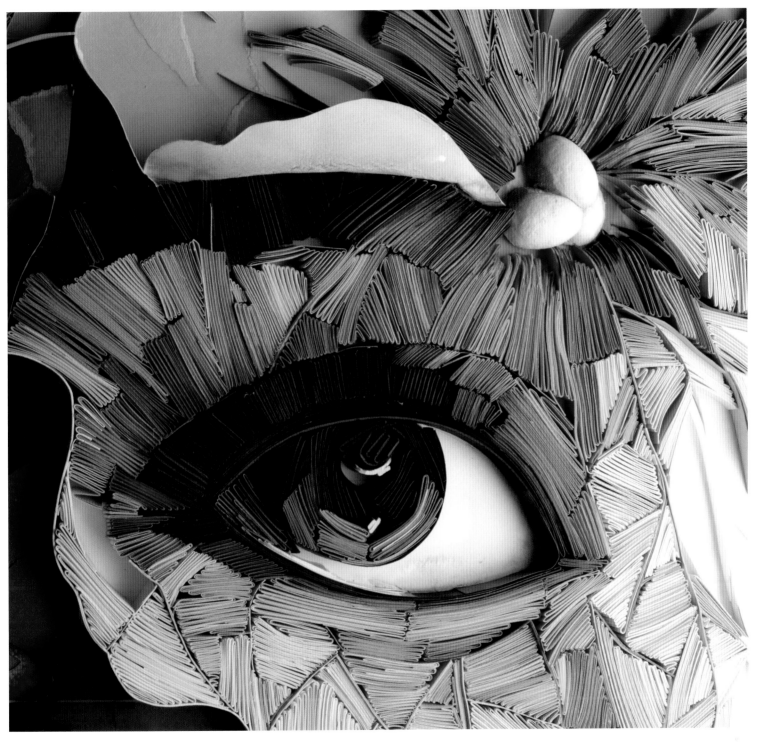

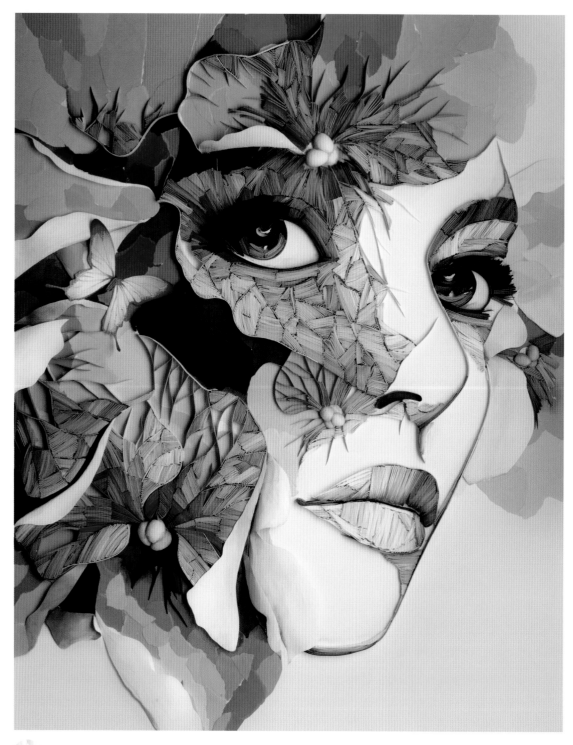

I consider the artwork completed when there is nothing that bothers my eye and thus requires an adjustment. I always double-check my decision that an artwork is officially finished by looking at it from a distance the next day, with fresh eyes.

"Vrubel Tribute"

It's not a typical project for me, but I really wanted to make a paper artwork inspired by the work and legacy of the 19th-century Russian symbolist painter Mikhail Vrubel. My fascination with his works comes from my art student time in Moscow; Vrubel's expressive style of painting and the decorative quality of his art were often used as an example and major source of inspiration for the students.

My tribute is an acknowledgment of my early interest in Vrubel's work and is based on several of his most famous masterpieces, drawing certain elements and inspirations from each and combining them into this unusual character. There are plenty of literal references, such as the turn of the girl's head, and the wings and gown—vaguely replicated from the *Swan Princess* painting; the peacock feathers and mountain range came from the *Demon Downcast*, and the crystal-like flowers and burning sunset are inspired by his *Demon Seated* painting ("Demon" has a connotation of a powerful spirit here, not an evil being).

For my crystal flower composition, I made a selection of various prism and pyramid-like shapes out of mount board (any thick heavy card works here), then glued them onto a background surface to be later covered with pieces of torn paper. This method is very similar to papier-mâché or decoupage techniques, where you achieve a 3-D effect by covering a shape with pieces of paper. For a crystal effect the key is to have enough contrast between the faces of a pyramid shape and make sure there is continuity in the light direction. This means choosing one side where the light is coming from and using light paper for the side of the pyramid that faces the imaginary light—in this work the light is coming from the top left corner.

The little peacock feathers are made with flat paper segments, the bottom edge of which I slightly tinted with blendable brush markers, then added a feather texture by making fine cuts with sharp scissors. The important thing here is to use at least two or three different tones of each color when cutting out the shapes, in order to achieve variety within the feather mass. I picked four different greens for the bottom segment, and three different beige papers for the middle, then mixed and matched them, creating individual feathers in diverse color combinations and sizes. Creating subtle diversity within a repetitive pattern is the way to achieve a harmonious, realistic look.

The larger wing feathers are made with tightly packed bent strips like I use in my painting-with-paper method, but with a couple of twists. I raised the white feather area by adding a layer of foam board underneath and covered the foam with flat paper. Then all the bent strips are glued on top of this raised pad. By raising the surface even by ¼ inch or so (0.5–1 cm) this way, you make that particular element higher than everything else around; it literally stands out more. I also applied the trimming method that I tested in "Feather Rose" and "Feather" designs: one end of the bent paper pack is rounded with scissors in order to smooth the sharp corner to help achieve a more realistic look.

I worked on the artwork with it lying flat on the table for as long as I could manage without assessing the overall progress. Then once I covered a big-enough area of the art and became unsure which area to tackle next, I propped the artwork on a reclining surface (table easel) so I could step away and see the whole picture and then proceed more consciously with the creative process.

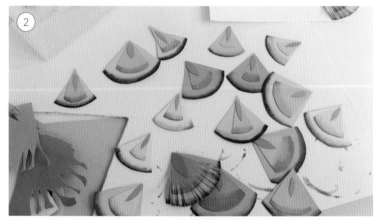

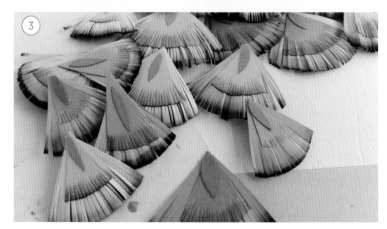

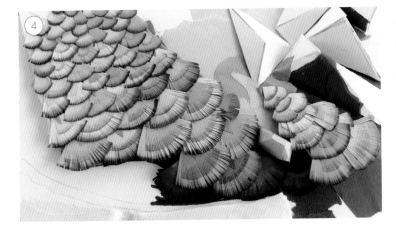

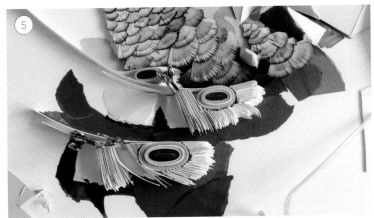

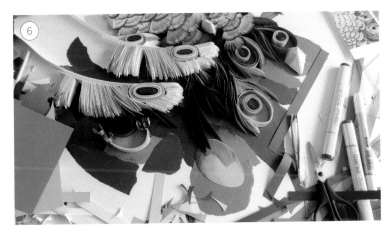

I started with the feathers because that part seemed really exciting to me; however, when there is a human face in the design, you can't leave it till the very last moment. I must admit I felt a little intimidated by the girl face and postponed starting the face for as long as I could, probably because of the challenge of conveying the desirable expression and emotional charge. However, once I made the eyes and mouth and figured out a skin tone that works in relation to the white in the gown and wings, and the dark backdrop, the process began to feel easier.

There are certain stages that I often have to go through when working on my art; the longer the working process, the more pronounced these stages can be. At first, I'm always excited about a new idea, can't wait to start the work, and feel energetic and inspired. This enthusiasm gradually wears out, and by the time I get to about a third of the way through, doubt and fatigue sometimes start to creep in. This can take the form of thoughts that the artwork I'm making is not worth the time and effort, or the working process feels like monotonous hard work and there is no joy in it.

I use two ways to overcome this problem: either I put the artwork aside and take a break until I feel excited about it again, or I just push through. Sometimes just an hour away walking does the trick. Or I simply concentrate on doing other tasks and chores for a while; sooner or later, when I come back and look at half-finished artwork with fresh eyes, the initial excitement comes back and I believe in it again.

Usually, though, I simply don't have enough time to allow myself a long break from a project, so I end up pushing through the difficult stage. I just try not to think and keep working one step at a time—it is not as difficult now as it was years ago, because right now I have enough experience to know that any tiredness and doubtful thoughts are temporary and should not be a reason to drop a project. I have learned that the enthusiasm and excitement come back in the final stages of the work. I get a second wind and become excited to put in the final effort and bring the artwork together.

There must be other ways to deal with the creative fatigue. Every artist has tricks to keep themselves going. What is important is to know that such a down stage is a normal part of the creative process, everyone goes through it at one point or another, and it is never all roses, even when you truly love what you do.

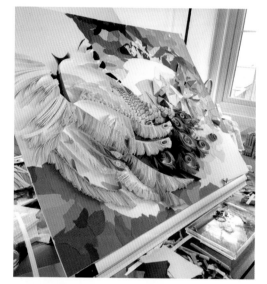
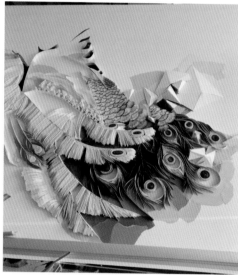
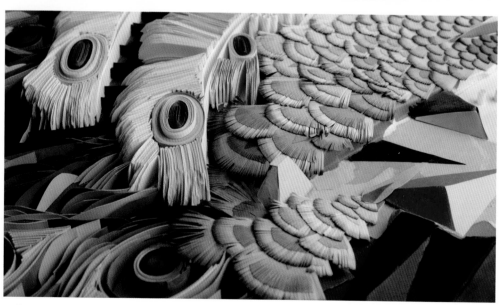
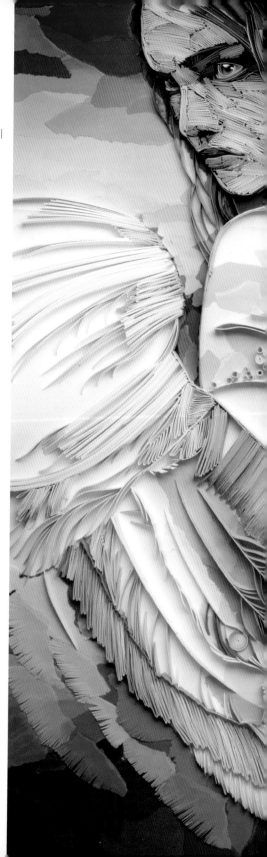

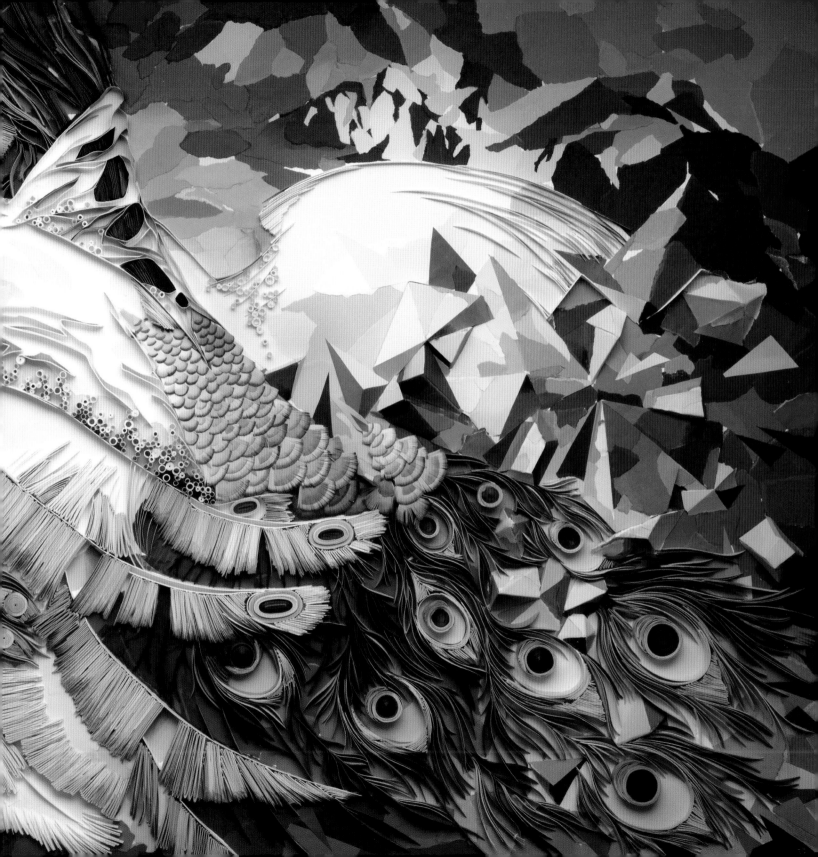

"Pull to the Light"

This is the largest paper portrait I have ever made; it measures 3 x 5 feet (1 x 1.5 m). I thought I would be intimidated by it, but surprisingly it felt quite comfortable. To begin with, I had to completely rearrange my working space and forget about working on a flat table; I simply couldn't reach the center of this huge mount board. Instead I inserted the mount board into a glassless frame for support and propped it up almost vertically. The challenge of working on a vertical surface is obvious: how to ensure that the edge-glued details do not slide down while the glue is still drying. My solution came from my past experience with smaller portraits: after blocking in the background colors, I attached a number of thick single strips to outline the key lines in the face. Yes, I had to spend some time holding each strip in position waiting for the glue to work, but as a result I established the starting points for other bent-paper packs to be attached to with clips.

Starting from those base strips, I began the work by moving from one area to another, building onto the already secured, tightly bent packs. There is an interesting continuity and organic growth in such a process, when you have to find a way to use a previous element for the next one to grow from.

While working on this piece I didn't experience any struggles and negative thoughts about the slow progress (surprisingly, it didn't feel slow at all), or worrying that the result is not worth the effort. I just followed my own advice to focus on one small action, one small detail at a time. I did step away to observe it from a distance, but I didn't allow myself to be intimidated by the amount of work and important design decisions lying ahead. I decided that I needed to trust myself to make the right decision when the moment came, instead of planning dozens of steps ahead and worrying about making a mistake.

Thanks to this project (and also writing this book), I came to a better understanding of my creative process. I always struggled with working on my art during the periods of unease, being stressed out by outside problems. I have always needed

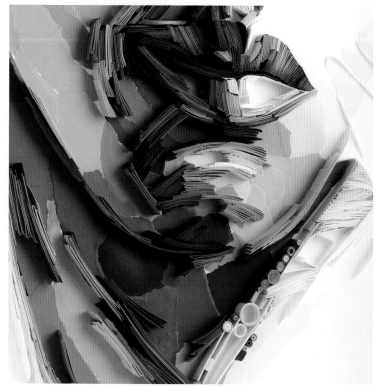

peace and calm to be able to work productively. Now I can keep working only when I put the problems and stresses aside; I realized that this means that my art can come only from a good place. Instead, I use the creative process as a way to stay present in the moment and get absorbed into the act of making something beautiful, the act that contains healing qualities in itself—there is joy, and it feels good to create.

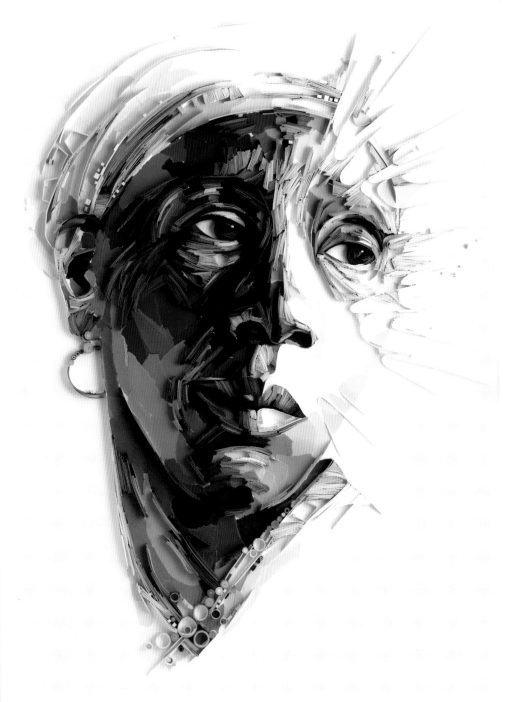

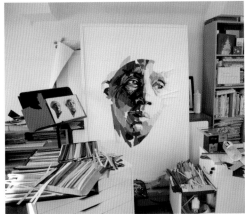

Final Words

Sometimes I'm asked what social, political, or environmental issues I strive to express through my art. My answer is "none"; I have never been driven purely by ideas and the urge to attract attention. I used to think that my work was not contemporary enough because it doesn't explore the problems of the modern world. However, I've changed my mind. There is nothing wrong with simply being inspired by the beauty of the natural world. Beauty is not meaningless! It has the ability to connect us to some deeper level of being that is impossible to explain with words. I think of beauty as a positive energy, positive emotions—something that is light and universally true.

Many people try to reconnect with their childhood—looking for ways to experience that novel sense of excitement and wonder. Small children are excited to see the world, but, sadly, most adults have seen too much to be excited that way about anything. Art has the ability to make a viewer experience familiar things through the eyes of an artist, to view things from a new perspective and see them differently. Being reminded about the beauty of the world around us is a powerful thing—that's what I'd like to share with my art, and I can't think of any more meaningful message or reason to create than that.

I believe that making something with your hands is an act of transferring energy, and there is something about paper and the process of rolling and shaping it that feels warm, positive, and joyful in its essence. When you invest so much time, attention, and care into creating something, that warmth always stays there and can be felt by other people.

I truly hope that my experiences and insights are encouraging—we become good at whatever we practice, so the key is to keep going no matter what; to know that every moment you are exactly where you need to be, and to enjoy the journey as much as possible.